ROBERT MAPPLETHORPE AND THE CLASSICAL TRADITION

Germano Celant and Arkady Ippolitov, with Karole Vail

Robert Mapplethorpe and the Classical Tradition: Photographs and Mannerist Prints

Deutsche Guggenheim

Published on the occasion of the exhibition
Robert Mapplethorpe and the Classical Tradition: Photographs and Mannerist Prints

Organized by Germano Celant and Arkady Ippolitov, with Karole Vail
Deutsche Guggenheim, Berlin, July 24–October 17, 2004

ISBN: 0-89207-313-6 (hardcover)
ISBN: 0-89207-312-8 (softcover)

Deutsche Bank & Solomon R. Guggenheim Foundation

Guggenheim Museum Publications
1071 Fifth Avenue, New York, New York 10128

Deutsche Guggenheim
Unter den Linden 13/15, 10117 Berlin

English edition available through:
D.A.P./Distributed Art Publishers
155 Sixth Avenue, 2nd floor, New York, New York 10013
Tel: (212) 627-1999; Fax: (212) 627-9484

Distributed outside the United States and Canada, excluding German-speaking countries,
by Thames & Hudson, Ltd., 181A High Holborn, London WC1V 7QX, United Kingdom

Design: Takaaki Matsumoto/Matsumoto Incorporated, New York
Production: Tracy Hennige, Melissa Secondino
Editorial: Elizabeth Franzen, Stephen Hoban, Edward Weisberger

Printed in Germany by Cantz

Cover, front: Robert Mapplethorpe, *Ken, Lydia, and Tyler*, 1985 (cat. no. 100);
and back: detail of Jacob Matham after Hendrick Goltzius, *The Graces*, 16th century (cat. no. 99)

Table of Contents

Deutsche Guggenheim

Deutsche Guggenheim is a unique joint venture between a corporation—Deutsche Bank—and a nonprofit arts foundation—the Solomon R. Guggenheim Foundation. Designed by American architect Richard Gluckman, the 510-square-meter gallery is located on the ground floor of the Deutsche Bank headquarters in Berlin. Since opening in fall 1997, Deutsche Guggenheim has presented three or four important exhibitions each year, many of which showcase a specially commissioned work by an artist. The exhibition program and day-to-day management of the museum is the responsibility of the two partners.

Deutsche Guggenheim joins the Solomon R. Guggenheim Foundation's other existing locations: the Solomon R. Guggenheim Museum in New York; the Peggy Guggenheim Collection in Venice; the Guggenheim Museum Bilbao; and the Guggenheim Hermitage Museum in Las Vegas. Deutsche Bank regularly supports exhibitions in renowned museums and since 1979 has been building its own collection of contemporary art under the motto "art at the workplace." The Deutsche Guggenheim initiative further represents a milestone in Deutsche Bank's advancement of the arts.

*Commissioned work by Deutsche Guggenheim

Although separated by four hundred years and thousands of miles, in terms of form and content, the photographs of American artist Robert Mapplethorpe and the engravings of late-sixteenth-century European Mannerists reveal astonishing similarities. It is the striking aesthetics of his statuelike nudes, whose beauty is charged with explosive energy, that links Mapplethorpe's contemporary images with Mannerism.

Robert Mapplethorpe and the Classical Tradition: Photographs and Mannerist Prints at the Deutsche Guggenheim traces this art-historical parallel for the first time in a public exhibition. The result of an American-European collaboration, the exhibition is the joint brainchild of Arkady Ippolitov, Curator of Italian Graphic Art at the State Hermitage Museum, St. Petersburg, and Germano Celant, Senior Curator of Contemporary Art at the Guggenheim Museum, New York. Thus each museum has contributed to the exhibition that features the brilliant photographs of Robert Mapplethorpe from the New York collection alongside graceful Mannerist engravings from the legendary Russian collection. A third partner in the project, the Staatliche Museen zu Berlin, has loaned two sculptures and three engravings for the exhibition.

We are proud and delighted to host this artistic premiere at the Deutsche Guggenheim and wish the exhibition every success as it travels to St. Petersburg and New York.

Dr. Tessen von Heydebreck
Member of the Board of Managing Directors of Deutsche Bank AG

Robert Mapplethorpe and the Classical Tradition: Photographs and Mannerist Prints has been jointly organized by the Solomon R. Guggenheim Foundation, New York, and the State Hermitage Museum, St. Petersburg. This project is an important milestone of the partnership established when our two museums signed a long-term collaboration agreement in June 2000. Following its inaugural venue at the Deutsche Guggenheim in Berlin, the exhibition travels to the Hermitage and to the Guggenheim Museum in New York.

The Deutsche Guggenheim itself is a partnership between the Guggenheim and Deutsche Bank, and is a testament to the ongoing commitment by both organizations to the arts and the dialogue that they can foster among nations. We are especially pleased to be working once again with Dr. Tessen von Heydebreck, Member of the Board of Managing Directors, Deutsche Bank AG, and the highly professional staff in Berlin. We are most grateful to Michael Ward Stout, President, and the Board Members of the Robert Mapplethorpe Foundation for their vital collaboration and their important loans, as well as to their most capable staff. Due to the Mapplethorpe Foundation's unprecedented donation in 1992 of two hundred of Mapplethorpe's finest photographs and unique objects, the Guggenheim Museum now boasts the most comprehensive repository of his works in any American or European museum. For its part, the Hermitage's superb collection of European painting and sculpture includes an impressive array of Mannerist works, and particularly fine Flemish prints and engravings. We extend our warmest thanks to Arkady Ippolitov, Curator of Italian Prints at the Hermitage, and Germano Celant, Senior Curator of Contemporary Art at the Guggenheim, for their curatorial partnership, and further acknowledge Mr. Celant as General Editor for his remarkable creative force behind the exhibition catalogue. Additional loans to the exhibition include several exceptional works from the Skulpturensammlung und Museum für Byzantinische Kunst and the Kupferstichkabinett, both of the Staatliche Museen zu Berlin. We are most grateful to these institutions for their generosity in allowing their fragile works to travel to some of the exhibition's venues. We are indebted to Deutsche Bank for sponsoring the exhibition at the Hermitage. Last, we thank Nic Iljine, European Representative of the Guggenheim, who has championed this project.

Thomas Krens
Director, The Solomon R. Guggenheim Foundation

Mikhail Piotrovsky
Director, The State Hermitage Museum

Acknowledgments

Every exhibition results from the work and input of many different people, and we are deeply indebted to all who contributed in some way or another to realize *Robert Mapplethorpe and the Classical Tradition: Photographs and Mannerist Prints*. This exhibition showcases the astonishing juxtaposition of works by one of the foremost photographers of the twentieth century together with sixteenth-century Mannerist prints, thus allowing for new readings and interpretations of classical themes, which Mapplethorpe and the Mannerists have relentlessly pursued.

The exhibition surfaced pursuant to many conversations with Thomas Krens, Director, Solomon R. Guggenheim Foundation; Lisa Dennison, Deputy Director and Chief Curator, Solomon R. Guggenheim Museum; and Professor Mikhail Piotrovsky, Director, the State Hermitage Museum. We are grateful to them for their faith in this project and for the encouragement they have given us throughout. We also thank Anthony Calnek, Deputy Director for Communications and Publishing, Solomon R. Guggenheim Museum, for his support.

We must express our sincerest thanks to Karole Vail, Assistant Curator, Solomon R. Guggenheim Museum. Her unfaltering dedication to the successful realization of all facets of this exhibition and its accompanying catalogue has indeed been of crucial importance. We extend our thanks to many people at the State Hermitage Museum, including Dr. Roman Grigoriev, Head of the Prints Department and Curator of Dutch and Flemish Prints, and to Dr. Sergei Androsov, Deputy Head of Department of Western Art and Curator of Italian Sculpture. We gratefully acknowledge Andrei Naslednikov, Curator of Photography; Dr. Dimitri Ozerkov, Curator; Sergei Orechov, Assistant Curator; Nikolai Zykov, Assistant Curator; and Olga Kovaleva, Assistant Curator, Prints Department, Department of Western European Art. We further extend our thanks to Valentina Kozareva, Head of the Laboratory of Paper Restoration and Conservation for her assistance. We also thank Yurii Molotkovetz for his photographs of the works from the Hermitage for the catalogue.

We would also like to thank Zelfira Tregulova, Deputy Director of the Kremlin Museum, Moscow, for all her help with the bibliography. We extend our thanks to Anna Konivets, Senior Research Fellow/Coordinator of the Hermitage-Guggenheim Project, and to Min Jung Kim, Program Director for Content Alliances, Solomon R. Guggenheim Museum, for their steadfast collaboration. We are particularly grateful to Nic Iljine, European Representative, Solomon R. Guggenheim Museum, for his commitment and his ongoing fund-raising efforts. We also gratefully acknowledge Lisa Panzera, Project Assistant Curator, Guggenheim Museum, who did most of the important groundwork in the early stages of this project, as well as Anna Costantini and Marta Léger, Studio Germano Celant, Genoa, for their assistance, as well as to former Curatorial Intern Catharina van Mossevelde, for all her helpful research.

We offer our heartfelt thanks to the Robert Mapplethorpe Foundation for its support and collaboration, and especially to Michael Ward Stout, President, and his fellow Board Members, Lynn Davis, Burton G. Lipski, Dimitri Levas, and Stewart Shining; Marisa Cardinale; Eric R. Johnson and John Charles Thomas, Legal Counsel; Edward Mapplethorpe; Gillian Cuthill and Joree Adilman, Foundation Managers; as well as former Foundation Manager Danielle DuClos. We are thrilled to have benefited from the Foundation's exceptional loans, including two sculptures once owned by Mapplethorpe. We are also grateful to Ken Moody, one of Mapplethorpe's models, for his time.

We are deeply grateful to several lenders, and we wish to thank Dr. Volker Krahn, Director, Skulpturensammlung und Museum für Byzantinische Kunst, Staatliche Museen zu Berlin, Preussischer Kulturbesitz; Prof. Dr. Hein-Th. Schulze Altcappenberg, Director, and Dr. Holm Bevers, Curator, Netherlandish Drawings, Prints, and Manuscripts, Kupferstichkabinett, Staatliche Museen zu Berlin, for their generosity in loaning several key works, which have enriched the exhibition. We also thank Jörg Anders for his photographs of the works from the Skulpturensammlung und Museum für Byzantinische Kunst and the Kupferstichkabinett.

We wish to acknowledge Dr. Jörg Völlnagel, Assistant Curator, Hamburger Bahnhof, Museum für Gegenwarts, Staatliche Museen zu Berlin, for his assistance in helping locate sculptures in Berlin.

We thank Deutsche Guggenheim and Dr. Tessen von Heydebreck, Member of the Board of Managing Directors of Deutsche Bank AG. We are grateful to Dr. Ariane Grigoteit and Friedhelm Hütte, Curators of Deutsche Bank Collection. Our thanks extend to Svenja Gräfin von Reichenbach, Gallery Manager; Sara Bernshausen; and Jörg Klambt, MuseumShop Manager; for carefully overseeing all aspects of the organization of the exhibition. We further thank Nikoline Kästner and Maria Bortfeldt, Conservators, as well as Uwe Rommel and his team; and Fabienne Lindner, Graphic Designer and Project Manager, Surface Gesellschaft für Gestaltung. The Deutsche Guggenheim team, including Kathrin Conrad, Sabine Ebner, Daniela Mewes, and Ulrike Heine, is also to be commended for their efforts.

We feel privileged to have this elegant catalogue designed by Takaaki Matsumoto and his staff. We wish to thank Jennifer Blessing, Guggenheim Project Curator, for her insightful essay on the representation of classical allegory in nineteenth- and twentieth-century photography. The production of an impressive book requires the notable skills of many people. In our admirable Publications Department we must acknowledge Elizabeth Levy, Director of Publications; Elizabeth Franzen, Managing Editor; Stephen Hoban, Assistant Editor; Edward Weisberger, Editor; Melissa Secondino, Production Manager; and Tracy Hennige, Production Assistant, for expertly seeing the catalogue through to fruition. David M. Heald, Director of

Photographic Services and Chief Photographer, is to be commended for his photographs, and we thank Kim Bush, Manager of Photography and Permissions, for her input. We extend our thanks to Barbara Conrad-Lütt, Bernhard Geyer, Moshe Kahn, Catherine Phillips, and Stephen Sartarelli for their commendable and most thoughtful translations of the catalogue essays into English and German, as well as to Heidi Ziegler, Editor, for her attentive work on the German edition.

We offer our appreciation to Gail Scovell, General Counsel; Brendan Connell, Assistant Legal Counsel; and Marion Kahan, Exhibition Program Manager; for their patient efforts with all contractual details; as well as to Meryl Cohen, Director of Registration and Art Services; Kathleen Hill, Project Registrar; Hannah Blumenthal, Global Programs Manager, as well as to Jennifer Russo, Public Affairs Coordinator, for all their efforts. We would like to thank Liz Jaff, Associate Preparator for Paper, for her skills and patience, as well as to Ana Luisa Leite, Manager of Exhibition Design, and Carolynn Karp, Exhibition Design Assistant; Peter Read, Manager of Exhibition Fabrication and Design; David Johnson; Liza Martin, Assistant Preparator; and Pat Holden, Art Handler. Both Nora Nagy, Sculpture Conservator, and Mara Guglielmi, Paper Conservator, assisted carefully in the review of each artwork's condition, and we are most grateful to them for their expertise. We also thank Carl Kaminsky of MEDFAX Portable Diagnostics Precision Health, Inc., for his helpful X-rays of sculpture. We are also appreciative of the patient assistance of Lynn Underwood, Director of Integrated Information and Management, and Danielle Uchitelle, Information Technology. Finally, we would like to thank Sarah Beller and Carla Melandri, Curatorial Interns, for their efforts.

Germano Celant
Senior Curator of Contemporary Art, Solomon R. Guggenheim Museum

Arkady Ippolitov
Curator of Italian Prints, State Hermitage Museum

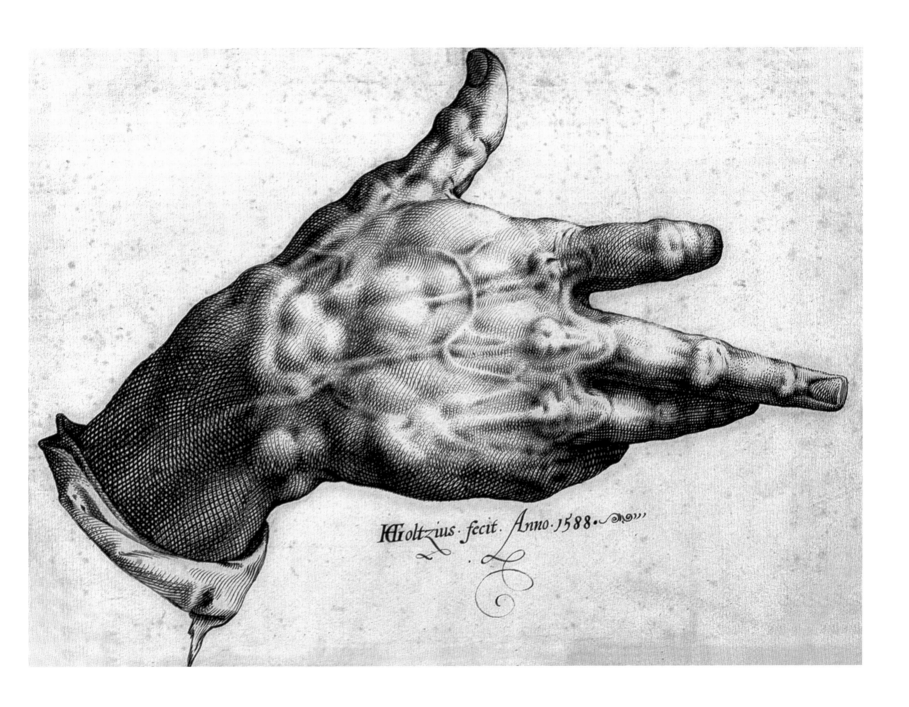

HGoltzius. fecit. Anno. 1588.

IMAGES AND ICONS
ARKADY IPPOLITOV

We are accustomed to think of the history of art as some kind of onward movement, an evolutionary process that began with the creation of Adam and continues to the present day. Events and facts are arranged in a set order, like links in a chain, one fact determining the appearance of another, naturally forming a single line, a line that is uneven yet unbroken, such that the history of art is reduced to a pattern of great genius set by the biblical narrative: Abraham begat Isaac; and Isaac begat Jacob; and Jacob begat Judas and his brethren; and Judas begat Phares and Zara of Thamar; and Phares begat Esrom; and Esrom begat Aram; and Aram begat Aminadab…and so on unto eternity, or rather right up to the present moment. How we treat the history of art—as a history of styles, social history, or art history as intellectual history—proves, in the end, to be irrelevant, for it is history that comes to the foreground, subordinating and determining our narrative.

Pointless to question the rightness of this biblical narrative. It is formed from our attitudes to time and one might as well seek to return one's youth by turning back the hands of the clock as refute its raison d'être. We would seem to have accepted on trust the truism—formulated by classical philosophy and taking firm root in our consciousness from the age of the Blessed Augustine—that time is like a flowing stream and that one cannot dip into the same water twice. Art, however, rises up against the dictatorship of the obvious, proving that time is not quite so linear, the changes not quite so irreversible, that the human spirit, forever in unsteady movement, takes liberties with history, and the theme of eternal return is no less important than that of the implacable passing of time.

Inexplicable art-historical parallels appear suddenly, unexpectedly, overturning accepted patterns of development, totally stumping those scholars who seek always the link between cause and effect, who wish to arrive at clear, logical explanations for every phenomenon. They are forced by the strange likeness between the portal sculpture of Reims Cathedral and classical Greek works to fantasize that medieval masters may have taken part in the Crusades, while similarities between Caravaggio's late-sixteenth-century *Bacchus* and images in Buddhist art lead to suggestions that the artist was acquainted with Indian art that might, perhaps, have been found in collections of exotic curiosities in Rome. Such hypotheses are groundless, fantastical, yet the similarities remain a reality that destroys all of history's accepted spatial and temporal bounds. In defiance of everything, art proves that it establishes its own bounds, regardless of in which century and by what means the artist creates his images, whether with the aid of a stone ax or a computer: in essence, the artist is always doing the same thing. History is but a fiction, something cooked up in order to explain that which has no need of explanation.

(page 15)
Hendrick Goltzius
Study of a Right Hand; Goltzius's Right Hand, 1588
Pen and brown ink on paper
9 x 12 ¹³⁄₁₆ inches (22.9 x 32.8 cm)
Teylers Museum, Haarlem, The Netherlands

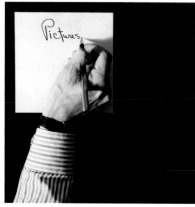

ROBERT MAPPLETHORPE
Pictures/Self-Portrait, 1977
Gelatin-silver print
Edition 3/10
20 x 16 inches (50.8 x 40.6 cm)
Solomon R. Guggenheim Museum, New York,
Gift, Robert Mapplethorpe Foundation
93.4281

Take two works: a drawing by Hendrick Goltzius, *Goltzius's Right Hand* (1588; also known as *Study of a Right Hand*), and a photograph by Robert Mapplethorpe, *Pictures/Self-Portrait* (1977). We are struck by some strange internal relationship. It lies not just in the object depicted—in both cases, the artist's right hand—but in a deeper, inner likeness. There are thousands of depictions of hands, all more or less alike, those numberless hands of martyrs, prophets, and creators, the hands of Leonardo, Dürer, and Rodin, but in this interchange across the centuries the external likeness, although it forces the viewer's gaze to linger, is but secondary. These ideally drawn fingers seem to make that sharp, hard contour, agonizing in its definition, despite wracking pain, and the viewer gets such a sensation of pitiless, harsh effort, of the overcoming of intense difficulty, that the image seems to be carved into our memory and consciousness. The nervous refinement is almost perfect, almost artificial; this is an image of a hand, but an image that is amazingly individual, full of explosive dynamism, forcing us to become physically involved in the act of creation that it embodies. These are self-portraits, bearing all the significance of their creators' terrible suffering, and differences in manner of embodiment—in how the image was produced—seem so pettily insignificant that one has not the slightest desire to meditate on the trivial question of whether or not Mapplethorpe had seen Goltzius's drawing.

Mapplethorpe almost certainly did not know the drawing and took no account of such associations. All the more surprising, therefore, that both artists, despite a clear dissimilarity of means and purpose, created through the depiction of hands a self-portrait that is simultaneously an ideal image and an extremely frank confession. The amazing likeness is what seems to matter, while all specific information regarding the circumstances in which these works appeared is interesting but insignificant. What is the relevance of the fact that Goltzius (as we are told by his biographer Karel van Mander) as a child burned his hand in boiling oil and was a cripple? It might be relevant in speaking of another artist, but not of Goltzius. It would be too trivial to find mere physiological explanations and motives for that sense of surmounting incredible obstacles in which the artist makes the viewer a participant. Burn specialists have come up with convincing explanations of how the deformation of the fingers results directly from that accident, treating the drawing like an illustration in some medical dictionary, but surely it is clear that everyday reality could not possibly lay claim to representing truth. It is clear as day that the hand before us is that of an artist, not of an invalid, and that physical suffering could not possibly explain the image's harsh painfulness.

Just as eloquent, and explaining as little as any observations on Goltzius's physical handicap, is the fact that Mapplethorpe's *Pictures/Self-Portrait* was produced as an

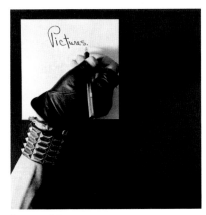

ROBERT MAPPLETHORPE
Pictures/Self-Portrait, 1977
Gelatin-silver print
Edition 2/10
20 x 16 inches (50.8 x 40.6 cm)
Solomon R. Guggenheim Museum, New York,
Gift, Robert Mapplethorpe Foundation
93.4280

invitation to simultaneous exhibitions opening in New York on February 5, 1977, at the Holly Solomon Gallery and The Kitchen, and that the two photographs of his own hand seemed to lift the curtain on his double life, "uptown" and "downtown." Boiling oil or a night in the "dark room"—what is the difference? It is axiomatic that chance is a means of revealing necessity, but because of that, necessity is far more important than chance. The painful ambiguity of art cannot be fully explained either by physical trauma or by the artist's way of life. Four hundred years divide these two images yet seem a mere nothing, as irrelevant as the difference between the sixteenth-century pen and a modern camera.

Mannerist theorists asserted that the image of the right hand indicated labor. The Latin inscription on Goltzius's drawing—*HGoltzius. fecit. Anno. 1588.*—is so full of meaning, so carefully executed, that it reads like a manifesto. Even the most finished of the master's works are not always endowed with a signature so calligraphically precise, which fixes the viewer's attention and provides convincing evidence that to Goltzius this drawing was not a simple study from life but something of far greater meaning. In Mannerist discussions of art's significance and painting's place in the hierarchy of the soul, one of the central questions dealt with the relationship between painting and the "free arts." Prior to this, the labor of craftsman and artist had been equated—anything created through the application of physical effort was a priori distanced from the sphere of pure spiritual activity. Music and poetry, not to mention philosophy and theology, were most definitely considered more worthy than any dabbling in painting or sculpture. What independence could lie in an artist's work if his images were but the imitation of nature, the artist himself no more than a mirror reflecting God's creation? It was his fate to be a copyist or, at best, an imitator. No great spirituality was required to reproduce or reflect; mere skill would suffice, based on a habit of physical labor alien to any truly noble person.

Goltzius's drawing should be perceived as a protest against the existing hierarchy. Making this image of a hand his emblem, he proclaims the handmade nature of art, but so perfect, so intellectual is the refined outline of the wrist that there can be no doubt: the symbol of manual labor has been transformed into a symbol of spiritual life. The artist's hand embodies the link between the inner world, filled with images wrought by thoughts and fantasies, and the outer world, physical and visible to the eyes, into which only the artist can carry the visions to which he has given birth, through a profound intensity of will and with the aid of pen, chisel, or brush. The image of the artist's hand is transformed into an icon miraculously revealed to the viewer, breaking down the equality between handmade and mechanical production.

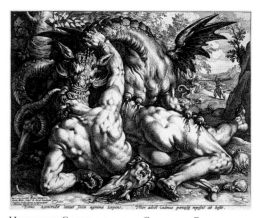

Hendrick Goltzius after Cornelisz. Cornelisz.
van Haarlem
The Dragon Devouring the Companions of Cadmus, 1588
Engraving
9 ½ x 12 ³⁄₁₆ inches (24.2 x 31 cm)
Rijksmuseum, Rijksprentenkabinet, Amsterdam

Those arguments that arose at photography's birth and have accompanied it right through to the present day somehow recall the problems that concerned the Mannerists. A miracle of technical progress, the camera lens divides process from result, alienating the artist from the work. Photography is but reproduction, the result of pressing a button leading to a momentary flash, firmly fixing reality. Value is given to photography by just one little detail, a *punctum* in the definition of Roland Barthes, and photography is thus attributed equal rights with nineteenth-century naturalistic realism. Although today photography has to all appearances gained equal rights with other art forms, it continues to be perceived as a kind of derivative reality, almost something like the art of fixation, in which everything depends solely on mere selection. In some strange manner the fact that photography is not handmade to that same degree as "handmade" is presupposed in painting, drawing, or sculpture has forced many to doubt its equal standing alongside the traditional arts. As a consequence, in all histories of art, photography is set apart, covered in a separate section, a sort of ghetto, as if it can only and should only exist purely within its own context, and it is permitted only faint allusions to what is proudly described as "classical art."

Mapplethorpe's *Pictures/Self-Portrait* is perceived as a paradoxical exhortation in defense of photography's handmade nature. The hand tracing the meaningful word "pictures" with such evident effort is as significant as in Goltzius's drawing. It is not in the camera flash, producing many reproductions of reality and allowing the photographer to reflect and represent himself, that the meaning of Mapplethorpe's art lies, but in the pictures created by the artist's imagination. The reality of uptown and downtown is secondary, insignificant, mere fertilizer for the image, and the artist uses it in order to create, to transform. Mapplethorpe's images are as handmade as the works of the old masters, and he intuitively uses the same symbol as did Goltzius to assert his place in the history of art, insistently proclaiming equal rights for the artist's labor with those free arts accepted as rightfully belonging to the sphere of intellectual activity.

Goltzius's drawing is in pen, imitating the technique of engraving with a chisel: the image of the hand is modeled with hard, crossed lines, sharper at the ends and thicker toward the middle, reproducing the traces made by a chisel on a metal sheet. The hand is not drawn on the surface of the paper but seems to be carved out of the surrounding space, its deep lines firmly and harshly accentuating its volume, giving it the tactility of metal. Physically, the convulsive tension of the fingers is like that demanded of an engraver working up a copper plate. Goltzius plays on the ambiguity of meaning—in a technique imitating engraving he reproduces the hand of an engraver. It is important for him to

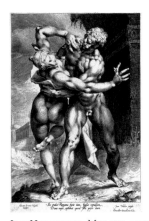

emphasize the sense of battle, of surmounting the material's resistance, which is necessary in any process of transformation. An image is born upon the surface as if from nothingness, an image endowed with sensual conviction—a miracle wrought by the artist's will. It is possible only thanks to pitiless effort, to concentration both spiritual and physical, making this miracle visible and comprehensible. Simultaneously the artist's hand is that of a magician, transforming matter rather than material; it would be quite naïve to suggest that Goltzius's hand, set so powerfully into eternity, was created merely with the aid of pen and ink.

Mapplethorpe's hand, working the sacred word "pictures" on the paper with the precision of a calligrapher, also seems to be cut out of reality. It would be odd to describe this photograph as a fixation of reality, so agonizing are the harsh contours captured by the lens. Mapplethorpe's hand proffers the viewer indubitable evidence of the latter's own dreams and nightmares, concealed deep within our everyday life in that place wherein lies a deep desire to commit some crime, wherein our erotic dreams take place, wherein hide unrealized desires, our hidden need to torment and be tormented, tangled up in a mass of unrevealed fantasies and desires so terrible that few are brave enough to peer into it voluntarily. The act of creation is transformed into a destructive outburst of willfulness, bringing to life amazing combinations of beautiful and monstrous forms, naturally drawing the viewer into its whimsical game, full of the cruelty of myth.

Mannerism is extremely cruel. A key work of Northern Mannerism is Goltzius's engraving from a composition by Cornelis Cornelisz. van Haarlem, *The Dragon Devouring the Companions of Cadmus* (1588). Monstrous jaws sink into the head of the doomed, naked man; claws tear at his body, blood spurts forth, dead heads and rotting bones are scattered around the dragon's lair; and the central element in this whole image is the flesh being torn so savagely to shreds. The small figure of Cadmus in the background is but a tiny fig leaf, tossed aside, utterly incapable of covering over this apotheosis of cruelty. Time to ask Goltzius the question put to Mapplethorpe during a conference at the Institute of Contemporary Art in London regarding his fist-fucking picture: "Now how much further do you think we can actually go?" And to get the answer that Mapplethorpe gave then: "Actually, I have one with two [fists]."

Mannerism is cruel not in the depiction of spilled blood, ripped flesh, and crucified martyrs; it is cruel as a style consisting of a perpetual search for beauty and the ideal, a search that demands profound intensity. All effort is cruel and the search for the ideal is also cruelty. Line is painful, no matter with what it is drawn, be it chisel or lens, just as the act of creation itself is painful, an act so very like erotic desire that it is as needless and

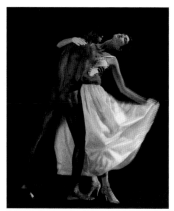

ROBERT MAPPLETHORPE
Thomas and Dovanna, 1986
Gelatin-silver print
A.P. 1/2
23 ⅛ x 19 ¼ inches (58.7 x 48.9 cm)
Solomon R. Guggenheim Museum, New York,
Gift, Robert Mapplethorpe Foundation
93.4303

pointless to deny it as it is to prove it. What interests the Mannerist artist in extravagantly twisted compositions showing Psyche and Mercury, Bacchus and Venus, Romans and Sabine Women? Clearly the interest lies in that the subject is secondary, and the same sense of intoxicating dance therefore arises from both joyful ascension and crude acts of violence, forcing bodies to melt into a single whole, in a vertiginous whirlpool of virtuoso twisted movement. This is the sphere of pure form, geometrical balance of beauty expressed in bodily plasticity, removing all contradictions between good and evil, darkness and light, male and female, night and day, real and invented. In the sphere of ideal form there are no oppositions; everything has been calculated and balanced, but that balance is fine, so fantastical, that the slightest puff will blow it away. Like Ariel's performance, which played out at the will of Prospero, the worlds of Mannerism and Mapplethorpe—whose Thomas, Dovanna, Ajitto, Ken, Lisa, Tyler, and Lydia are those same figures of Mercury and Psyche—are fragile and gentle in their cruelty.

Translated from the Russian by Catherine Phillips.

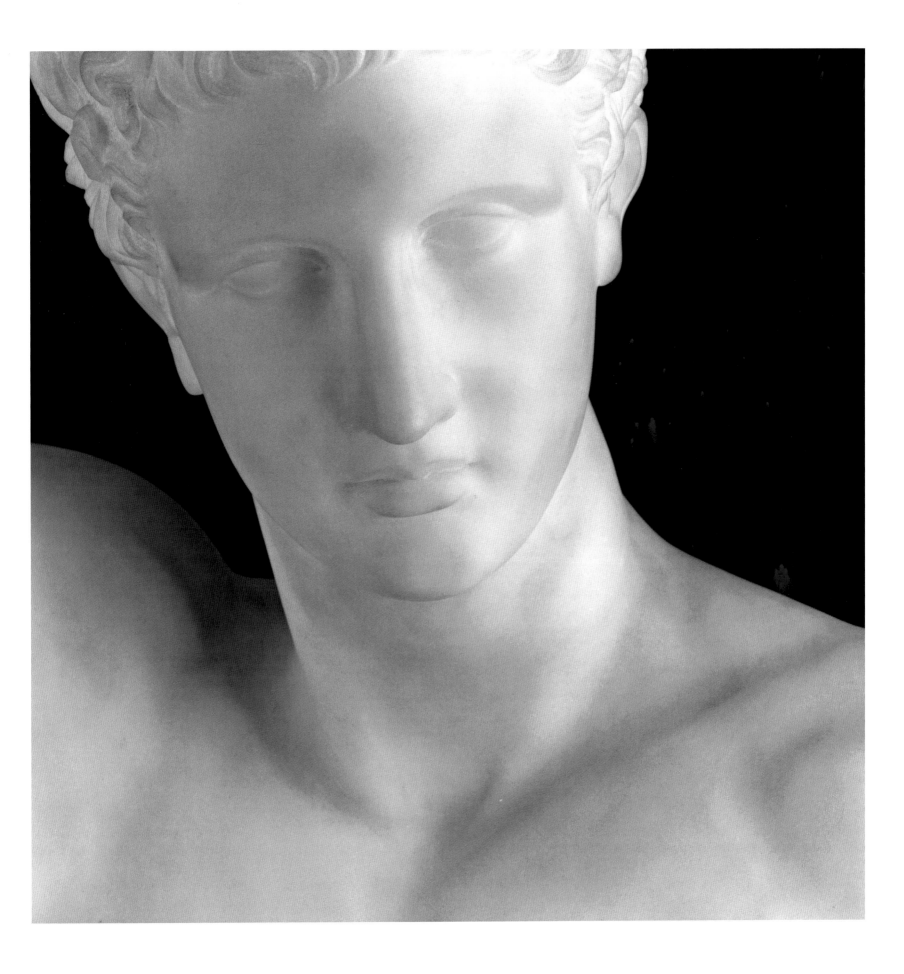

Classical Allegory in Photography
Jennifer Blessing

Allegory in plastic art, like allegory in literature, presumes the existence of a level of meaning beyond that which is readily apparent. While we may admire the form, the grace, of a sculpted nude, when we learn its name, say Apollo or Hermes, our comprehension of the significance of the form blossoms to include a narrative that lies beyond the plainly visual. Allegory is therefore an addition, a supplemental signification. Rather than what you see is what you get, you get much more than what you at first see. In classical antiquity, sculptures of mortal beings with symbolic attributes—perhaps a trident or cornucopia—represent divinities whose machinations give explanatory logic to existential riddles, from the changing of the seasons to the nature of evil. The roots of allegory, therefore, are fundamentally theological or metaphysical.

In the case of plastic art, the allegorical interpretation is usually derived from a literary text. During the Renaissance (so named for its revival of the antique) lessons of classical sculpture were incorporated into biblical narratives. The ancient artwork was sheared of its mythological meaning through ignorance or by layering it with a new Christian interpretation via Neoplatonic philosophy; who is God in Michelangelo's Sistine Chapel ceiling but Zeus with another name? In turn, Mannerist prints reflect the Renaissance fascination with the classical body and continue the transcendence of iconographic distinctions. Mythological and biblical subjects had become stylistically interchangeable, with both gods and saints demonstrating the epitome of physical perfection. Scenes of naked maidens gamboling in their bath, whether Artemis spied by Actaeon or Susannah and the Elders, betray a purely sensual, base delight in corporeality despite the lofty and presumably moral message conveyed by their allegorical titles.

Aesthetic theory of the last approximately two hundred years has held allegory in contempt, primarily because it is seen as extraneous to the form of the work itself.[1] A given image of a draped woman might be labeled interchangeably with any number of abstract concepts like Justice or Clemency or Fortune. The late eighteenth and early nineteenth centuries witnessed a last gasp of classically inspired allegorical history painting, such as Jacques-Louis David's *Oath of the Horatii* (1784–85), in which an antique antecedent is constructed to suggest the heroic dynamism of contemporary political culture. A new belief—in democracy, individuality, and the common man—is now the impetus for allegory. In mid-nineteenth-century France the critical art establishment distinguished between modernists and historicists. Modernists (with the Impressionists as their apotheosis) were essentially realists who painted the transitory moments of lived experience. The historicists were fundamentally allegorists, endeavoring to create timeless works of art by illustrating literary and genre subjects. Gustave Courbet's "realist

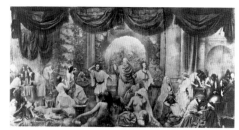

OSCAR G. REJLANDER
Two Ways of Life, 1858
Gelatin-silver print
16 ⅛ x 31 ⅛ inches (41 x 79 cm)
George Eastman House, International Museum
of Photography and Film, Rochester, New York,
Gift from the Royal Photographic Society

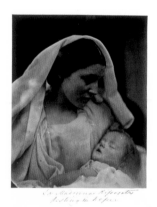

JULIA MARGARET CAMERON
La Madonna Riposata / Resting in Hope, 1866
9 ¹³⁄₁₆ x 7 ¹⁵⁄₁₆ inches (25 x 20.2 cm)
Albumen print
National Museum of Photography,
Film & Television, Bradford, England

allegories," including *The Painter's Studio* (1855), were his attempts to bridge the chasm between the two approaches.[2] Nominally Christian or classical, Courbet's allegories extend into the political and personal.

Meanwhile, in the nascent realm of photography criticism, a different debate vis-à-vis realism was developing. Challenged by a sense of inferiority engendered by the technical nature of their craft, early photographers attempted to prove the art of their medium by setting out to rival painting. Many photographers sought to affiliate themselves with the tradition of the antique, which had come to represent a generic notion of the Ideal (whether in polis or aesthetics). Daguerreotypes that depict cacophonous compositions of ancient sculpture copies and architectural fragments are allegories of the arts that implicitly include photography, and are among the earliest photographic compositions.

Before the advent of modernism, history painting was considered the most exalted of genres, above portraiture, landscape, and still life. It required knowledge of literary and historical themes and, through allegory, aspired to a moral message that went beyond the mundane. At a time when this tradition appeared increasingly moribund, at least in avant-garde aesthetic circles, the photographer Oscar G. Rejlander created *Two Ways of Life* (1858), in which a bearded elder presents two young men with the choice of the path of virtue or vice. Rejlander's goal was to showcase the artistic possibilities of photography by creating a complicated multifigural composition with "high" moral intentions. To do so, he called upon painterly touchstones like Raphael's *School of Athens* (ca. 1510–12), with its theatrical proscenium presentation, and used vaguely classical costume and nudity to present allegorical archetypes such as Religion, Mercy, and Industry, contrasted with representations of gambling, drinking, and licentiousness.[3] Pitting the virtues of work against the vices of idleness was a particular nineteenth-century concern that corresponds with the rise of industrial capitalism. It was a frequent subject of genre paintings of happy peasants, for example, but has also been a prime photographic theme throughout the history of the medium. Even the myriad documentary photos of workers, which appear to be straightforward recordings of reality, tacitly imply an allegory of the manual laborer's virtue.

Rejlander's experiment, which entailed more than thirty negatives painstakingly combined over the course of six weeks, was a rarity of its kind, while allegorical portraiture was almost ubiquitous, at least in Britain. Parlor games—the domestic creation of tableaux vivants, plays, and fancy dress—may have influenced the plethora of these images in British photography. Thus it was not unusual to present a photographic portrait of an aristocratic woman as Truth, for example. Typical of this practice is Julia Margaret

MAN RAY
Monument à D. A. F. de Sade, 1933
Gelatin-silver print and ink
7 ⅞ x 6 ⁵⁄₁₆ inches (20 x 16 cm)
The Vera, Silvia and Arturo Schwarz
Collection of Dada and Surrealist Art in
the Israel Museum, Jerusalem

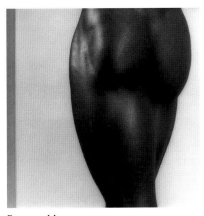

ROBERT MAPPLETHORPE
Derrick Cross, 1983
Gelatin-silver print
16 x 20 inches (40.6 x 50.8 cm)
Robert Mapplethorpe Foundation

Cameron's work, a curious photographic hybrid of religious and historical painting, à la Pre-Raphaelites, combined with the vein of allegorical portraiture especially popular in the eighteenth century. Cameron produced highly theatrical photographs of her household muses—servants, relatives, and guests—in the guise of biblical figures or in costumed tableaux illustrating contemporary English literature. She rarely engaged classical antecedents directly, preferring to employ a Renaissance ideal of the draped religious figure in photographs like *La Madonna Riposata / Resting in Hope* (1866), for which her maid, Mary Hillier, posed with a conveniently available sleeping toddler. Yet the titles of Cameron's many madonnas—Love, Joy, Peace, Repose, Long-Suffering, Gentleness, Goodness, Faith, Temperance, Aspiration, Trust—recall the classical tradition of assigning allegorical meaning to the human figure. And since these various names for Cameron's somewhat bored, seemingly put-upon maid often seem to be interchangeable, in that no aspect of her costume or demeanor helps us guess a particular photo's title, they also serve to illustrate the critical argument against the allegorical as an extraneous appendage. Cameron's images also exemplify a crucial aspect of allegorical photography in general: the problematic confrontation between the transcendent ideal of a work's narrative inspiration and the obviously mundane, specific, and intense reality of the individual sitter's visage. While this conundrum is not unknown to painting—note the criticism of the seemingly too-dirty feet in Caravaggio's altarpieces or of hyperrealist French nineteenth-century religious painting generally—the materiality of paint tends to distance the modern viewer in a way the indexically determined photograph does not.

With the rise of twentieth-century modernism, allegory in the visual arts seemed to be relegated to conservative realms such as memorials and aesthetic promotions of state ideologies, including post–World War I retrenchment in France, in "retour à l'ordre" paintings of mothers, and Italy, in Fascist sculptures of muscle-bound men. For modernists, however, allegory was a form of ornament and, as Adolf Loos proclaimed, "ornament is crime." And yet much Surrealist art has an allegorical dimension, though not in the traditional codified, presumably idealistic, way. Instead, Surrealist allegory is frequently obscure, Freudian, and darkly sexual. Take, for example, Man Ray's *Monument à D. A. F. de Sade* (1933). The image could be read as a detail from a Hellenistic sculpture type, the Aphrodite *kallipyge*, or "beautiful bottom," while the daggerlike outline accentuating the buttock's upper crevice defines a phallic form. Certainly, the Goddess of Love is appropriately invoked in conjunction with the Surrealists' patron saint of sex, the Marquis de Sade. On some level, this photographic work is an allegory of Surrealism and/or Surrealism's Dada roots, reflecting the Surrealists' Freudian-inspired interest in

CINDY SHERMAN
Untitled, #250, 1992
Color photograph
50 x 75 inches (127 x 190.5 cm)
Courtesy of the artist and Metro Pictures Gallery,
New York

CINDY SHERMAN
Untitled, #15, 1978
Gelatin-silver print
9 ⅜ x 7 ⅟₁₆ inches (23.8 x 18 cm)
Solomon R. Guggenheim Museum, New York,
Purchased with funds contributed by the
International Director's Council and Executive
Committee Members: Eli Broad, Elaine Terner
Cooper, Ronnie Heyman, J. Tomilson Hill,
Dakis Joannou, Barbara Lane, Robert
Mnuchin, Peter Norton, Thomas Walther,
Ginny Williams 97.4573

antiquity, in fragments and ruins. The inverted cruciform shape drawn on the photograph evokes both de Sade's sacrilege and Dada and Surrealist anticlericalism. A seeming defacement, the drawing also brings to mind an assisted readymade by Man Ray's frequent collaborator, Marcel Duchamp, specifically *L.H.O.O.Q.* (1919), his "hot-assed" version of the Mona Lisa with its drawn-on moustache.[4] The hermaphroditic character of *Monument à D. A. F. de Sade* further recalls Duchamp's female alter ego, Rrose Sélavy.

Nineteenth-century photographs of classical sculpture, including the profuse assemblages featured in daguerreotypes, presumably elevate their producers' art to the status of the antique. In the twentieth century, however, references to classical sculpture, particularly of the male nude, frequently suggest a realm of homoerotic connotations. For the predominantly heterosexual Surrealists, ancient objects allude to the melancholic lost past that the ruin also signifies, or perhaps to the Freudian uncanny. For gay artists like George Platt Lynes or Robert Mapplethorpe, the classical male nude—whether statuary or the sculpted physique of a live man—represents a notion of the ideal that both embodies and expands on its historical antecedents. Conveying power and perfection, the buttocks in Mapplethorpe's *Derrick Cross* (1983, cat. no. 22) mirror those in the Farnese Hercules. The cropped detail in Mapplethorpe's photo fetishizes and sexualizes the body, and is in keeping with the search for historical homosexual precedents and rationales that has traditionally underlain grecophilia, from the Renaissance to the present. This amounts to a quasi-religious secularization of the classical in order to invest it with a new hope for youth, beauty, timelessness, and even immortality. Photographs promote the ideal of eternal youth, while also seeming to document the searches of artists for their Pygmalions, perfections of creation that come to life for their creators' enjoyment.

And yet photographs also inherently allegorize death. They are by their very nature memento mori, attempting to forever fix a moment that is lost. Classical antiquity in early photographic representation not only suggests the timelessness of masterful creations but also their inevitable decay, as well as the transitory nature of their makers' fame and life itself. The perfection of youth is but an embodiment of *vanitas*; comparison with a crone is a premonition. While any means of representation participates in this seesawing between denial (of death) and anxiety, photography is especially apt. From its inception it has been used to document the deceased through a final record that often simulates life, as in postmortem photos in which children appear to be sleeping, or used to assert death's seeming banality, as in photojournalistic accounts of fatal accidents. In his *Self-Portrait* (1988, cat. no. 119), Mapplethorpe defiantly plays with the vanitas tradition by foregrounding a cane with death's head. Cindy Sherman, in a fictional photo, *Untitled, #250* (1992), presents a

CINDY SHERMAN
Untitled, #223, 1990
Color photograph
58 x 42 inches (147.3 x 106.6 cm)
Courtesy of the artist and Metro
Pictures Gallery, New York

SAM TAYLOR-WOOD
XV Seconds (After Scorsese), 2000 (detail)
Lambda print
10 ⅜ x 85 ⁷⁄₁₆ inches (27 x 217 cm)
Solomon R. Guggenheim Museum, New York, Gift,
Danielle and David Ganek 2003.105

frightening hag in the position of a sexy centerfold, thus encompassing the beauty of youth and the fear of age one might find in a painting by Hans Baldung Grien.

As critic Craig Owens argues, postmodern art (of which Mapplethorpe and Sherman are considered practitioners) may by its very nature be allegorical in its references to media culture, appropriated like fragmentary ruins. Perhaps the potential for allegory lies within photography itself, particularly the directorial or fictional mode rather than the documentary variety, which purports to straightforwardly represent "found" reality.[5] Images of constructed scenes have been around since the invention of photography; Hippolyte Bayard's *Self-Portrait of a Drowned Man* (1840) is considered the first and is followed by a long line of narrative scenes and portraiture characterized by artifice and allegorical implications. Given that the primary virtue of photography—its very essence— has been considered its privileged relationship to the real, the glaring gap between the idealism of intention in fictional photos (their antinaturalism) and the inherent realism of the medium leads to a high theatricality that can verge on camp and kitsch. Contemporary artists who use photography tend to accentuate this gap by using strategies of irony, humor, and self-conscious exaggeration. Sherman's *Untitled Film Stills* (1977–80), which reenvision 1950s B-movie heroines, are avatars of this approach. Derived from the world of media spectacle, they nonetheless remain insistently personal, as self-portraiture, and emphasize the split between reality and fantasy through their relatively low production values.

As is typical of postmodernism, contemporary photographic works thematize a critical distance from the image world they allegorize. Classical (and biblical) allegory, or what survived of it in the twentieth century and into the twenty-first, is enlisted less as a means to harness additional meaning and more as a way to emphasize a break with the past. Just as Man Ray's intention in *Monument à D. A. F. de Sade* is to corrupt the notion of classical purity and idealism, so Sherman's interest in her riffs on art-historical masterpieces like Caravaggio's *Sick Bacchus* (ca. 1593) or a Renaissance Madonna is to heighten the strange disjunctions between image and message inherent in the original works, and not to perpetuate the traditional, allegorized values.

Sam Taylor-Wood's *XV Seconds (After Scorsese)* (2000) is a rare example of a contemporary updating of classical allegory. This monumental photograph was originally created to cover three sides of a London department store's exterior. It is a reimagined Parthenon frieze in which the gods are now Elton John and other celebrities, who are aligned with the new manna, the consumer commodity. As with Sherman, Taylor-Wood critically appropriates and reinvests classical imagery in a personalized allegory that also

Matthew Barney
CREMASTER 5: her Giant, 1997
C-print in acrylic frame
52 ¾ x 42 ⅝ x 1 inches (134 x 108.3 x 2.5 cm)
Courtesy of the artist and Barbara Gladstone
Gallery, New York

has social and political implications. In the 1990s this kind of analytic and personal reinterpretation of traditional and media allegory yields a more hermetic type, of which Matthew Barney's *Cremaster* film cycle (1994–2002)—combining multiple narrative antecedents and oneiric metaphors in fabulous new wholes—is an especially complex example.[6] Barney's still photographs from his films, such as *Cremaster 5: her Giant* (1997), reference the internal logic of his own allegorical universe.

Notes

I would like to thank Allegra Getzel and Shannon Wearing for their kind and thorough responses to research questions.

1. This discussion is indebted to Craig Owens, "The Allegorical Impulse: Toward a Theory of Postmodernism," in Brian Wallis, ed., *Art after Modernism* (New York: New Museum of Contemporary Art; Boston: D. R. Godine, 1984), pp. 203–35. Reprinted from *October*, no. 12 (spring 1980), pp. 67–86, and no. 13 (summer 1980), pp. 59–80.

2. The full title is *The Painter's Studio: A Real Allegory Summing Up Seven Years of My Artistic Life*. See Linda Nochlin, "Courbet's Real Allegory: Rereading 'The Painter's Studio,'" in Sarah Faunce and Linda Nochlin, *Courbet Reconsidered*, exh. cat. (New York: Brooklyn Museum; New Haven: Yale University Press, 1988), pp. 17–41.

3. See Stephanie Spencer, *O. G. Rejlander: Photography as Art* (Ann Arbor, Mich.: UMI Research Press, 1985), pp. 95–103.

4. The letters L. H. O. O. Q., pronounced in French, sound like "elle a chaud au cul," which translates as "she's got a hot ass."

5. See Owens, p. 207 (where he begins by quoting Walter Benjamin): "'An appreciation of the transience of things, and the concern to rescue them for eternity, is one of the strongest impulses in allegory.' And photography, we might add. As an allegorical art, then, photography would represent our desire to fix the transitory, the ephemeral, in a stable and stabilizing way." It is not coincidental that all of Owens's examples of postmodern art are photographic or have a strong photo component.

6. See Nancy Spector, *Matthew Barney: The CREMASTER Cycle* (New York: Guggenheim Museum, 2002).

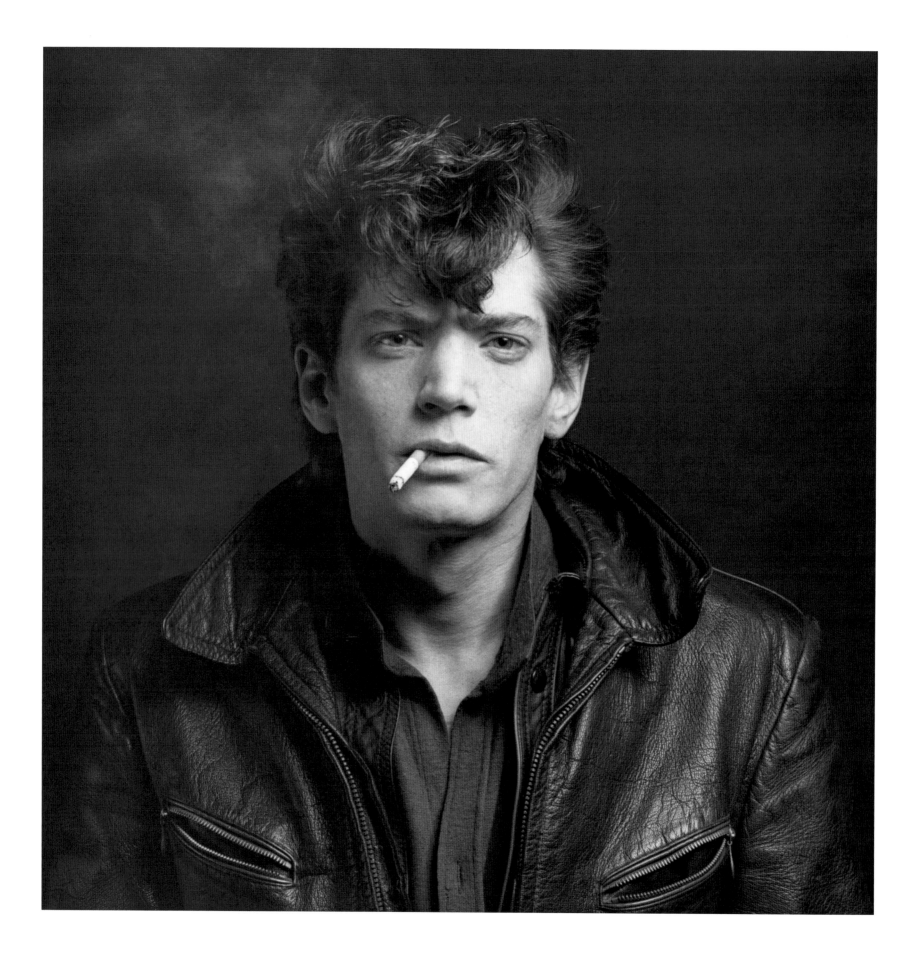

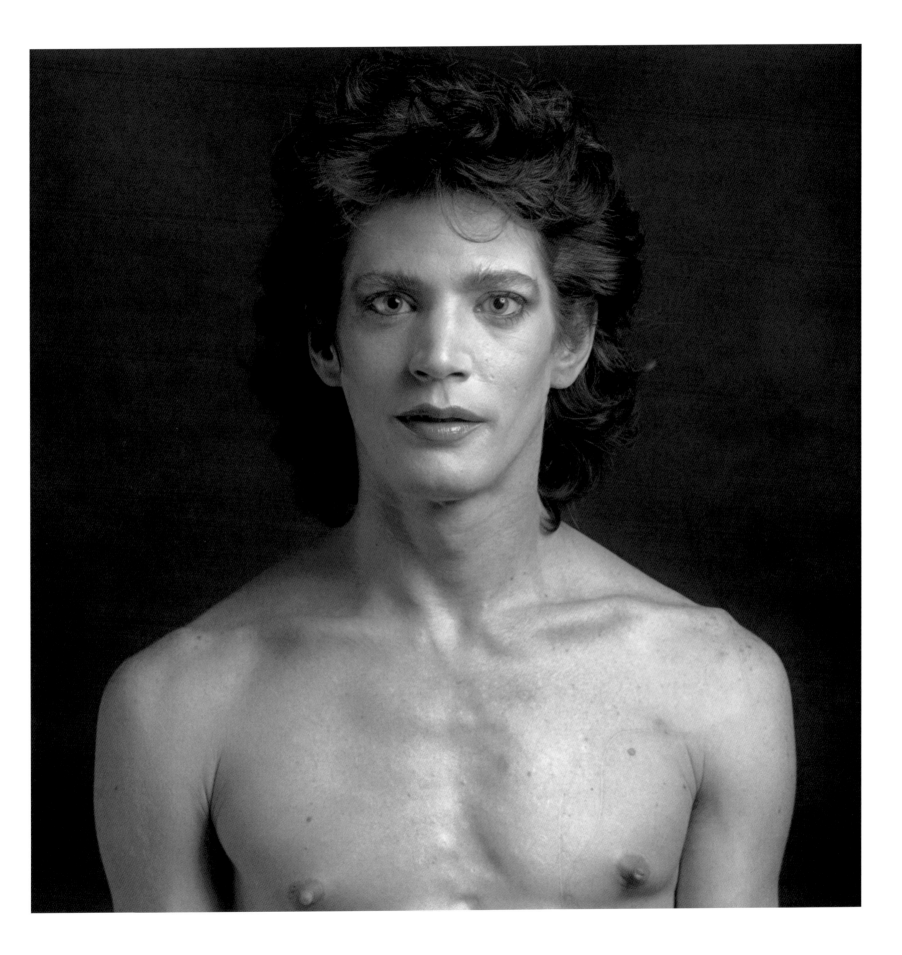

MAPPLETHORPE AS NEOCLASSICIST

GERMANO CELANT

Freedom, only freedom, has lifted art to perfection.

—Johann Joachim Winckelmann

Eros dominates the world, and the photographs of Robert Mapplethorpe glorify its power and multiplication. They do not, however, recognize in eros the predominance of a single, univocal sex, whether masculine or feminine; rather, they exalt it for the plurality of its expressions, its irregular, diverse movements, and the disorder it provokes in the identities of individuals.

Mapplethorpe affirms an eros that excludes no manner of exchange or passion whatsoever, a desire that acts on free, open ground and can be found anywhere human experience avails itself of it. He believes in a satisfied, realized eros, one that encompasses ever-new peripheries of life, ever-new powers of love. This is a continuous outburst of sexual pluralities, encounters, and affects, an absence of all guilt for the indomitable, insatiable will to being. This is an acceptance of all forms of love—without restriction and beyond all limits—and they must interweave or unravel around the free wanderings of the libido and desire; their interlacement, which includes sexuality and tenderness, cannot depend on a process of renunciation, repression, and inhibition.

Mapplethorpe's photographs crystallize a maximum investiture of people and things with desire. His journey into the vertigo of the senses—from the eyes to the genitals—is one that allows only the free, circular union of beings, expanding and surpassing the latest conceptions of eroticism.

What Mapplethorpe portrays is the exuberance of an *ars amatoria* aimed at self-pleasure, one that precludes any differentiation between love and perversion, active and passive, dominator and dominated, good and evil. It transcends opposites and distinctions because its interest is in moving within those intervals and gaps that, by separating, attract individualities, producing those extraordinary surprises of personal and sensual events that we define as erotic. However, the erotic charge that pulsates within an image and manages both to fascinate and disturb us finds its explanation in a dialectic between provocation and aesthetic harmony. In their crystallization, there is a condensation of energy and vital potency that moves toward the "limit" yet manifests itself as composed and felicitous. It is a plenitude, a haven where beings cease to clash and instead plunge into the flow of the senses.

From the very beginning of his practice, Mapplethorpe always attempts, consciously or unconsciously, to resolve the dichotomies between opposites: order and disorder, dissent and assent, anarchy and idealism. He works with the latent power of their bond

and reconciliation, aiming for the final result that would achieve a simultaneity of masculine and feminine, man and woman. His use of provocation and the unification of opposites, with its audacious undermining of traditional attitudes of amatory expression, is linked to the need to conquer those who want to be loved, not least of these being the public. The upsetting and dislocation of erotic understanding and vision are tools of seduction; by resorting to the power and reason of an expanded sexuality—incorporating the feminine in the masculine and vice versa—they allow one to master a different conception of eros.

Transcending the forbidden fosters, and brings into focus, a secret enjoyment and dynamic expression of the libido, rendering the human being versatile and various. Likewise, aesthetic harmony—with its mastery of bodies and their articulation, its equilibrium of volumes and forms, its control of structure and repetition—gives purifying, reassuring value to any and every kind of amorous ceremony, keeping one constantly available to the possible lovers who, though upset by provocative imagery, still perceive some positive quality in them, something based in the order of things. Harmony is timeless truth and the obligatory path to the reconquest of totality: one and two brought together.

What, in Mapplethorpe, gives rise to these figures, these manifestations of anarchy and provocation, sex and perversion, coupled or intertwined with order and harmony, love and tenderness? Where and when do they arise? By what personal and historical routes do they come to establish themselves in the photographer's images? Can they be retraced to some linguistic, artistic, individual, or social code? Is their contrasting presence attributable to the dazzling energy of its twofold nature?

Mapplethorpe's early works, from 1970 to 1976, trace the emergence of a double code: on the one hand, the scandal of homophile love and the cult of sexual and racial "diversity"; on the other, the sublimation of the images through the rigorous composition of the figures, the cultured, constructed representation of an ideal beauty that finds its meaning in antiquity. The attack on modesty and the use of provocation as a gesture of social rebellion come close to Dadaism and Surrealism,[1] while the logic of order and harmonious vision, embodied in the plastic rigorism of the figurations, reflects the study of the model in Renaissance and neoclassical sculpture.

Mapplethorpe lays claim to these precedents, first of all, because historical ideas provide a detachment from the present. Indeed, referring to the past is a way to freeze the impetus of intense, sensual images; seeking to imprison the tension of life into already proven art is a way to brake and remove the images from the accelerated, intense pace imposed by Mapplethorpe's existence. For the photographer, to rejoin the present with the

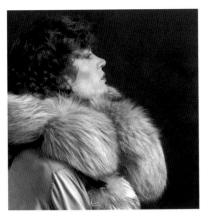

past, especially when it is a question of eros, is to give substance to events that appear insubstantial and unacceptable, to segregate the violence of sexual and behavioral provocation in the metaphysical sphere of classical art, to shift to the realm of the sublime an iconographical break that does not conform to current models but rather hooks up with tradition to make itself acceptable to the general public.

When Mapplethorpe, to give expression to his sexual diversity, reclaims the memory of Michelangelo or Antonio Canova, Antonio Pollaiuolo or Leonardo da Vinci, he does so to underscore the fact that artistic events are brought to life by the fascination of a body that is transcended through art but has its physical and sensual roots in reality. Clearly, by citing these precedents, the photographer dehistoricizes them, but it is also a way to anchor his own aesthetic and existential values, which otherwise can be taken outside of time. Mapplethorpe's photographs of nudes and erotic interlacements imply an intentionality, one that seeks an ideality in his own life and images, one that transcends his historical dimension and inner inclinations as a homosexual artist on a par with Michelangelo or Pollaiuolo.

By reflecting the classicism of great figures of the sixteenth and seventeenth centuries, Mapplethorpe means to juxtapose reason with sentiment and passion. Such works are linked to his personal events. This we see in the portraits of his lovers or companions in their sadomasochistic forays. But the story he tells is that of his own poetic intention, which is sustained on the rationality of seeing and sculpting, illuminated by thought and composition in accordance with classical principles.

The symmetrical composition of the body—presented in a perfect physical, muscular, and epidermal development that calls to mind the ephebes of ancient Greece, and in ideal poses and treatments that reduce the anatomy to the essentials—transforms the figures, with their strong, impetuous eroticism, into pure, innocent beings, even though nude bodies sometimes present an irrepressible, intolerable brilliance.

Finally, the recourse to the nude allows the photographer to strip the people Mapplethorpe loves, mostly black men, of all external elements, freeing them of their social fetters in order to place them on a pedestal outside of time. This perspective, which aims at the triumph of the absolute, naked body, brings him, beginning in 1973, to wed photography and art in a rigorous, classical language. In *Untitled* (1973), composed of six Polaroids, he goes so far as to juxtapose images of a neoclassical sculpture with images of his own naked and clothed body. Here, the interwoven and parallel movement is given significance by the fact that the positions of the living figure, at times wrapped in mesh, mimic that of the statue. Arms, legs, torso, and head make the same gestures, except flesh takes the place of marble and sculptural virtuosity gives way to absolute

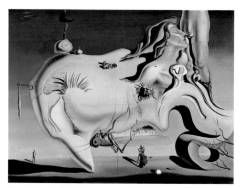

SALVADOR DALÍ
The Great Masturbator, 1929
Oil on canvas
43 ⁵⁄₁₆ x 59 ¹⁄₁₆ inches (110 x 150 cm)
Museo Nacional Centro de Arte Reina Sofía, Madrid

photographic mastery. By harmonizing them in a single context, Mapplethorpe begins to display, alongside the theme of eros, another essential aspect of his work: neoclassical photography.

For Mapplethorpe, studying the problem of the classical monument and its living ambiguity and juxtaposing the past sculpture with the present model, though in a reverse direction, means aspiring to mirror art in life and in photography: "I want people to see my works first as art, and second as photography."[2] He wants to transcend the latter through detachment and quality, to become the "high priest" of his own truth: eros captured in all its forms and manifestations. And the truth is expressed in a severe, restrained style proper to communicating noble, edifying themes, an honest, decidedly antiexpressive style capable of conveying clear and intransigent assertions, a style of uttermost purity and sober clarity—a style that can only be classical, though approaching the present and therefore neoclassical.

Starting in 1973, Mapplethorpe begins to work more and more on the boundaries between sculpture and the human figure, between art and photography, in order to offer a radicalism of subject in classical terms. One might therefore say that his photographs of sadomasochistic relations fall within a kind of classicizing naturalism. Indeed, if studied very closely, their compositions reveal a careful study of the models and figural gestures typical of historic art from the Renaissance classicism of Michelangelo to the elegant, statuary rationalism of Jacques-Louis David and Canova. It is an orthodox formalism that, when blended with an upsetting of traditional values, leads to a manner of perception capable of giving vibrancy to any subject, which may then surrealistically become "erotic." "I'm looking for perfection in form," says Mapplethorpe. "I do that with portraits. I do it with cocks. I do it with flowers."[3]

A predilection for the classical recurs in *The Slave* (1974), for which Mapplethorpe photographs the open pages of a book on Michelangelo. A knife rests on the pages, which show two images of the sculptor's *Prisoner* (1513–15; also known as *Dying Slave*) that detail the torso and center of the chest, where the figure's hand languidly touches the bands in which he is wrapped. The composition of the elements engenders a sublimation of desires. The knife, in ancient symbologies, alludes to the active principle that transforms passive material, and in this context, being associated with the Michelangelesque figure, it might refer to the creative will, which brings new works of art into being. If taken, on the other hand, as an initiatory, phallic instrument, it suggests a rereading and resexualization of the inner motivations of a "prisoner." Thus, the truth of the image can be erotic as well as religious, introducing a sexual ambiguity into the subject.

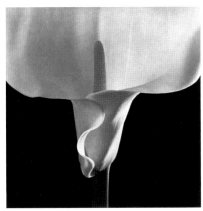

The *Prisoner* in fact suggests nudity and the gesture of baring oneself, the attempt to possess one's own essence. Alluding to this may mean aspiring to a mastery of one's self beyond all bounds and constraints. The subject of the photographic whole—*Prisoner* plus knife—foregrounds the communion of two symbolic entities in Mapplethorpe, the man-artist and penetrating sign that together represent his achieved, desired individuality, which in the coupling of extremes, the interlacement of art and sadomasochism, becomes iconoclastic.

The *Prisoner*, moreover, belongs to Michelangelo's "unfinished" world and, therefore, to the aspiration of spirit and form to free themselves from matter and its weight. No deity can stop this process, nor can it be stopped by the danger of being subject to the criticism and lynching of "common reason," always ready to cry scandal. Turning one's attention to the *Prisoner*—which represents not only the triumph of physical magnitude but also the externalization of a body overcome by divine force—means, for Mapplethorpe, who was raised a Catholic, gazing upon the inner beauty of a spirit that is the victim of a body in which it is chained and imprisoned. But the liberation from an oppressive condition, the contemplation of masculine beauty emerging and freeing itself from matter, can be interpreted as a reaching toward the liberation of pleasure, a Promethean expansion of the dormant sexual condition.

Considering that Michelangelo's homosexuality, like Leonardo's, is now more widely accepted as proven, citing the *Prisoner* might also mean evoking the latent power of homosexuality. Classical quotation thus becomes an allusion to history as a place of lost origins, as well as to the place of origins as loss. This dialectic is underscored by the symbolism of the knife, which establishes a phallic, initiatory relationship between such active and passive behavior as that typical of historical homosexuality, the warrior's dichotomy between *eromenos* and *erastes*,[4] between the sexually desired but immature and submissive body and the adult, naked, active body.

The revival of the classical source is instrumental. In the *Prisoner*, the photographer-artist sees the beautiful youth, the homosexual desire, the statuesque body, the photograph looking at tradition, and finally himself—that is, Mapplethorpe sees the preconditions for understanding his own work: "I'm working in an art tradition . . . to me sex is one of the highest artistic acts."[5]

The codification of an "unnamed" but visualized personal condition becomes manifest and openly declared in *Self-Portrait* (1975), in which Mapplethorpe portrays himself by letting the visual field be occupied by his extended right arm. In the *Prisoner*, the arm is bent to free itself of the bands wrapped around it, pointing to the inner center of the figure's feeling, as well as the introversion of his desire. The arm stands against power, but it is also

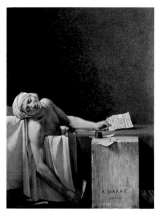

JACQUES-LOUIS DAVID
The Death of Marat, 1793
Oil on canvas
64 ¹⁵⁄₁₆ x 50 ⅜ inches (165 x 128 cm)
Musée d'Art Moderne, Musées Royaux
des Beaux-Arts de Belgique, Brussels

erectile, pushing against repression and letting one into the space of its own desire. The 1975 *Self-Portrait* represents photography as erotic mirror; to cite Roland Barthes, who is referring precisely to this *Self-Portrait* and echoing the contents of Michelangelo's *Prisoner*:

> *The erotic photograph, on the contrary (and this is its very condition), does not make the sexual organs into a central object; it may very well not show them at all; it takes the spectator outside its frame, and it is there that I animate this photograph and that it animates me. The* punctum, *then, is a kind of subtle beyond—as if the image launched desire beyond what it permits us to see: not only toward "the rest" of the nakedness, not only toward the fantasy of a praxis, but toward the absolute excellence of a being, body and soul together. This boy with his arm outstretched, his radiant smile, though his beauty is in no way classical or academic, and though he is half out of the photograph, shifted to the extreme left [sic] of the frame, incarnates a kind of blissful eroticism; the photograph leads me to distinguish the "heavy" desire of pornography from the "light" (good) desire of eroticism; after all, perhaps this is a question of "luck": the photographer has caught the boy's hand (the boy is Mapplethorpe himself, I believe) at just the right degree of openness, the right density of abandonment: a few millimeters more or less and the divined body would no longer have been offered with benevolence (the pornographic body shows itself, it does not give itself, there is no generosity in it): the photographer has found the right moment, the* kairos *of desire.*[6]

It is possible to add another level of interpretation. According to the Surrealists, physical metamorphosis never occurs without violence. The body must be cut up, destroyed, and reconstructed, as in Hans Bellmer and Salvador Dalí (e.g., Dalí's *The Great Masturbator*, 1929), to rediscover its "real" condition. Broken to pieces and taken apart, it lives its own life in triumph; dismembered, it can reincarnate ad infinitum in an endless sequence of images. If you take away the parts, other bodily and sensual functions can be added. This breakdown engenders a multiplication of the possibilities of desire. The arm is thus an opening to sex; it opens up the pubis of the armpit. The open armpit, indeed, is one of the fundamental images, along with the ant-filled hand, the sea-urchin spines, and the woman as she looks at her cut hand, in the film *Un chien andalou* (1928), made by Luis Buñuel in collaboration with Dalí, and it is a key to understanding the ambiguity and latent libido between male and female.[7]

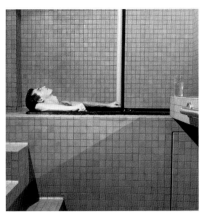

ROBERT MAPPLETHORPE
James Ford, 1979
Gelatin-silver print
20 x 16 inches (50.8 x 40.6 cm)
Robert Mapplethorpe Foundation

But let us return to the neoclassical component. In the history of art, the Michelangelesque arm, symbol of liberating strength and antipower, returns in David's *The Death of Marat* (1793), in which the classical ideal is not only a poetic inspiration but also an ethical model.[8] Mapplethorpe returns to this neoclassical masterpiece in *James Ford* (1979), with its figure in a bathtub.[9]

The return to the neoclassical source reenacts the photographic project in the context of the history of art, with the difference that in Mapplethorpe the fatal aspect of the body in the water is transformed into an ecstatic condition, to the point that Ford's arms rest on the bathtub in a sensual communion of the whole body. The reaffirmation of history again recurs in portraiture, as the photographer, like David, reflects on the contingency of events and their protagonists, who are never autonomous from the historical period but deeply bound up with it. The same can be said for Mapplethorpe's attention to Jean-Auguste-Dominique Ingres's *Bather of Valpinçon* (1808), where the allusion to Canova's aesthetic of "ideal beauty" transforms bodies into pure form, though giving it a more Romantic sentiment. According to Mapplethorpe, "My work is about order. I'm a perfectionist. I don't want anything to be questionable. If I'm doing a head, it has to be in the right position, where the nose hits the cheek."[10]

The sculptural tension of Mapplethorpe's photography, with its eye to the history of art from the Renaissance to Romanticism by way of neoclassicism, has yet another correspondence in the art of Auguste Rodin, whose work brings the photographer's historical awareness to the threshold of the twentieth century, a period beginning to be dominated by photography.[11] After Rodin, Mapplethorpe turns to the masters of the reproduced image, and the path of his artistic quotations follows that of the major figures of photography.

But why Rodin? Mapplethorpe's initial relationship to the sculptor arises from his attraction to the eros and sensuality of the sculpted bodies. Rodin and Mapplethorpe are artists who are interested in the fleshly forms and volumes of their models, both masculine and feminine, as means to realizing an experience that is at once plastic, visual, and personal. They use the eroticism of the figures to transgress and violate the taboos of their times, as well as to create rupture and innovation in their respective arts: sculpture and photography. They deny themselves no experience, inside or outside the studio, confident that any experience is granted its own autonomous dignity and value. They go beyond, toward excess, in the pursuit and conquest of a borderline experience. The goal is the affirmation of a self, where the eros of the sculptural and photographic material and configurations may fully circulate through all its sensual and sexual loci.

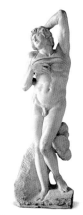

MICHELANGELO
Prisoner; Dying Slave, 1513–15
Marble
Height 90 ⅛ inches (229 cm)
Musée du Louvre, Paris

In their works, the artists themselves become art and technique, tools of visual production through which to grasp and realize their own critical and emotional relationships with the world and its society. First, Rodin states:

> *Art, moreover, is taste. It is the reflection of the artist's heart upon the objects that he creates. It is the smile of the human soul upon the house and upon the furnishing. It is the charm of thought and of sentiment embodied in all that is of use to man.*[12]

Then, Mapplethorpe, in a less Romantic tone:

> *I don't photograph things I've not been involved with myself . . . I went into photography because it seemed like a perfect vehicle for commenting on the madness of today's existence. I'm trying to record the moment I'm living in and where I'm living, which happens to be New York. I'm trying to pick up on that madness and give it some order. As a statement of the times it's not bad in terms of being accurate. These pictures could not have been done at any other time.*[13]

The one puts his heart into the elegy and intoxication of the naked bodies with which he loves to surround himself in his studio for inspiration in drawing and sculpture; the other into achieving an eroticism that takes shape in photographic images of physical and intellectual partners. For both, what matters most is the propagation of a "corporeality" that is provocative in so far as it moves the boundary between good and evil, beautiful and ugly, moral and immoral, from its commonly accepted place. And since it was the Renaissance that made it possible to represent the nude body in full, without veils, both Rodin and Mapplethorpe use a classical form of representation, that of Michelangelo, as their starting point, and then proceed to a further despoliation that finds its justification in history and assumes not only an artistic value but a linguistic and sexual one as well.

Around 1880, Rodin, in sculpting his *Adam*, looks to Michelangelo's *Creation of Adam* and *Creation of Eve* panels in the Sistine Chapel, Rome,[14] while for his seated nudes such as *The Thinker*, he turns his attention to Michelangelo's sculptures in the Medici Chapel, Florence. Similarly Mapplethorpe, for *The Slave* in 1974—early in his photographic adventure and just after his experiments with collages and montages of cutouts from pornographic magazines—takes a photograph of pages reproducing Michelangelo's *Prisoner*.

ROBERT MAPPLETHORPE
Jamie, 1974
Unique gelatin-silver print with painted frame
20 x 16 inches (50.8 x 40.6 cm)
Solomon R. Guggenheim Museum
Gift, Robert Mapplethorpe Foundation 98.4423

The citation of Michelangelo does not end with this shot; in the same year, Mapplethorpe makes the portrait *Jamie* (cat. no. 36), a beautiful boy photographed while mimicking the pose and gesture of the *Prisoner*. The allusion to the subject and plasticity of Michelangelo reveals that a sculptural vision with roots in Renaissance and Christian tradition is not only the province of sculptors but can also be embraced by a photographer. We may therefore assert that Mapplethorpe is seeking to transform the photographic sensibility in a "neoclassical" direction, aspiring to assert the truths of his time through the use of timeless forms and figures, compositions and articulations. His obsession with symmetry may be seen as proof of this concern: "I'm a nut on symmetry, as you can see. It's ingrained in me. I think it comes out of the Catholic Church—I was brought up a Catholic."[15]

And yet it is precisely their recourse to Michelangelesque classicism that enables Rodin and Mapplethorpe to be iconoclasts. By using the dignity of tradition, expressed in forms and figures of the loftiest sobriety, the two artists manage to convey contents unbearable for their eras, such as heterosexual and homosexual love, including sadomasochistic scenes. The exaltation of the heroic moment of the nude or clothed body belongs to artistic tradition, and asserts in all its frozen exemplarity the right to disturb the current language with the vigorous celebration of eros. The passage from the past to the present is more than formal, for the temporal dislocation of the sensual and sexual aspects, from Michelangelo to Rodin and later to Mapplethorpe, does not resolve the separation between physical and nonphysical, erotic and pornographic, beauty and truth, homosexual and heterosexual. What these artists aim at is the transcendence of oppositions, pushing the arts of painting, sculpture, drawing, and photography to the point where they might "satisfy" one's own and others' imaginary and secret drives.

In Mapplethorpe's conception, the relationship to the subject or model takes on interpersonal connotations. Between the photographer and the sitter, he seeks an emotional and markedly libidinal fluidity. He considers himself a partner, not a voyeur. Mapplethorpe thus rejects the role of the active protagonist intent on projecting and imposing himself onto the image, and instead aspires to an exchange and passage of energy that is at once creative and erotic. He favors the transmission of sensory difference, presupposing an intimate encounter, lasting or ephemeral, but always vigorously lucid, as it is consigned to the mutual pleasure of expressing and being oneself, behind and in front of the camera:

I prefer people I know, or at least people I have had conversation with, because it
is about a relationship, between photographer and subject.[16]

I'd like to think ideally I could hang out with the person and ideally maybe have
a better experience than photographing them.[17]

Mapplethorpe leaves it up to the other people to burst onto the photographic stage, which is always set up in the intimacy of his studio (another parallel with Rodin), and to make manifest his hidden or obvious identity in front of the camera. He gives himself over to a state of arousal that he establishes with the subject, letting the images grow out of the resultant erotic situation. Sadomasochistic moments are thus a function of love and passion, not of perversity or sexual sacrifice. It is in their unleashing that the rules and boundaries of individual and artistic boundaries are crossed. On the subject of his sadomasochism (S&M) photographs, Mapplethorpe says:

> *I wanted people to see that even those extremes could be made into art . . .*
> *And I think the best of those pictures do that, again because of the composition.*
> *I think that's an accomplishment, it's a problem that I'd set out to solve. I was*
> *trying to prove a point about sexuality. I was enthusiastic about people*
> *experimenting with themselves.*[18]

> *Most of the people in S&M were proud of what they were doing. It was giving*
> *pleasure to one another. It was not about hurting. It was sort of an art. Certainly*
> *there were people who were into brutality, but that wasn't my take. For me,*
> *it was about two people having a simultaneous orgasm. It was pleasure, even*
> *though it looked painful.*[19]

As Mapplethorpe mobilizes, from 1976 onward, his subjects and relationships on a daily basis, one understands the continuous sensual outpouring of his work, which becomes swirling and violent when representing homoerotic relations, impetuous and hot when documenting heterosexual encounters, or sweet and intense when the photographer gives himself over to the beauty of a black man's muscular body or the velvety tactility of a fragile flower. The power of his photographs of this period wells up from a fully uncovered, available reality, whose "portrait" is taken by Mapplethorpe.

Rodin, too, allows nature—that is, the bodies of the models invited to move about naked in his studio—to engage in a dialogue with sculpture. He abandons himself to nature with the same passivity as a lover allowing himself to be seduced:

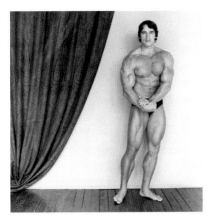

ROBERT MAPPLETHORPE
Arnold Schwarzenegger, 1976
Gelatin-silver print
20 x 16 inches (50.8 x 40.6 cm)
Robert Mapplethorpe Foundation

I take from life the movements I observe, but it is not I who impose them. Even when a subject I am working on compels me to ask a model for a certain fixed pose, I indicate it to him, but I carefully avoid touching him to place him in position, for I will reproduce only what reality spontaneously offers to me. I obey Nature in everything and I never pretend to command her. My only ambition is to be servilely faithful to her.[20]

During the 1880s and 90s, Rodin's contemplation gives rise, for example, to two bodies about to engage in homosexual and heterosexual acts, as in *The Kiss*, or to autoerotic, anatomical particulars, as in *Danaïde*, in order to transcend the ideal vision of the human figure. He avoids the scientific, Enlightenment view of the body, consolidating instead its powerful inner eroticism, derived from the sensuality of the flesh and the gesture:

> *In front of a model I work with as great a wish to reproduce the truth as if I were making a portrait. I do not correct nature but incorporate myself in it. It guides me. I can only work with a model. The sight of the human sustains and stimulates me. I have boundless admiration for the naked body. I worship it . . . Sometimes, looking at a model, you think you have found nothing. Then, all at once, little by little, nature reveals itself, a strip of flesh appears, and the shred of truth conveys the whole truth and enables you to rise at a single bound, to the absolute principle of things.*[21]

On the level of artistic reality, the excess of energy leads to the creation of a "glorious" body, which in Rodin liquefies into the tensions of the bronze material and in Mapplethorpe emulsifies into black skin surfaces that acquire the same power as metal: "The form," the photographer points out, "really reads nice on the black, it's like a bronze."[22]

The bodies these two artists portray seem pervaded by a Promethean strength that, while perpetuating the allusion to Michelangelo's "unfinishedness," goes beyond it by virtue of an aptitude for the absolute plenitude of a life that is vibrant and aimed at embracing the power of corporeal matter. The prototype of the being that has explored the limits of this fullness is the athlete, bodybuilder, or dancer, choice subjects for the art of Rodin and Mapplethorpe. Both artists take on the athlete as the emblem of the visual motility of human matter. Rodin captures the muscular compression of the wrestler Samuel Stockton White and translates it into *The Athlete* (1901–04); Mapplethorpe photographs the bodybuilders Arnold Schwarzenegger, Lisa Lyon, and Lydia Cheng, as

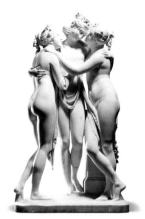

well as the dancers Bill T. Jones and Lucinda Childs. In every detail, the sculptural and photographic material reflects the intense incandescence and efflorescence of torsos, legs, faces, and hands. Muscles and skin appear in a state of ebullition, as though fraught with explosive force. Even when Rodin and Mapplethorpe break up the body into parts, focusing their gaze on back or thigh, penis or vagina, arm or neck, navel or armpit, the "cut" does not lessen the energy's grip; instead, the body part finds its powerful truth. This kindles a sensual vertigo fed by the pleasures of the flesh, male or female, black or white. The result is the offering of a body cleansed of all impurities, sexual or racial, moralistic or ideological.

Rodin's sculptures, like Mapplethorpe's photographs, become the felicitous terrain of a force that rises up from below, from bodies in perfect fusion, where any and every manner of expression is possible. Herein lie the reasons for the continual attention to homophilia and homosexuals, both masculine and feminine, as agents of that osmosis, that dialectical condition of the body, which alchemically converges in the figure of the hermaphrodite, the coexistence of opposites.

There is another source of inspiration, always active in both artists, which we must not forget: the great theme of the intellectual in each era. The French sculptor makes portraits of George Bernard Shaw, Charles Baudelaire, Séverine (Caroline Rémy), Pierre Puvis de Chavannes, Victor Hugo, and Honoré de Balzac as if they were supreme fragments of a higher material energy distilled from the breath of fancy and the mind. Mapplethorpe, too, celebrates "heroes" and "heroines," whether of art, music, dance, photography, architecture, literature, theater, cinema, television, or fashion, as though he is in the grip of a reverse mysticism that is interested in the ephemeral luster of a face or body whose mass-media and physical immortality might be short-lived indeed. In this sense, compared to Rodin's absolutizing, selective designations, Mapplethorpe is lighter, faster. Aside from the technical-linguistic difference of photography versus sculpture, Mapplethorpe's epoch is marked by Warholism and media consumerism, for which the image is a mere whisper.

Not all the comparisons with the sculptor yield likeness. The photographer is decidedly against, for historic reasons among others, the use of "symbolism." For Mapplethorpe, metaphor must become a physicalized event. There is thus an absence of allegories or idealizations, asphyxiating mythology or impressionistic mentalism. Nonetheless, he does not engage in abstraction; rather, he exalts the hypervitality of people and bodies, of things and gestures, both natural and artificial, human and animal. What interests him is the physical ability to duplicate the "explosion" of life that can be made

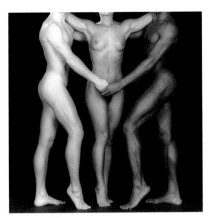

ROBERT MAPPLETHORPE
Ken, Lydia, and Tyler, 1985
Gelatin-silver print
16 x 20 inches (40.6 x 50.8 cm)
Robert Mapplethorpe Foundation

just as manifest in a flower as in a penis, a beloved's body as in a stranger's body. The thing need only be animated by a vital force, which becomes pure existence:

I get something out of flowers that other people don't get. I completely immerse myself in that flower. I love my pictures of flowers more than I love real flowers.[23]

My approach to photographing a flower is not much different than photographing a cock. Basically it's the same thing. It's about lighting and composition. It doesn't make much difference. It's the same vision.[24]

All of Mapplethorpe's images become libidinal targets. The point is not, however, to stoke a sexual revolt or a desecrating process, that is, not to transform a flower into a genital organ, perceive a human body in the same way as a feline's, look at a ship as an erotic vessel or a sadomasochistic ritual as an archetype of every amorous relation. Instead, it is a question of appropriating the infinitude and vitality of all these things, of looking at images with a renovated perspective that rejects the negativity of suppression and accepts the positivity of the vital kindling of eros. Mapplethorpe allows the sensuality of the everyday world to emerge triumphant, putting to rout the specters of repression and giving photographic flesh to real gestures of passion capable of effective transformations. In him, the will to sexualize any image betrays an intent to do away, once and for all, with the asexuality and sterility, not to mention impotence, of the "visual sign" and to produce reality and life. His images of flowers, still lifes, and sculptural busts bring out, from beneath the representation, a nervous energy that bears witness to the photograph's rejection of itself as an impersonal, sexless document. If, like any other art, photography is part of a creative genesis, it not only represents the real but also ingests reality back into the vital humus of the artist (society's actor and victim). And it is in the quest for voluptuousness between pleasure and pain that Mapplethorpe—after passing through Michelangelo, David, and Ingres—encounters Rodin and realizes his plan: "Photography is just, like, the perfect way to make a sculpture."[25]

The echo of classical art is also a way of looking to beauty and death, because turning one's gaze to the past and its memories means bringing attention back to an infinite, eternal condition such as time's undoing. Moreover, returning to the archetypal notion of art means recovering a figurativeness in which the spirituality of paganism and Christianity resides. The clear allusion to antiquity, under the sign of the myth of beauty, is continually reiterated by Mapplethorpe, as when he evokes such classical themes as the

Judgment of Paris or the Three Graces, which span the full spectrum of art from ancient Greece through Mannerism and all the way to Canova's *The Three Graces* (1813–17). In Mapplethorpe's *Ken, Lydia, and Tyler* (1985, cat. no. 100), however, the image of beauty moves in the direction of a sexual totality encompassing male and female, black and white, homosexual and heterosexual. The same can be said as concerns death, so that when the photographer alludes to the visual memory of the Etruscan Sarcophagus of the Husband and Wife of Caere (second half of sixth century BCE) or to a funerary urn of the fourth century BCE, he does so by interpreting a different type of couple, as in *David Hockney and Henry Geldzahler* (1976).

A consciousness of the passage of time emerges in the final years of Mapplethorpe's life, when, aware of his physical deterioration from AIDS, he confronts the problem of representing the infinity of being and existence.

The recourse to history is renewed yet again. On the threshold of death, the photographer captures himself on the boundary between light and darkness: *Self-Portrait* (1988, cat. no. 119). Unlike the figure of Michelangelo's *Prisoner*, all matter and body, Mapplethorpe is a being in a state of transmutation—the black and white of the photograph—into a phantom, a figure dissolving between earth and sky, presence and memory, human and divine, cosmos and chaos, living through a sweet passage, and presenting to his witnesses, the public, a cane with a death's head in the foreground. The metaphor is that of the wayfarer undertaking a long journey into nothingness, where decline is sublimation and the body's destiny is dissolution. The circle closes, so that death is not only a dark vortex but also a window of light that presents itself to the scrutiny of the languid sculpture in *Sleeping Cupid* (1989, cat. no. 118). Formerly titled *Icarus*, this photograph is a kind of self-portrait that, in its composition, depicts a preview of death, echoing the figure representing the genius of death in Canova's Monument of Clement XIII (completed 1792). *Sleeping Cupid* also highlights a state of ecstasy in this neoclassical photographer who dared to fly very high and to direct his meticulous, perfect gaze toward aspects of the truth of sexual identity, gender, and ethnicity, from a personal, spontaneous perspective that opened the way to a rethinking of eros and the body.

Translated from the Italian by Stephen Sartarelli.

Notes

1. Regarding provocation as gesture of social rebellion, see Xavier Gauthier, *Surréalisme et sexualité* (Paris: Gallimard, 1971).

2. Mapplethorpe, quoted in Inge Bondi, "The Yin and Yang of Robert Mapplethorpe," *Print Letter* (Switzerland) (Jan.–Feb. 1979), p. 11.

3. Mapplethorpe, quoted in David Hershkovits, "Robert Mapplethorpe," *East Village Eye* (New York) (Apr. 1983), p. 9.

4. See Bernard Sergent, *L'homosexualité dans la mithologie grecque* (Paris: Payot, 1984).

5. Mapplethorpe, quoted in Carol Squiers, "With Robert Mapplethorpe," *The Hamptons Newspaper Magazine*, Aug. 27, 1981.

6. Roland Barthes, *Camera Lucida: Reflections on Photography*, trans. Richard Howard (New York: Hill and Wang, 1981), p. 59. The photograph is flopped in Barthes's book (p. 58), and he is mistaken in describing the figure as being "shifted to the extreme left of the frame"; it is shifted to the right when reproduced correctly.

7. See Raymond Durgnat, *Luis Buñuel* (London: Studio Vista, 1967), p. 27.

8. See Giulio Carlo Argan, *L'arte moderna 1770–1970* (Florence: Sansoni Editore, 1970), p. 39.

9. For an earlier discussion on the similarity between David's *The Death of Marat* and Mapplethorpe's *James Ford*, see Mike Weaver, "Mapplethorpe's Human Geometry: A Whole Other Realm," *Aperture* (New York) (winter 1985), p. 43. Weaver's essay is an essential theoretical contribution toward an understanding of the symbolic and sexual complexity of Mapplethorpe's work.

10. Mapplethorpe, quoted in Cathleen McGuigan, "Walk on the Wild Side," *Newsweek* (New York), July 25, 1988, p. 57.

11. Here, I am adapting the critical interpretation I developed in Germano Celant, *Mapplethorpe versus Rodin* (Milan: Electa, 1992), pp. 9–21.

12. Rodin, quoted in Paul Gsell, *Entretiens avec Rodin* (Paris, 1957).

13. Mapplethorpe, quoted in Sarah Kent, "Mapplethorpe," *Time Out* (London), Nov. 3–9, 1983, pp. 12–13.

14. See Albert E. Elsen, *The Gates of Hell by Auguste Rodin* (Stanford: Stanford University Press, 1986), pp. 74–77.

15. Mapplethorpe, quoted in Kent, p. 12.

16. Mapplethorpe, quoted in Bondi, p. 11.

17. Mapplethorpe, quoted in Bart Everly, "Robert Mapplethorpe," *Splash* (New York) (Apr. 1988), unpaginated.

18. Ibid.

19. Mapplethorpe, quoted in Dominick Dunne, "Robert Mapplethorpe's Proud Finale," *Vanity Fair* (New York) (Feb. 1989), p. 186.

20. Rodin, quoted in Gsell.

21. Ibid.

22. Mapplethorpe, quoted in Everly, unpaginated.

23. Mapplethorpe, quoted in Kent, p. 13.

24. Mapplethorpe, quoted in Gerrit Henry, "Robert Mapplethorpe—Collecting Quality: An Interview," *The Print Collector's Newsletter* (New York) (Sept.–Oct. 1982), p. 129.

25. Mapplethorpe, quoted in Anne Horton, "Robert Mapplethorpe," in *Robert Mapplethorpe 1986*, exh. cat. (Berlin: Raab Galerie; Cologne: Kicken-Pauseback, 1987).

PLATES

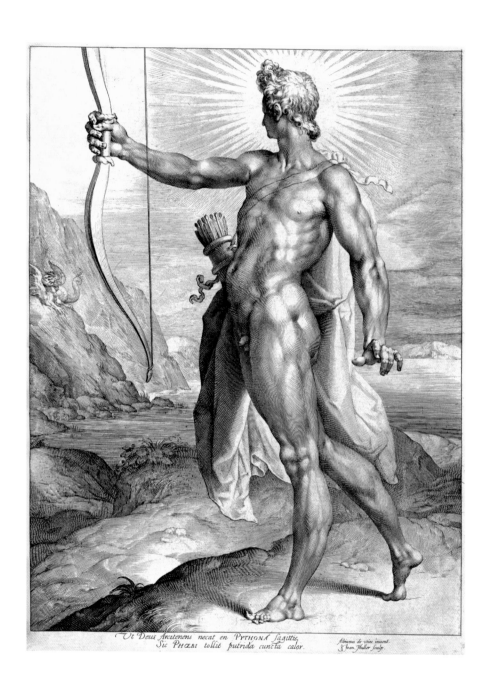

Ut Deus Arcitenens necat en PYTHONA sagittis,
Sic PHŒBI tollit putrida cuncta calor.

Adrianus de vrise inuent.
& Joan. Muller sculp.

1. JAN HARMENSZ. MULLER AFTER ADRIAEN DE VRIES

Apollo Armed with His Bow for the Battle with Python, 16th century

2. Robert Mapplethorpe

Arnold Schwarzenegger, 1976

3. After Michelangelo

Samson Conquers Two Philistines, 16th century

4. Robert Mapplethorpe

Derrick Cross, 1983

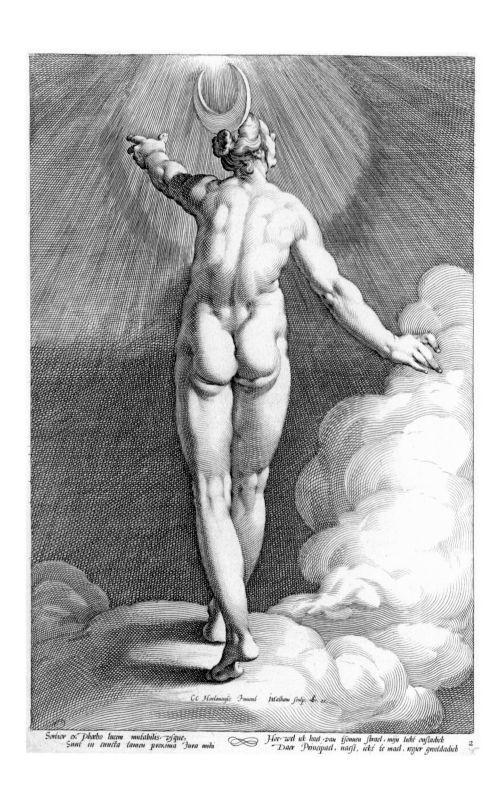

5. JACOB MATHAM AFTER CORNELIS CORNELISZ. VAN HAARLEM

Diana in the Clouds, 16th century

6. ROBERT MAPPLETHORPE

Lisa Lyon, 1981

7. Robert Mapplethorpe

Ken Moody, 1983

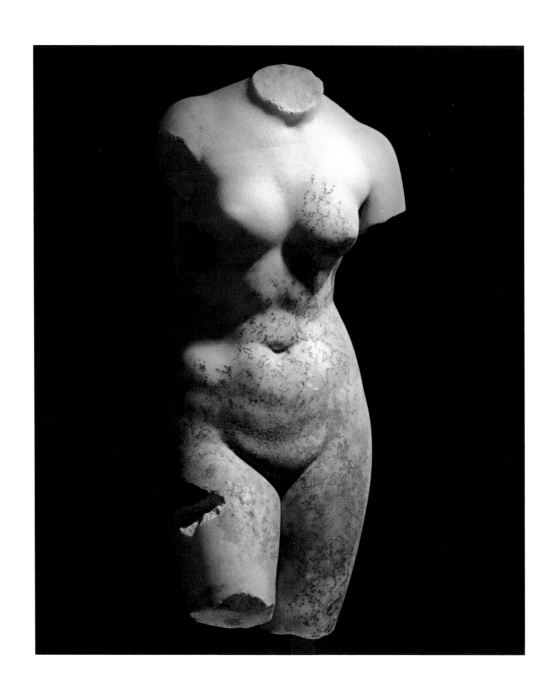

8. ROBERT MAPPLETHORPE

Female Torso, 1978

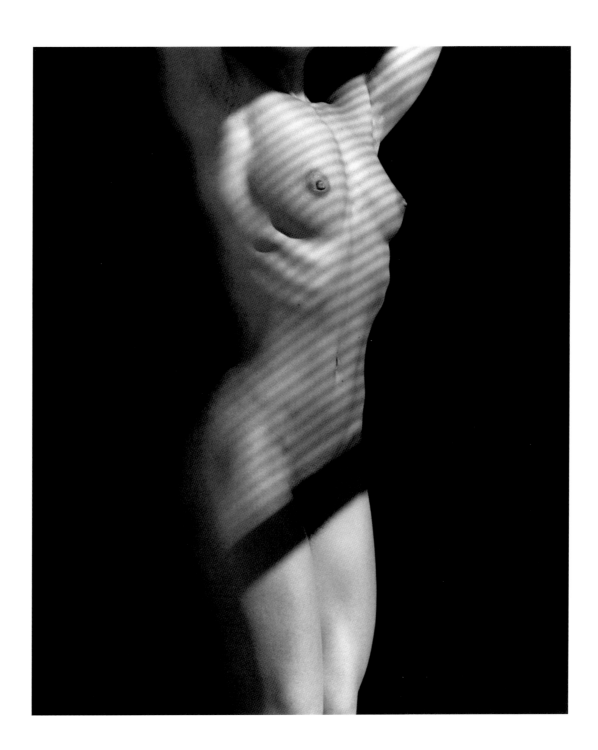

9. Robert Mapplethorpe

Lydia Cheng, 1987

"I want people to see my works first as art, and second as photography."

Mapplethorpe, quoted in Inge Bondi, "The Yin and Yang of Robert Mapplethorpe," *Print Letter* (Zurich) (Jan.–Feb. 1979), p. 11.

"If I had been born one or two hundred years ago, I might have been a sculptor, but photography is a very quick way to see, to make sculpture."

Mapplethorpe, quoted in Andrew Szegedy-Maszak, "A Distinctive Vision: The Classical Photography of Robert Mapplethorpe," *Archaeology* (New York) 44, no. 1 (Jan.–Feb. 1991), p. 63.

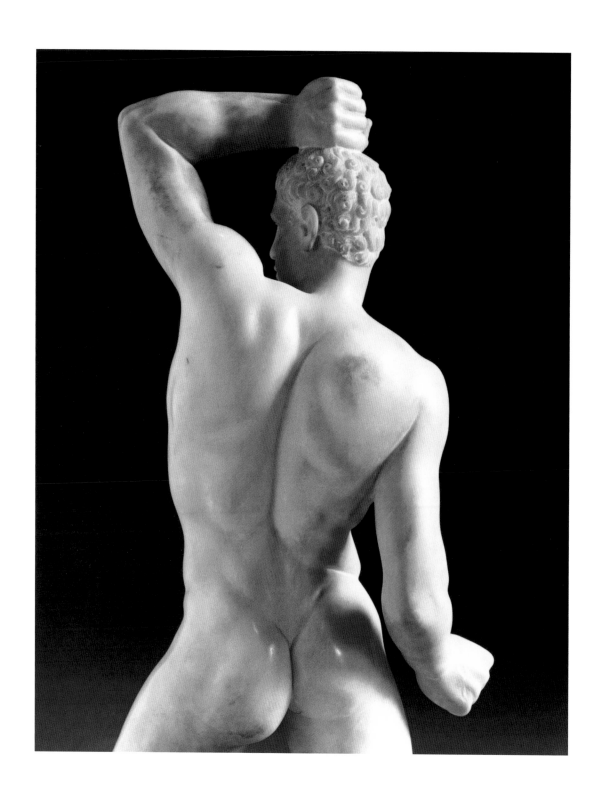

10. ROBERT MAPPLETHORPE

Wrestler, 1989

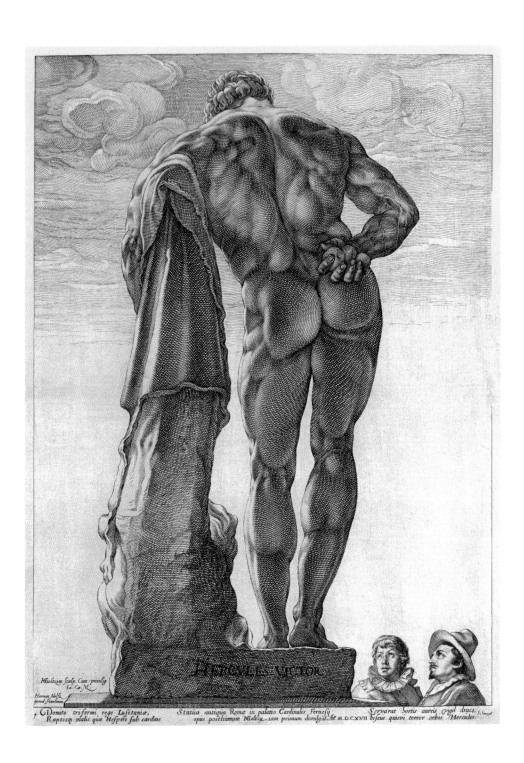

11. Hendrick Goltzius

The Farnese Hercules, from *Antique Statues in Rome*, ca. 1592, dated 1617

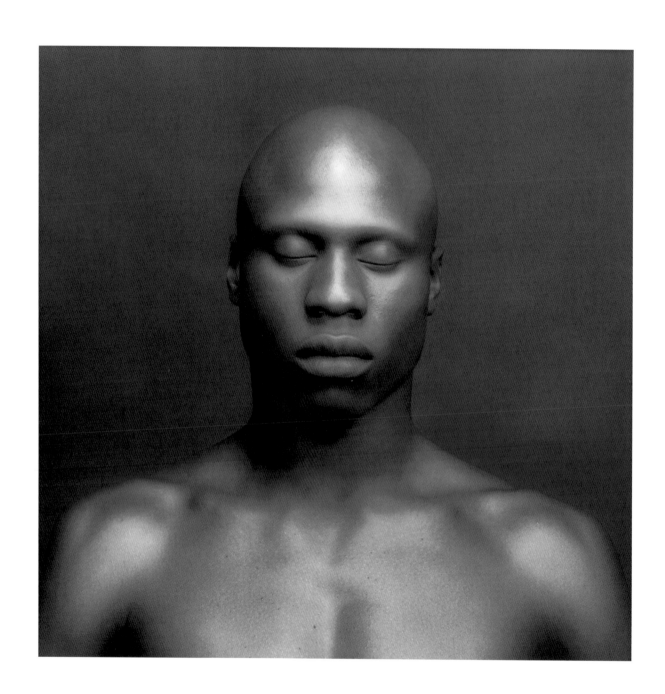

12. Robert Mapplethorpe

Ken Moody, 1983

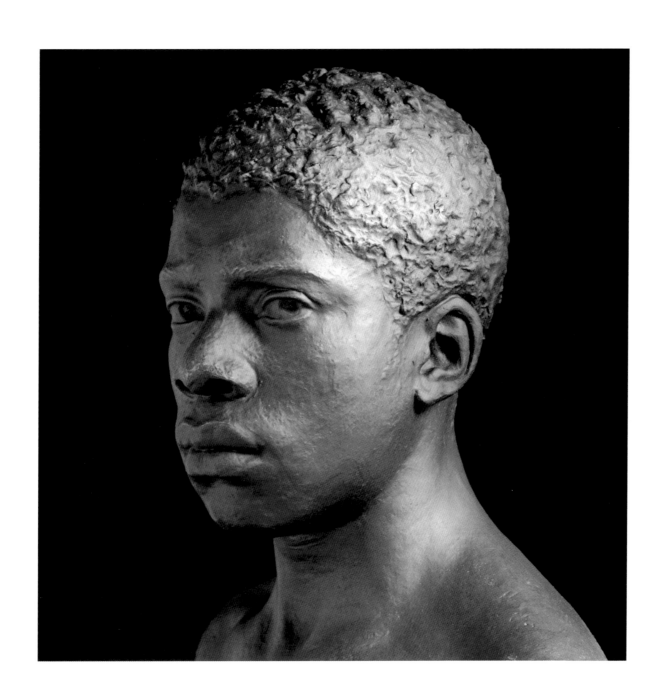

13. ROBERT MAPPLETHORPE

Black Bust, 1988

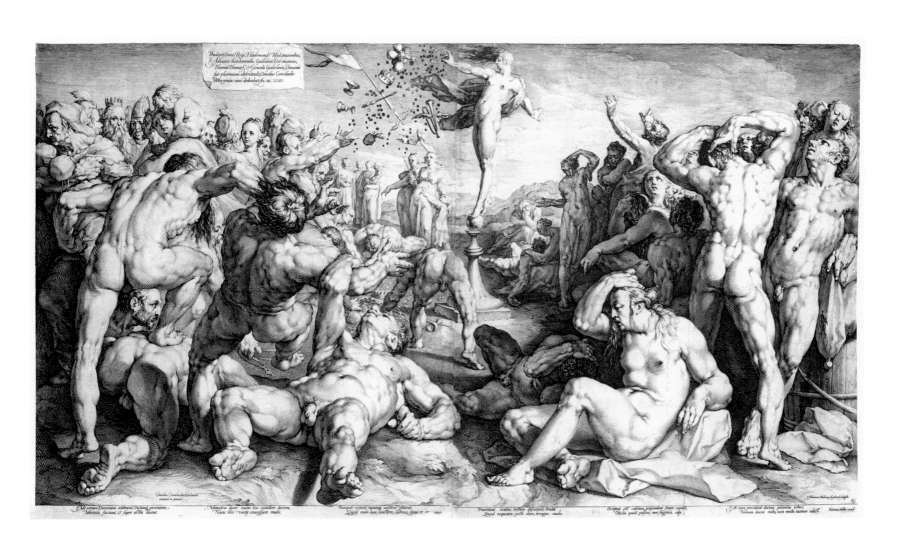

14. JAN HARMENSZ. MULLER AFTER CORNELIS CORNELISZ. VAN HAARLEM

Fortune Showing Its Blindness by the Way It Dispenses Its Favors, 16th century

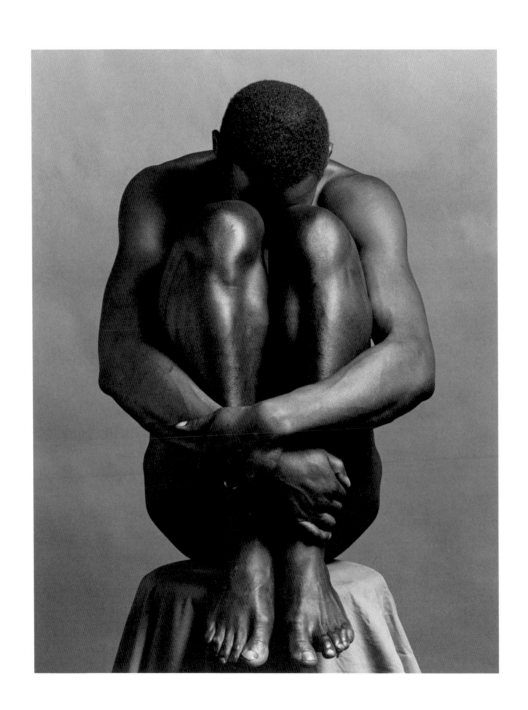

15. ROBERT MAPPLETHORPE

Ajitto, 1981

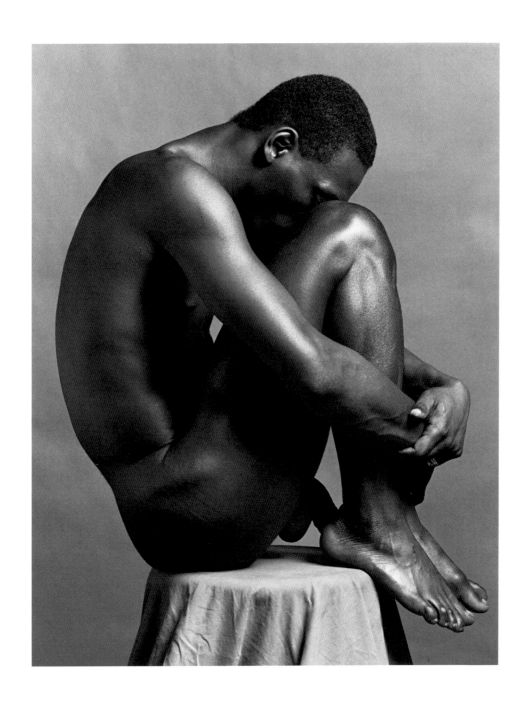

16. Robert Mapplethorpe

Ajitto, 1981

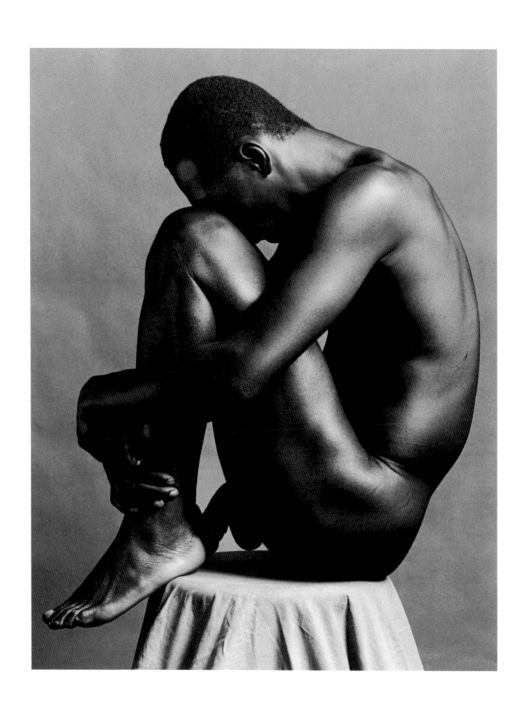

17. Robert Mapplethorpe

Ajitto, 1981

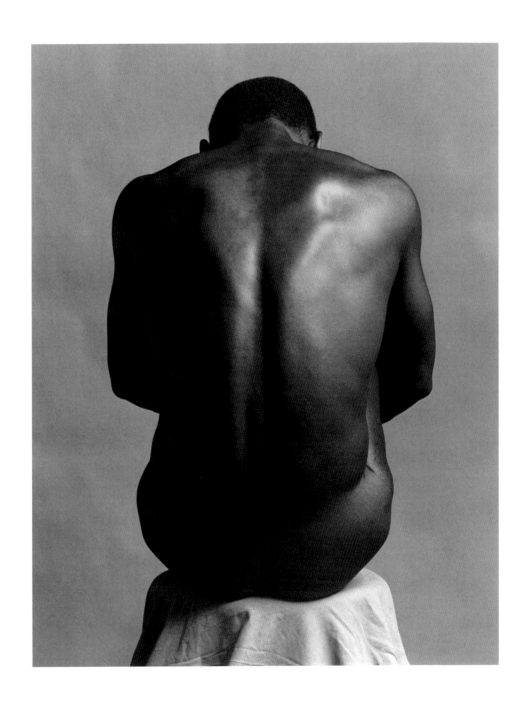

18. Robert Mapplethorpe

Ajitto, 1981

IG

19. Jan Saenredam after Hendrick Goltzius

Venus, 16th century

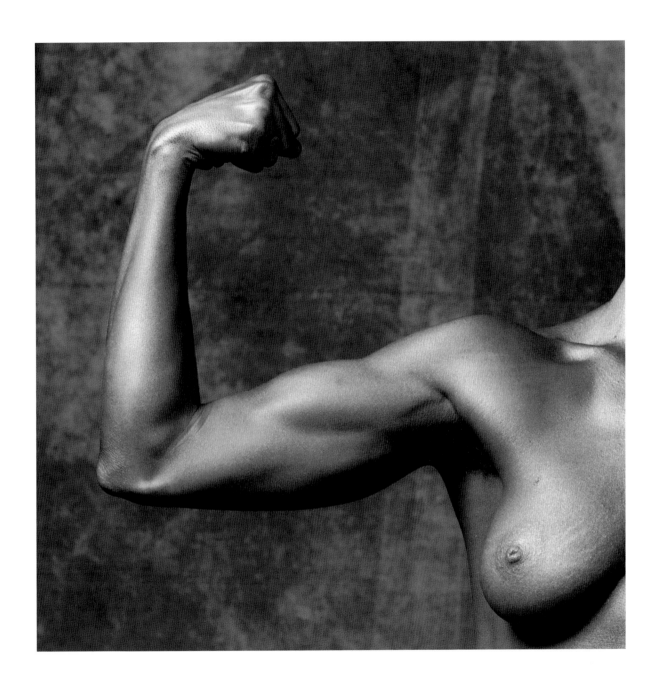

20. ROBERT MAPPLETHORPE

Lisa Lyon, 1981

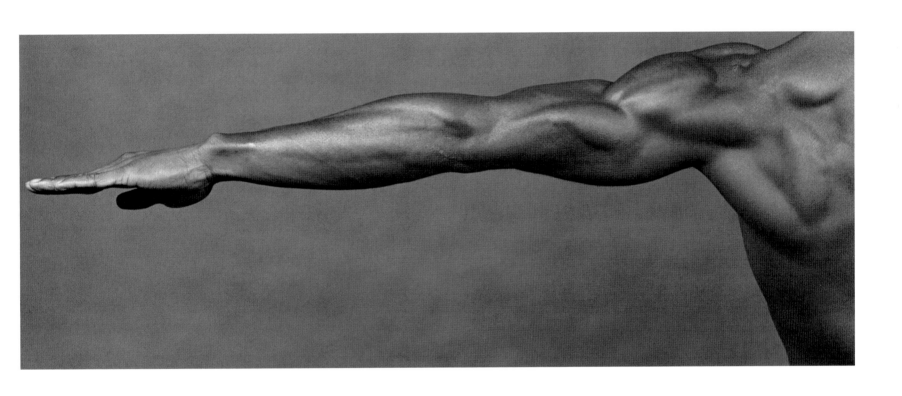

21. ROBERT MAPPLETHORPE

Derrick Cross, 1982

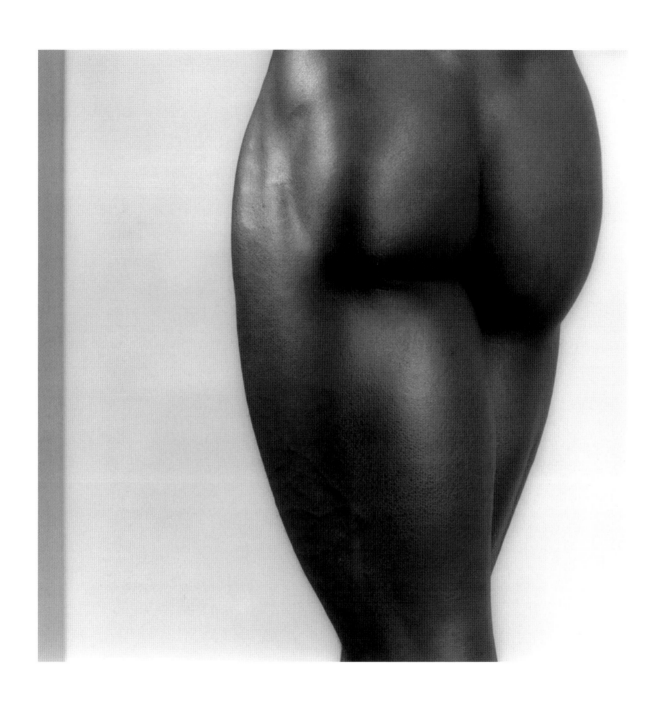

22. ROBERT MAPPLETHORPE

Derrick Cross, 1983

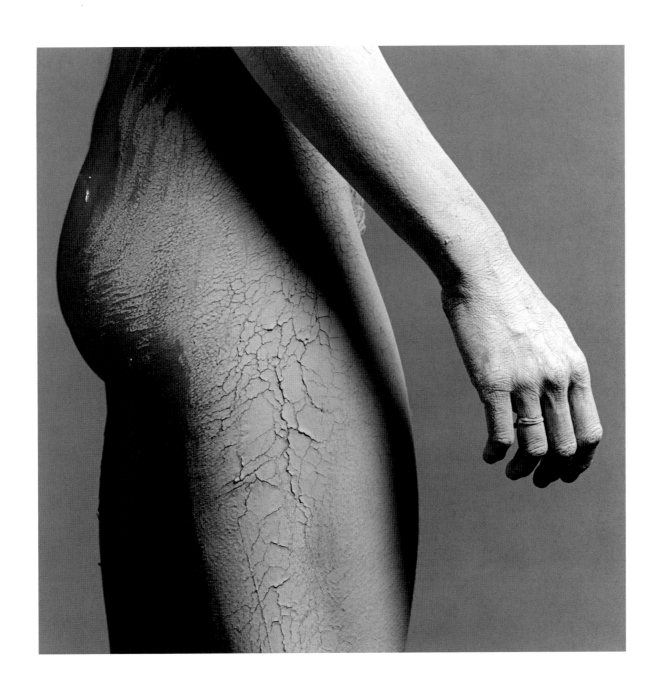

23. ROBERT MAPPLETHORPE

Lisa Lyon, 1982

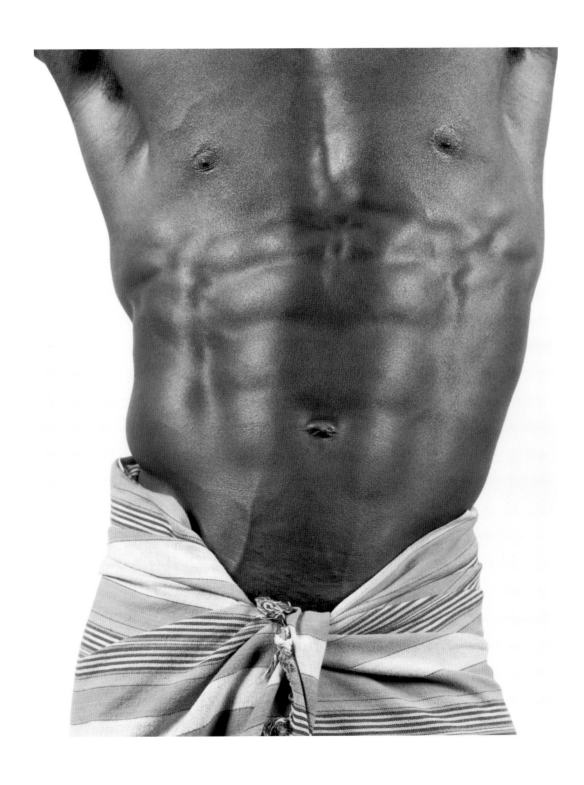

24. Robert Mapplethorpe

Derrick Cross, 1983

25. ROBERT MAPPLETHORPE

Donald Cann, 1982

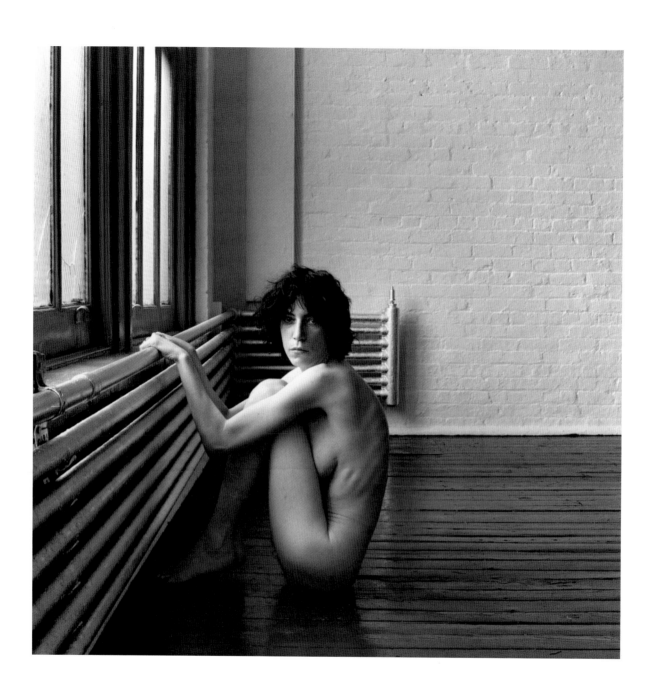

26. ROBERT MAPPLETHORPE

Patti Smith, 1976

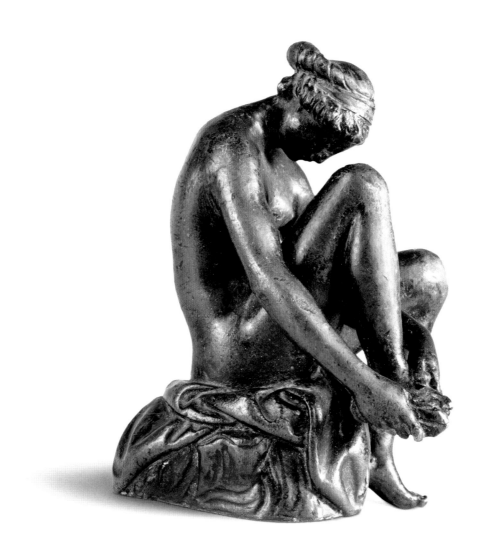

27. Barthélémy Prieur

Young Woman Cutting Her Toenails, ca. 1565

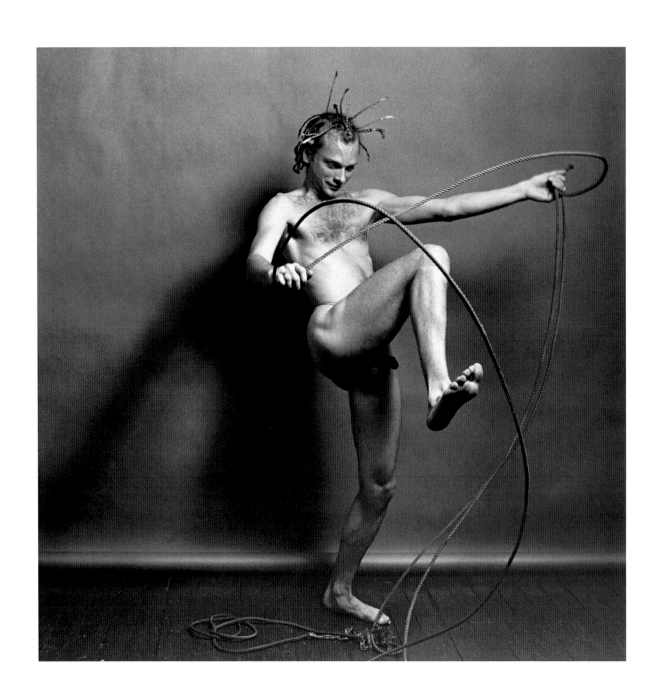

28. Robert Mapplethorpe

Alan Lyne, 1979

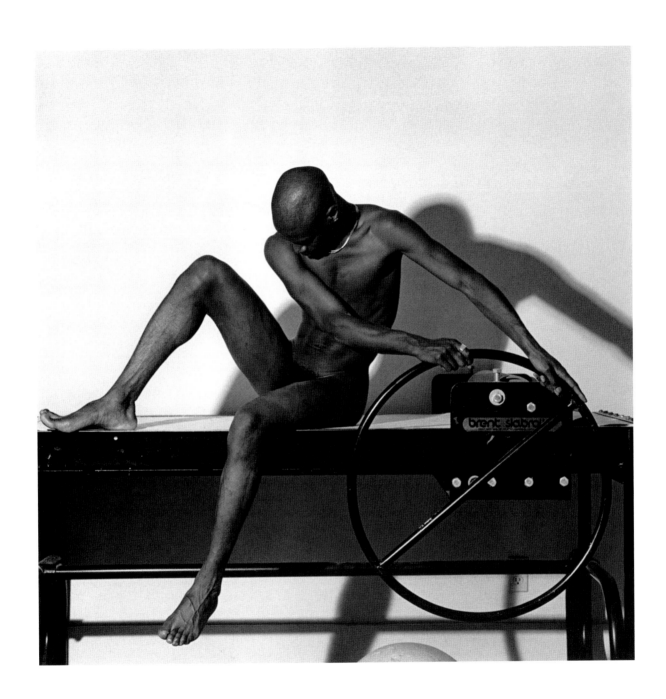

29. Robert Mapplethorpe

Bruce, 1980

"I wanted people to see that even those extremes could be made into art. Take those pornographic images and make them somehow *transcend* the image."

Mapplethorpe, quoted in Bart Everly, "Robert Mapplethorpe," *Splash* (New York) (Apr. 1988), unpaginated.

"I'm just trying to sort of be on the edge."

Mapplethorpe, quoted in C. S. Manegold, "Robert Mapplethorpe, 1970–1983; On the 1983–1984 Retrospective," *Arts Magazine* (New York) 58, no. 6 (Feb. 1984), p. 96.

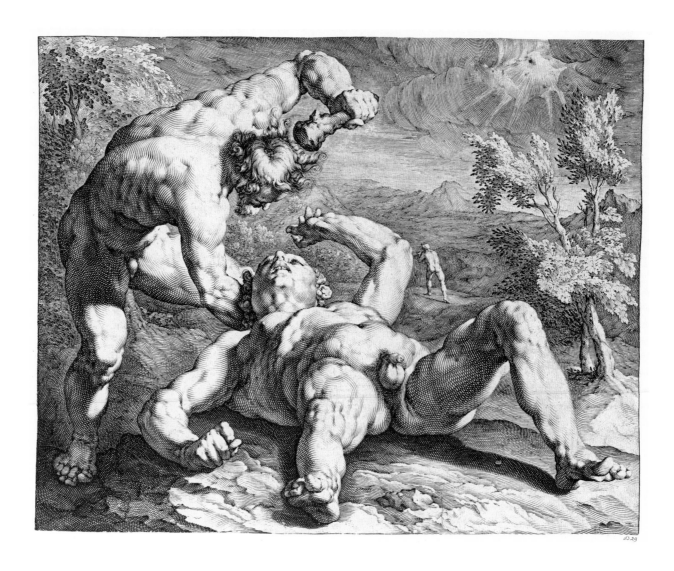

30. Jan Harmensz. Muller after Cornelis Cornelisz. van Haarlem

Cain Killing Abel, 16th century

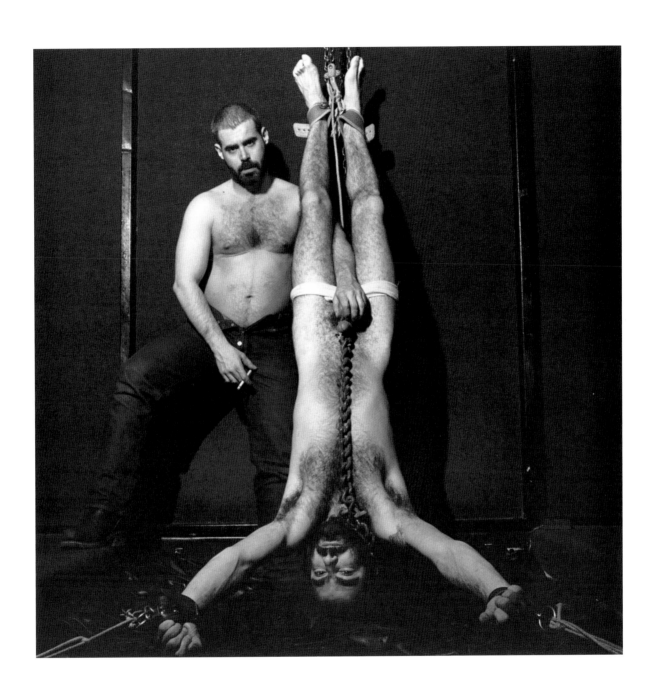

31. ROBERT MAPPLETHORPE

Dominick and Elliot, 1979

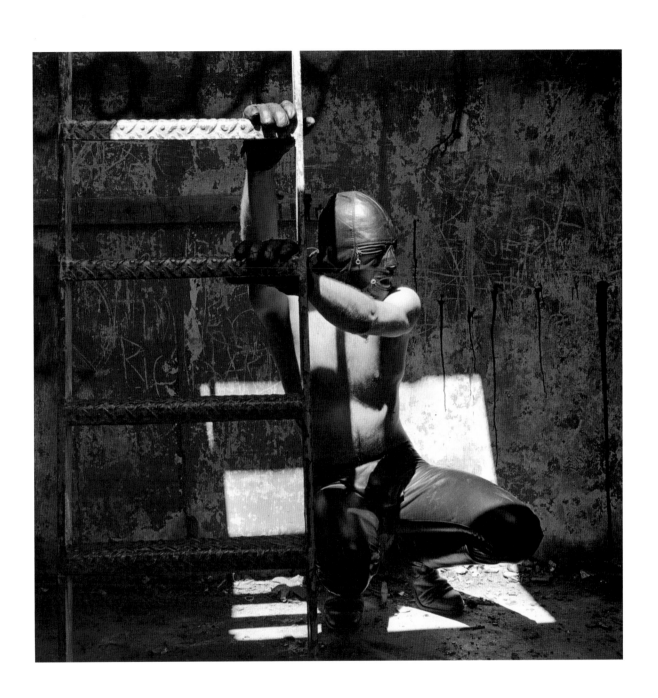

32. Robert Mapplethorpe

Jim, Sausalito, 1977

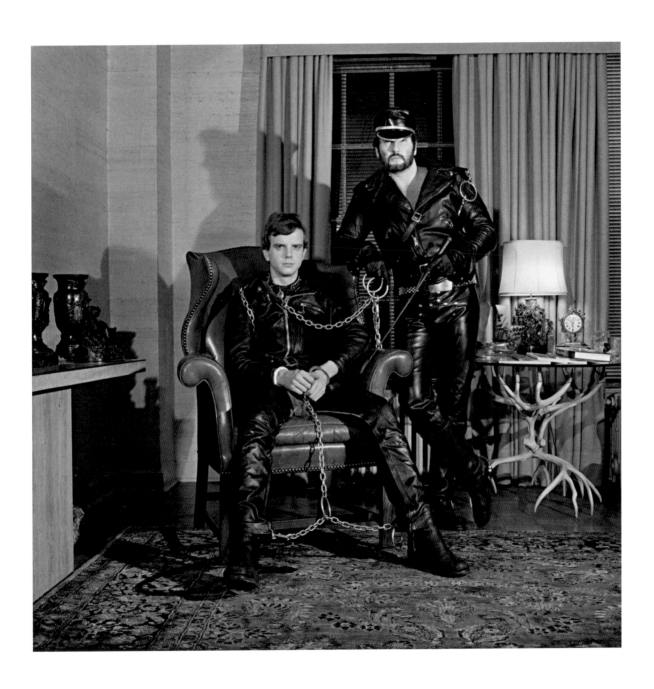

33. Robert Mapplethorpe

Brian Ridley and Lyle Heeter, 1979

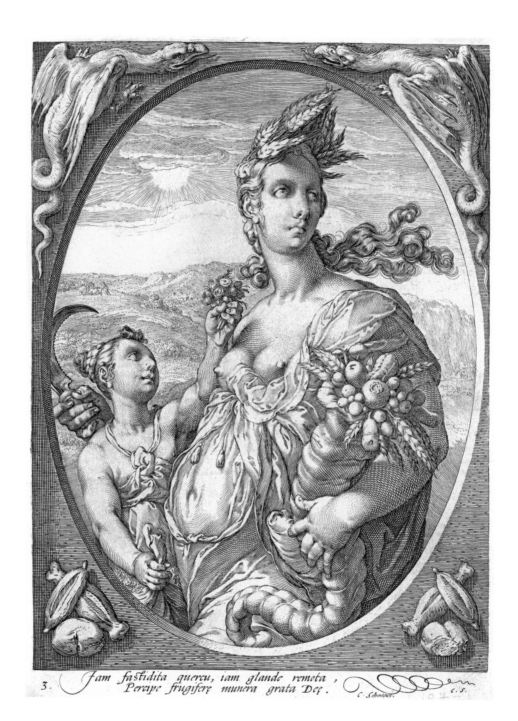

Iam faſtidita quercu, iam glande remota,
Percipe frugiferæ munera grata Deæ.

34. JAN SAENREDAM AFTER HENDRICK GOLTZIUS

Ceres, 16th century

35. JAN SAENREDAM AFTER HENDRICK GOLTZIUS

Bacchus, 16th century

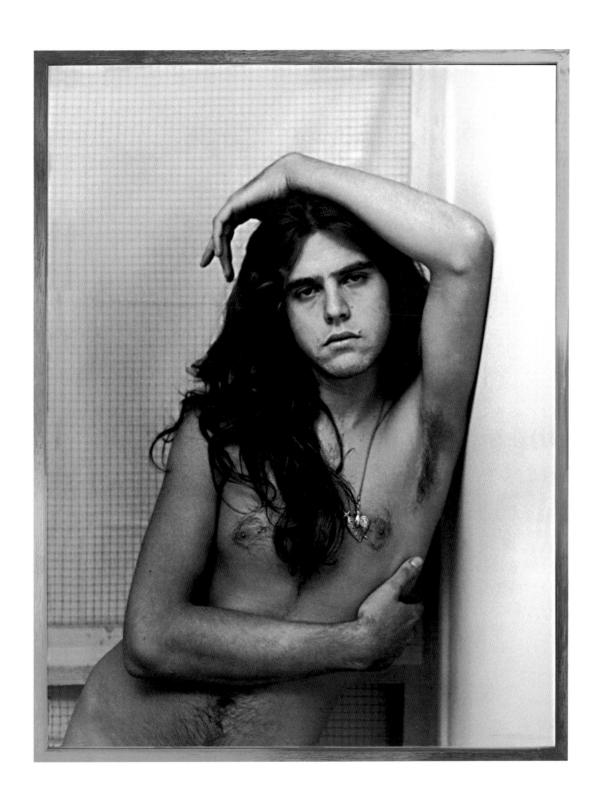

36. ROBERT MAPPLETHORPE

Jamie, 1974

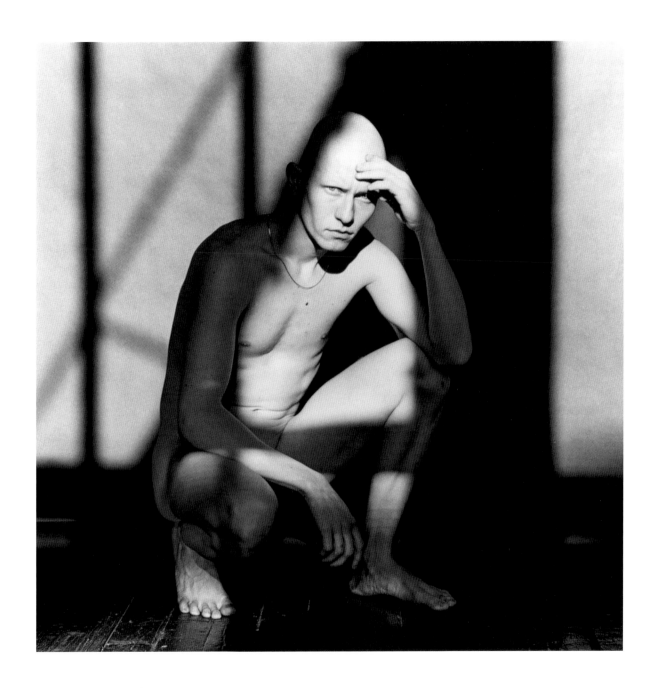

37. Robert Mapplethorpe

Robert Sherman, 1979

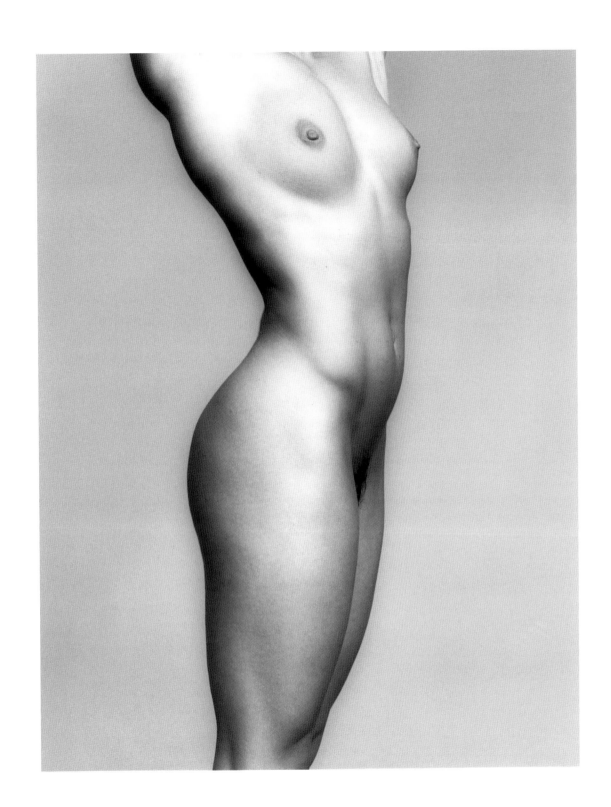

38. Robert Mapplethorpe

Lydia Cheng, 1985

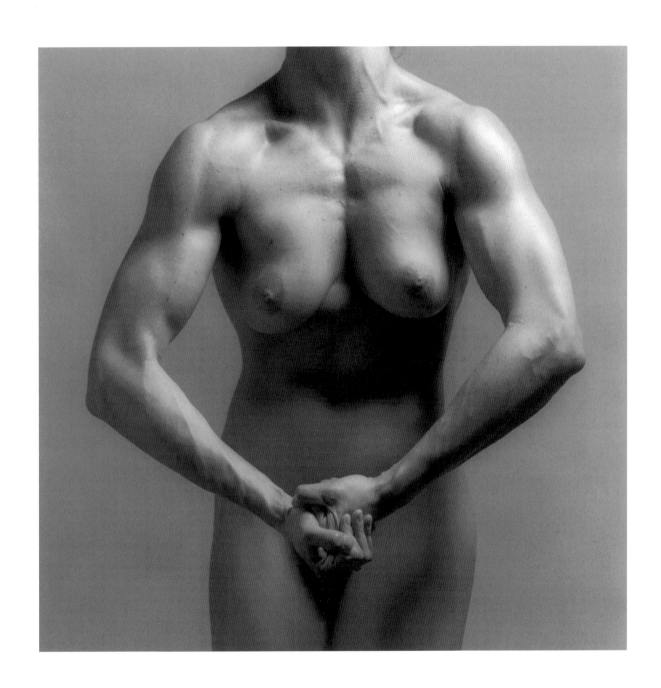

39. ROBERT MAPPLETHORPE

Lisa Lyon, 1982

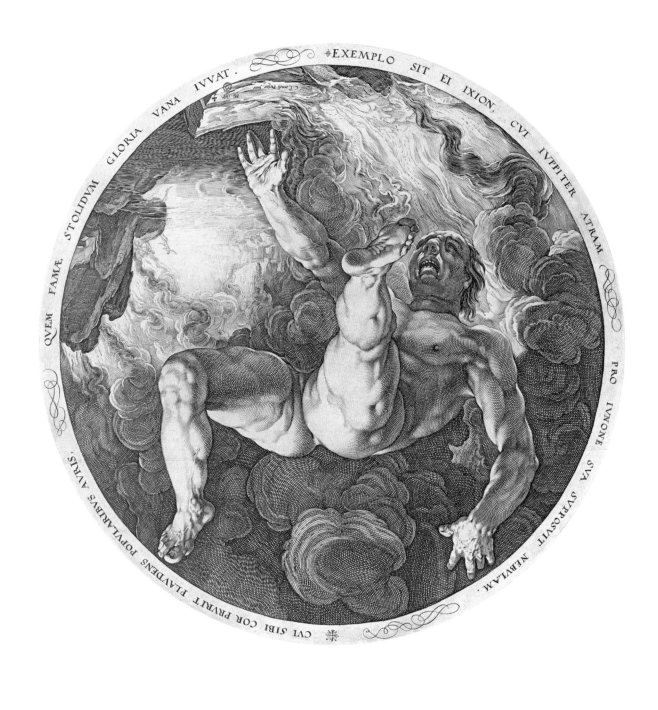

40. HENDRICK GOLTZIUS AFTER CORNELIS CORNELISZ. VAN HAARLEM

Ixion, from *The Four Disgracers*, late 16th century, first state dated 1588

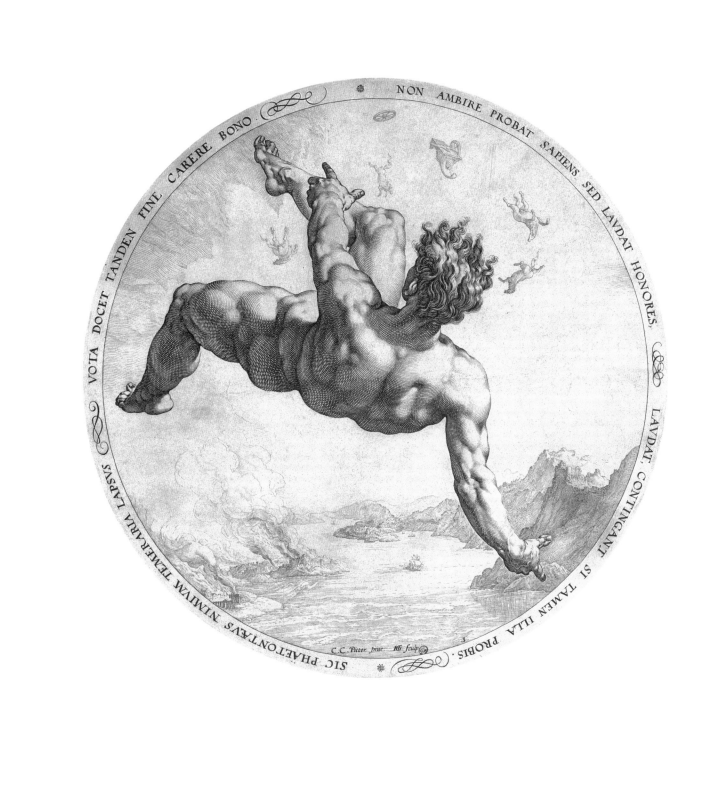

Within the circular border: NON AMBIRE PROBAT SAPIENS SED LAVDAT HONORES, LAVDAT, CONTINGANT SI TAMEN ILLA PROBIS. SIC PHAETONTAEVS NIMIVM TEMERARIA LAPSVS VOTA DOCET TANDEN FINE CARERE BONO.

C C. *Pictor. Inue* HG. *fculp* 3.

41. HENDRICK GOLTZIUS AFTER CORNELIS CORNELISZ. VAN HAARLEM

Phaeton, from *The Four Disgracers*, late 16th century, first state dated 1588

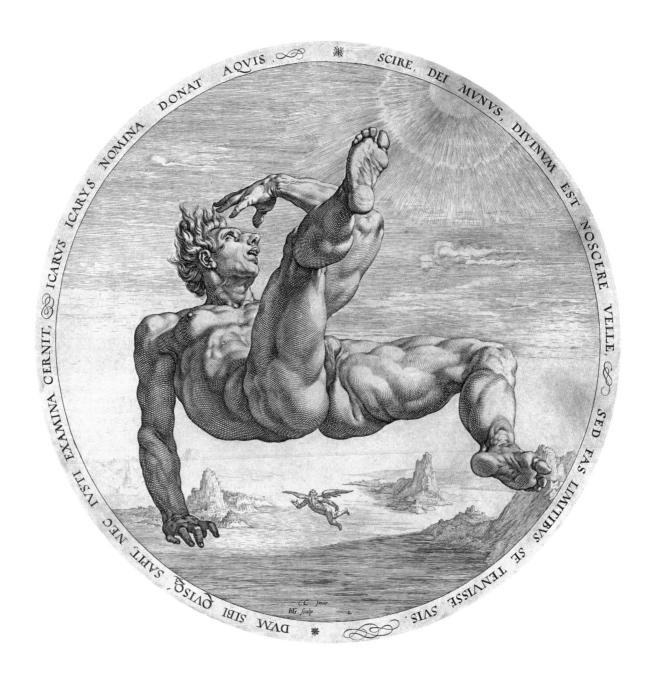

Text around the circle: SCIRE, DEI MVNVS, DIVINVM EST NOSCERE VELLE, SED FAS LIMITIBVS SE TENVISSE SVIS. DVM SIBI QVISQ; SAPIT, NEC IVSTI EXAMINA CERNIT, ICARVS ICARVS NOMINA DONAT AQVIS.

42. Hendrick Goltzius after Cornelis Cornelisz. van Haarlem

Icarus, from *The Four Disgracers*, late 16th century

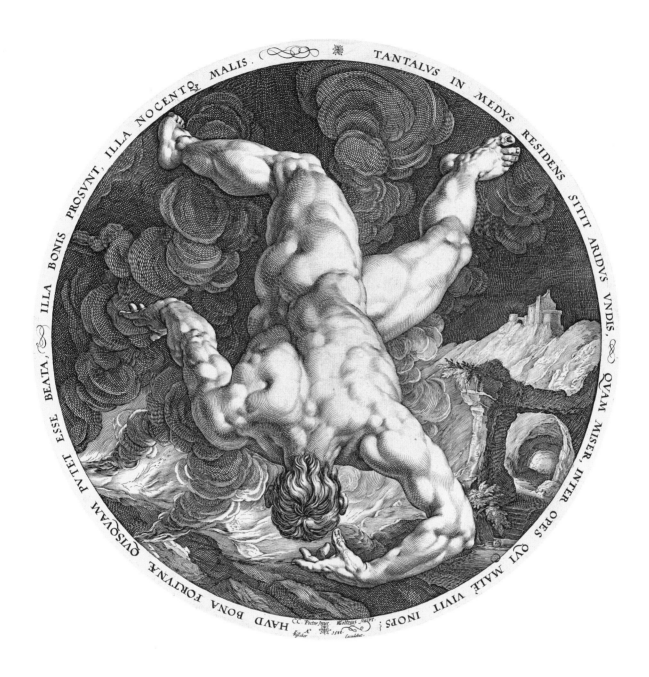

43. Hendrick Goltzius after Cornelis Cornelisz. van Haarlem

Tantalus, from *The Four Disgracers*, late 16th century, first state dated 1588

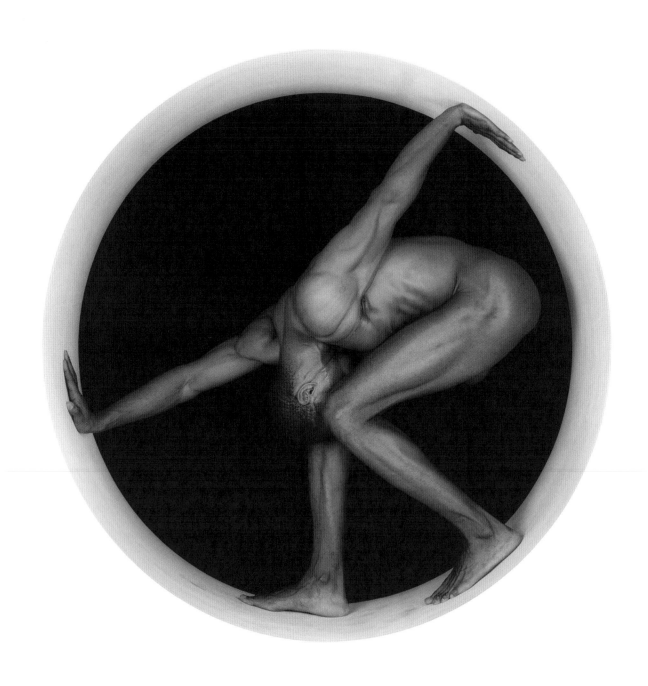

44. Robert Mapplethorpe

Thomas, 1987

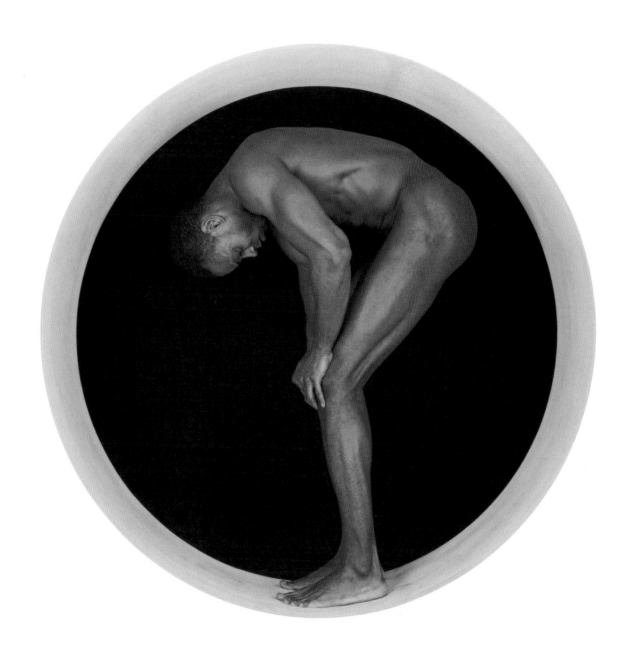

45. ROBERT MAPPLETHORPE

Thomas, 1987

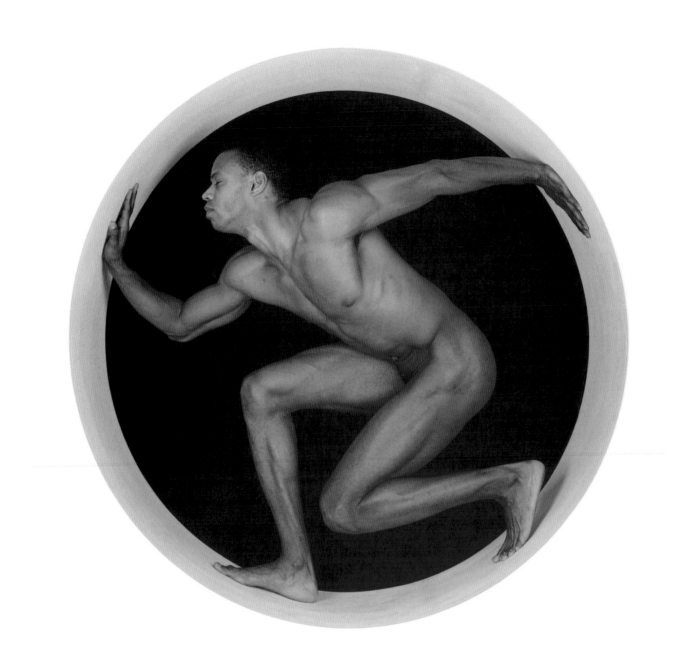

46. Robert Mapplethorpe

Thomas, 1987

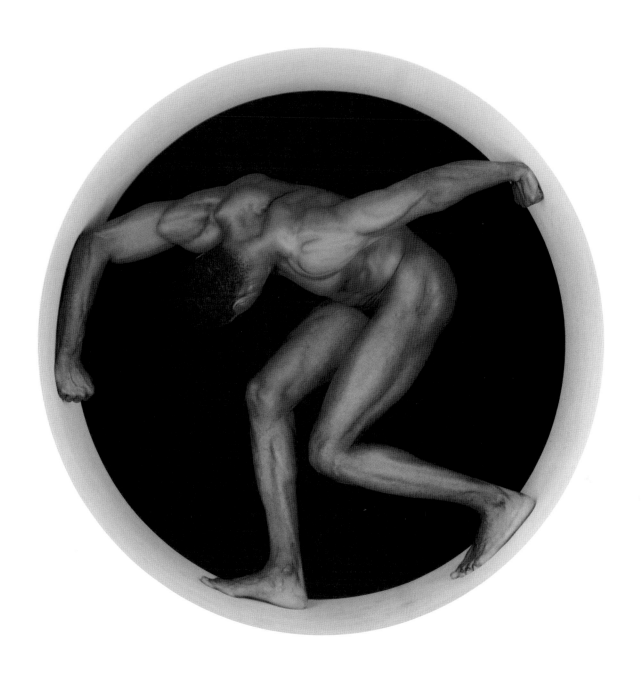

47. Robert Mapplethorpe

Thomas, 1987

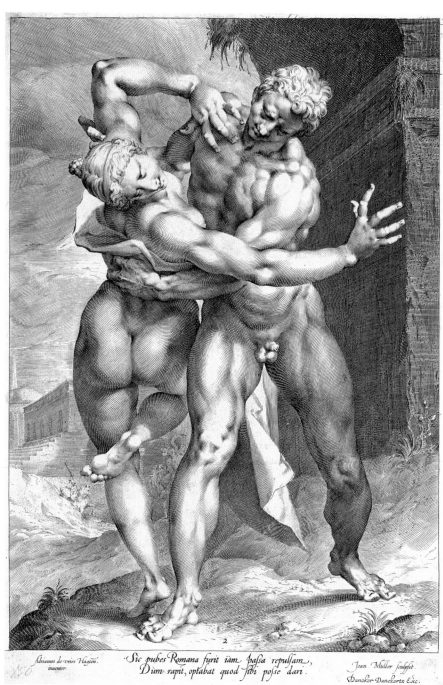

Sic pubes Romana furit iam passa repulsam,
Dum rapit, optabat quod sibi posse dari.

Adrianus de Vries Hagien.
inuentor

Joan. Muller sculpsit.
Danckor Danckertz Exc.

48. Jan Harmensz. Muller after waxworks by Adriaen de Vries

A Roman Abducting a Sabine Woman, from *The Rape of the Sabine Women*, 16th century

49. ROBERT MAPPLETHORPE

Thomas and Dovanna, 1986

50. Hendrick Goltzius

Hercules and Telephos, from *Antique Statues in Rome*, ca. 1592, dated 1617

51. Hendrick Goltzius

The Apollo Belvedere, from *Antique Statues in Rome*, ca. 1591, dated 1617

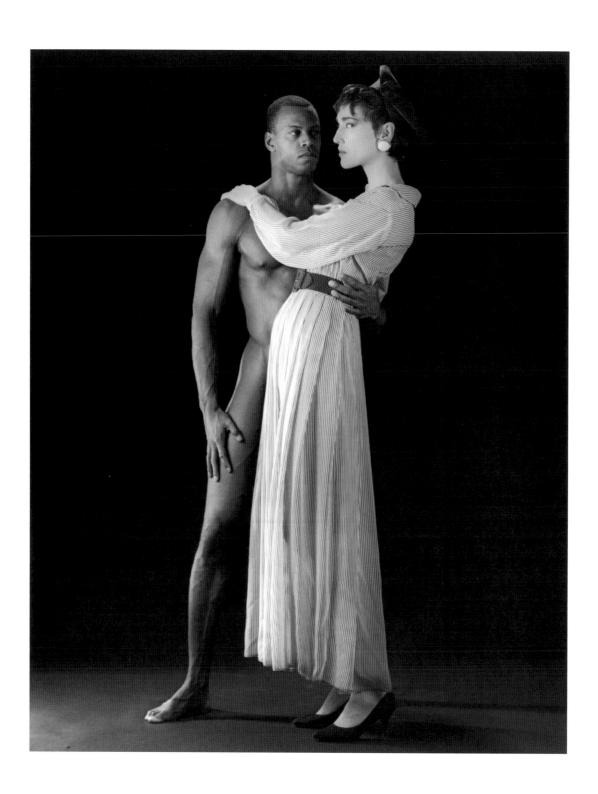

52. ROBERT MAPPLETHORPE

Thomas and Dovanna, 1986

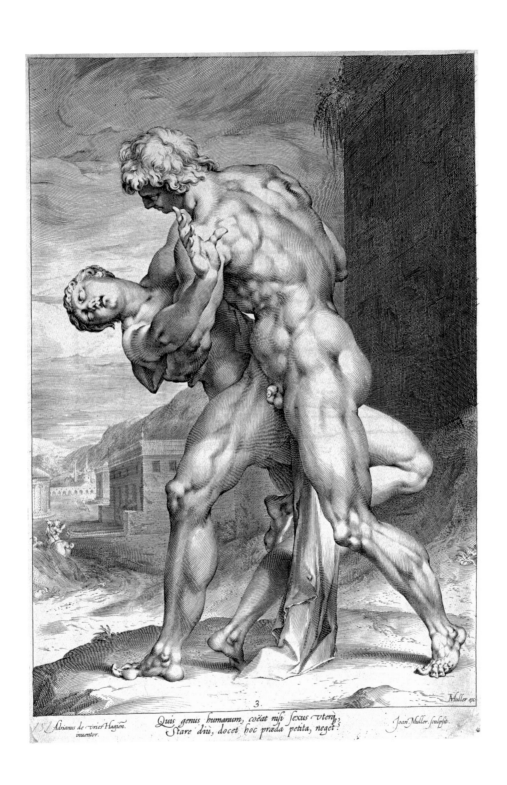

J.l.Adrianus de vries Hagien.
inuentor.

Quis genus humanum, coëat nisi sexus vteris,
Stare diù, docet hoc præda petita, neget.

Joan.Muller.sculpsit.

53. JAN HARMENSZ. MULLER AFTER WAXWORKS BY ADRIAEN DE VRIES

A Roman Abducting a Sabine Woman, from *The Rape of the Sabine Women*, 16th century

54. WORKSHOP OF BENVENUTO CELLINI

Perseus, late 16th century

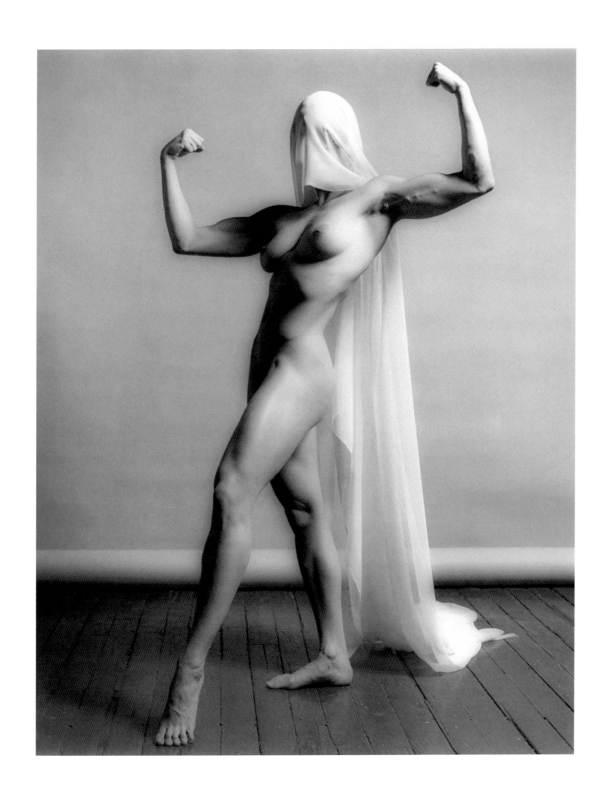

55. ROBERT MAPPLETHORPE

Lisa Lyon, 1982

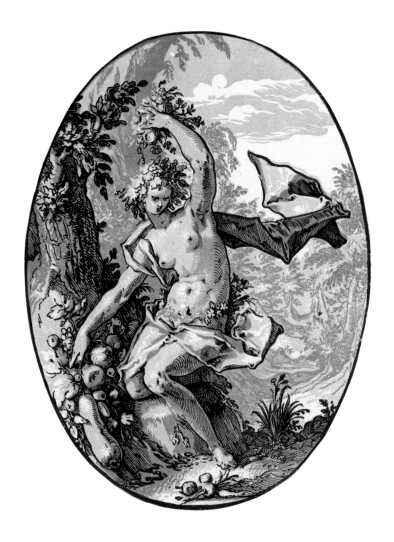

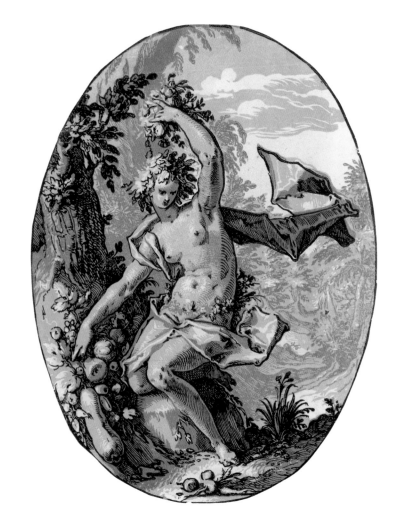

56. Hendrick Goltzius

Persephone (Flora), ca. 1594

57. Hendrick Goltzius

Persephone (Flora), ca. 1594

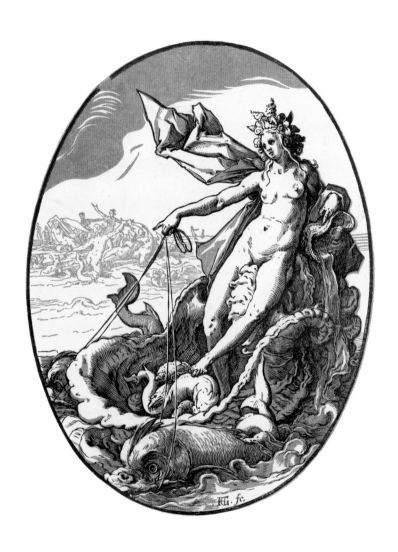

58. Hendrick Goltzius

Venus Marina, ca. 1594

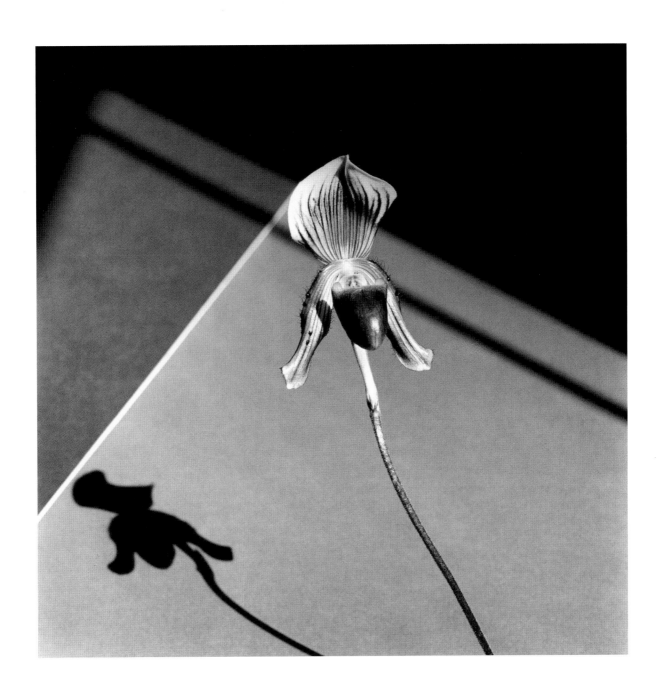

59. Robert Mapplethorpe

Orchid, 1986

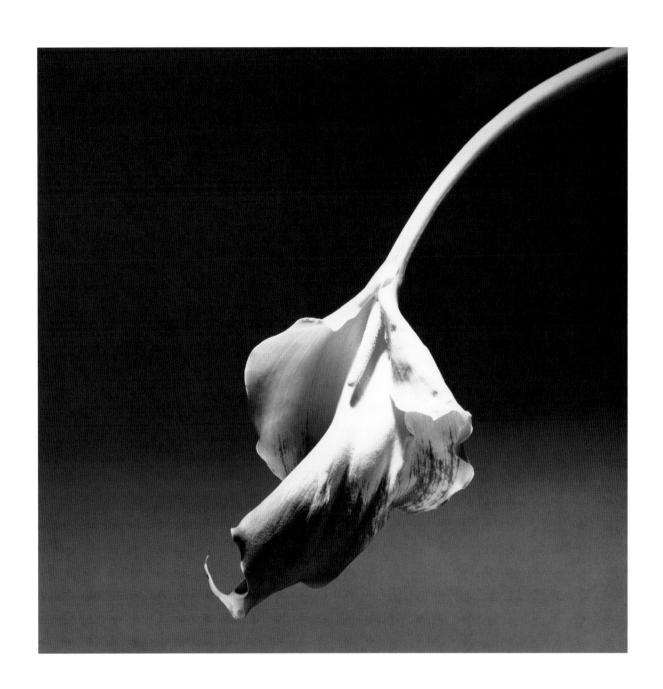

60. Robert Mapplethorpe

Calla Lily, 1986

61. Hendrick Goltzius

Nox, ca. 1594

62. Hendrick Goltzius

The Magician (The Cave of Eternity), ca. 1594

63. Robert Mapplethorpe

Poppy, 1988

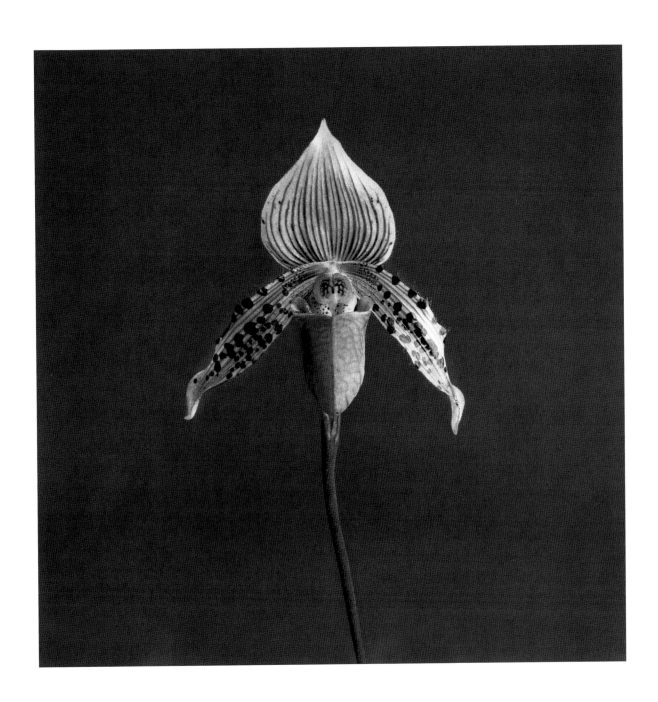

64. ROBERT MAPPLETHORPE

Orchid, 1987

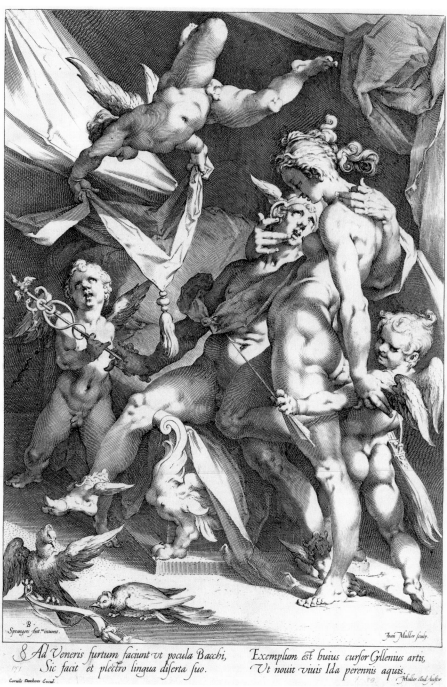

Ad Veneris furtum faciunt vt pocula Bacchi,
Sic facit et plectro lingua diserta suo.

Exemplum est huius curfor Cyllenius artis,
Vt nouit viuis Ida perennis aquis.

65. Jan Harmensz. Muller after Bartholomäus Spranger

Venus and Mercury, 16th century

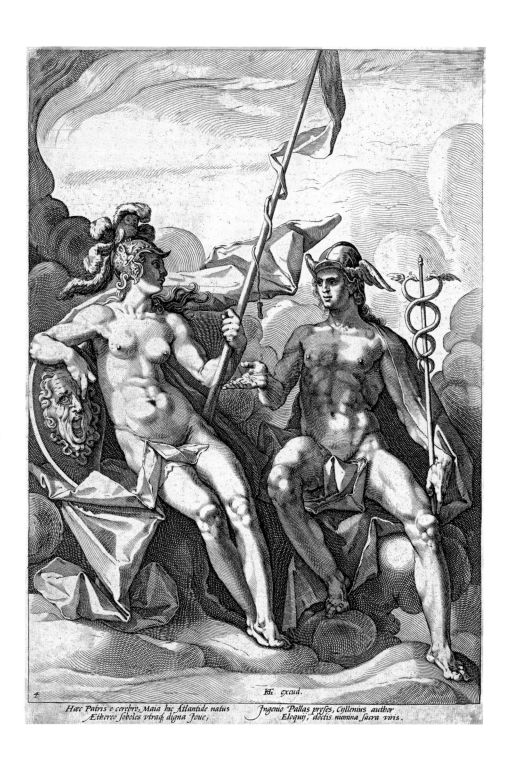

Hæc Patris e cerebro, Maia huc Atlantide natus
Æthereo soboles vtraq; digna Ioue,

Ingenio Pallas preses, Cyllenius author
Eloquij, doctis numina sacra viris.

66. Jacob Matham after Hendrick Goltzius

The Alliance of Athena and Mercury, 16th century

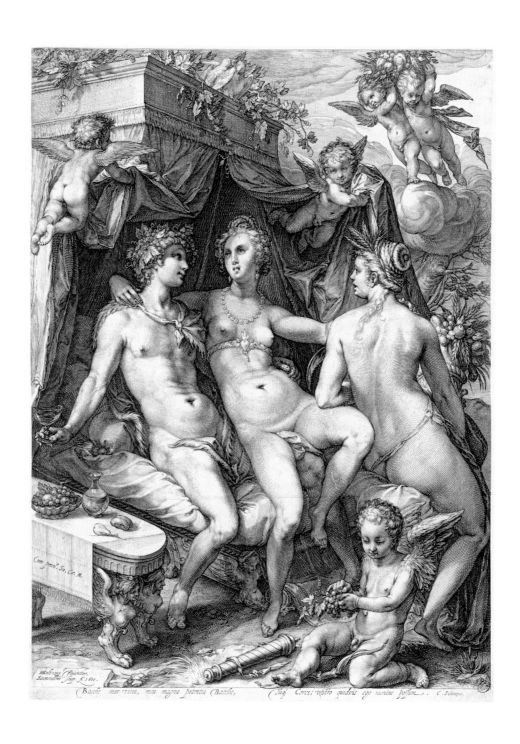

Bacche, mae viv, mea magna potentia Bacche, Juq; Ceres; vestro quadvis ego numine possum. C. Schonæ.

67. Jan Saenredam after Hendrick Goltzius

Venus, Bacchus, and Ceres, 16th century

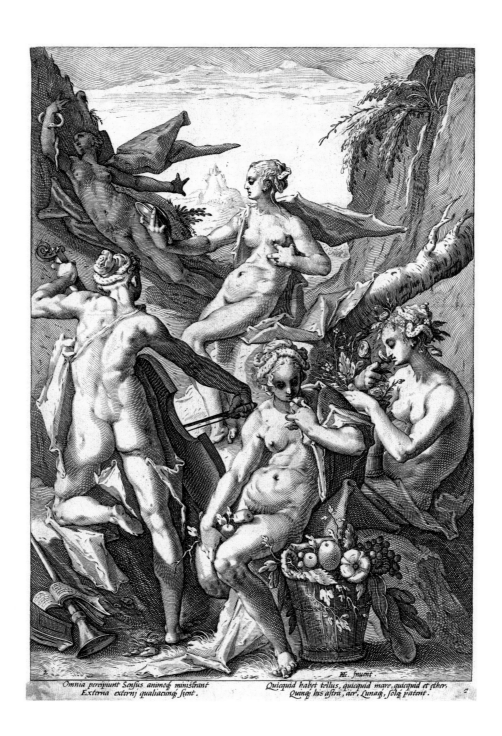

68. Jacob Matham after Hendrick Goltzius

The Five Senses, 16th century

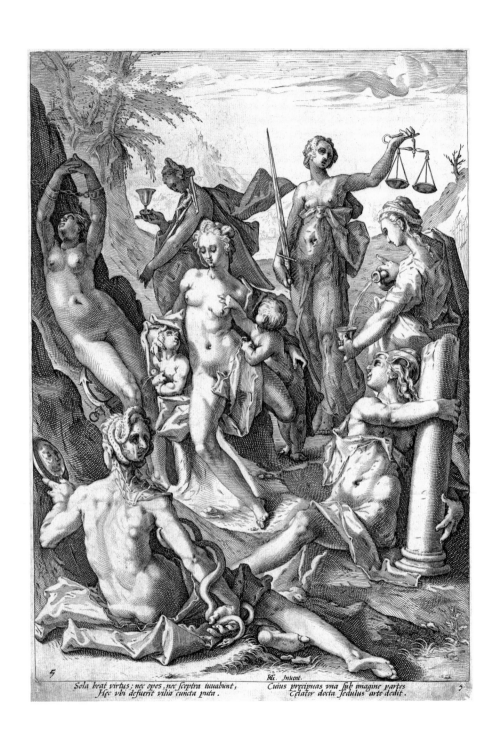

Sola beat virtus; nec opes, nec sceptra iuuabunt,
Hæc vbi defuerit vilia cuncta puta.

Cuius præcipuas vna sub imagine partes
Cælator docta sedulus arte dedit.

69. Jacob Matham after Hendrick Goltzius

The Seven Virtues, 16th century

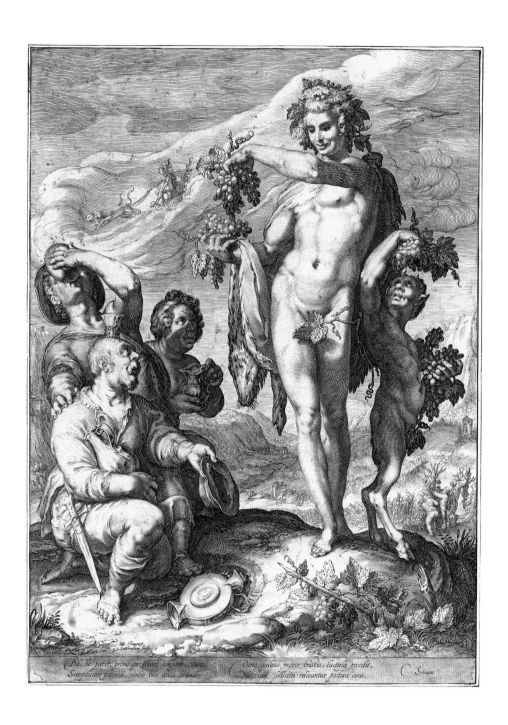

70. Jan Saenredam after Hendrick Goltzius

Drinkers Asking Bacchus for the Continuation of His Gifts, 16th century

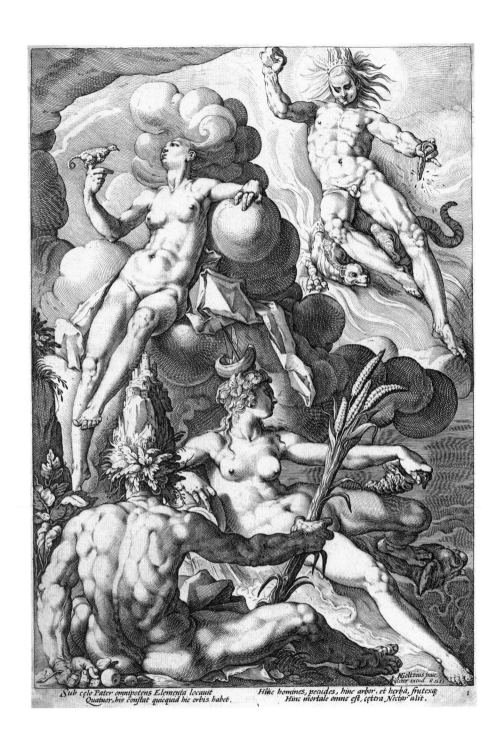

Sub cęlo Pater omnipotens Elementa locauit Hinc homines, pecudes, hinc arbor, et herba, frutexq; 1
Quatuor, his conſtat quicquid hic orbis habet. Hinc mortale omne eſt, cętera Nectar alit.

71. Jacob Matham after Hendrick Goltzius

The Four Elements, 1588

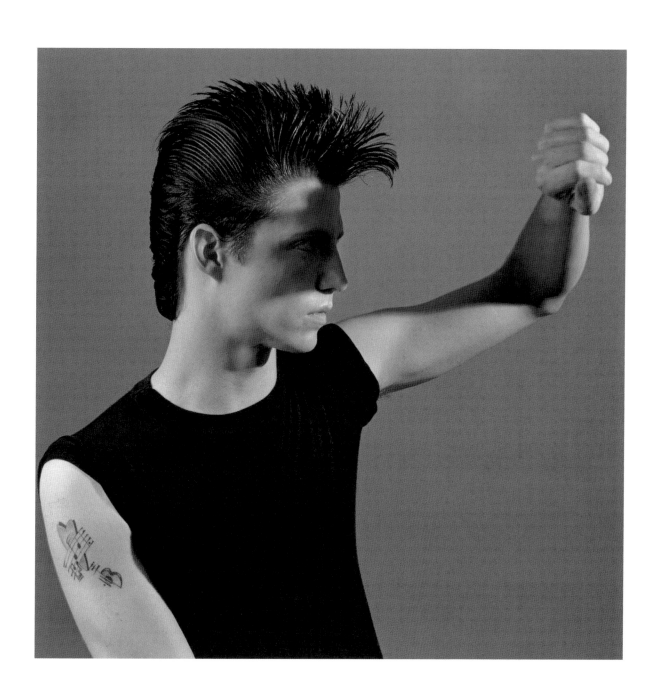

72. Robert Mapplethorpe

Tim Scott, 1980

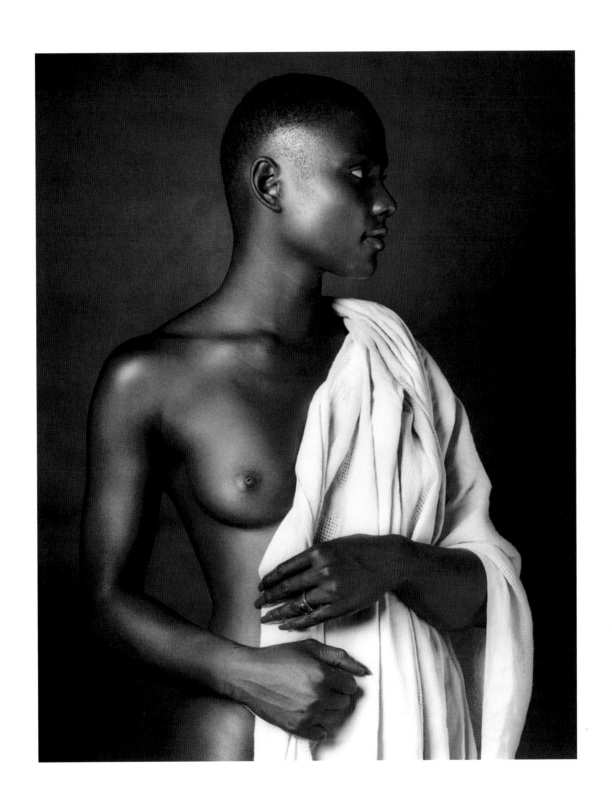

73. ROBERT MAPPLETHORPE

Ada, 1982

74. Robert Mapplethorpe

Francesco Clemente, 1982

75. ROBERT MAPPLETHORPE

Lisa Lyon, 1982

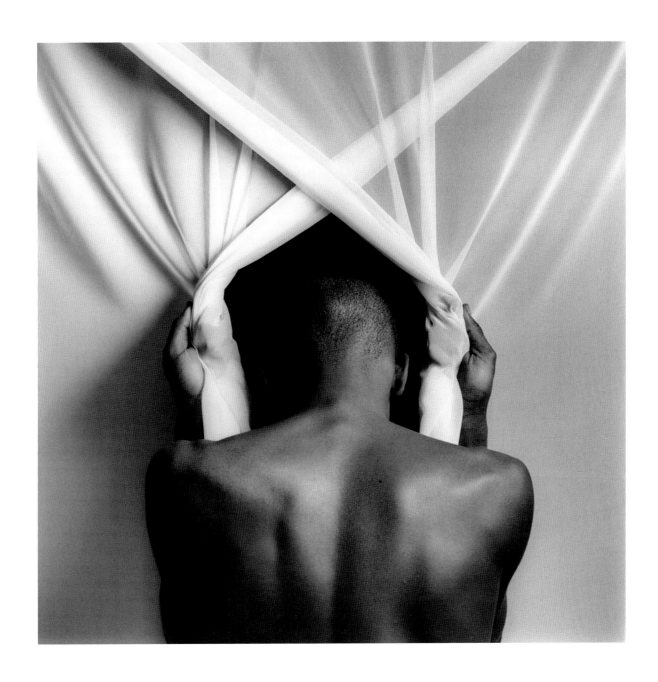

76. Robert Mapplethorpe

Phillip Prioleau, 1982

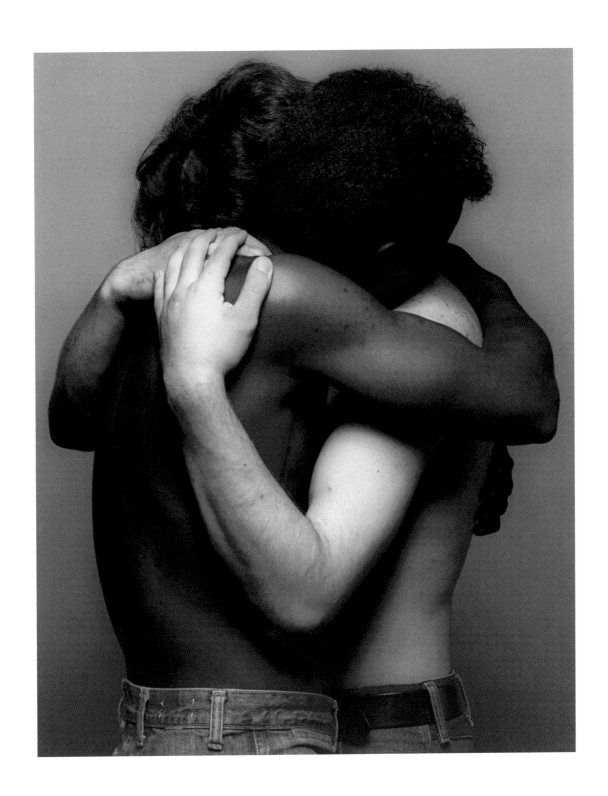

77. Robert Mapplethorpe

Embrace, 1982

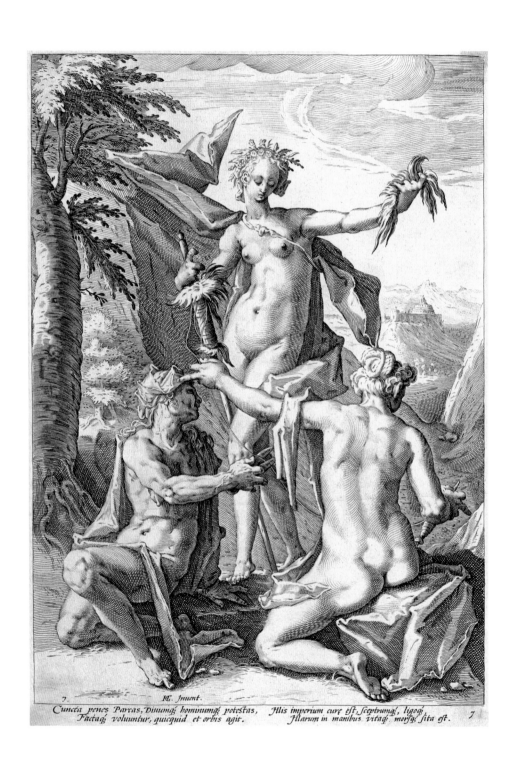

7. H. Inuent.

Cuncta penes Parcas, Diuumq; homuumq; potestas, Illis imperium curæ est sceptrumq; ligoq;
Factaq; voluuntur, quicquid et orbis agit. Illarum in manibus vitaq; morsq; sita est.

7

78. Jacob Matham after Hendrick Goltzius

The Fates, 16th century

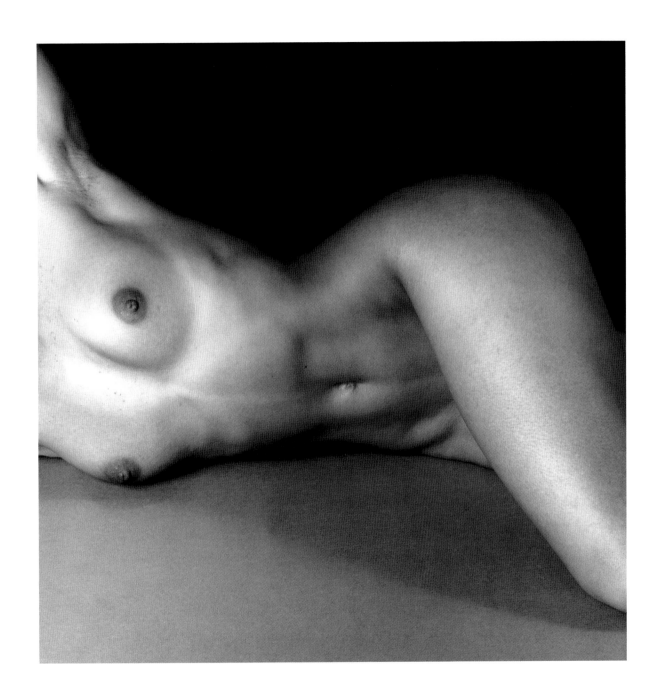

79. Robert Mapplethorpe

Lydia Cheng, 1987

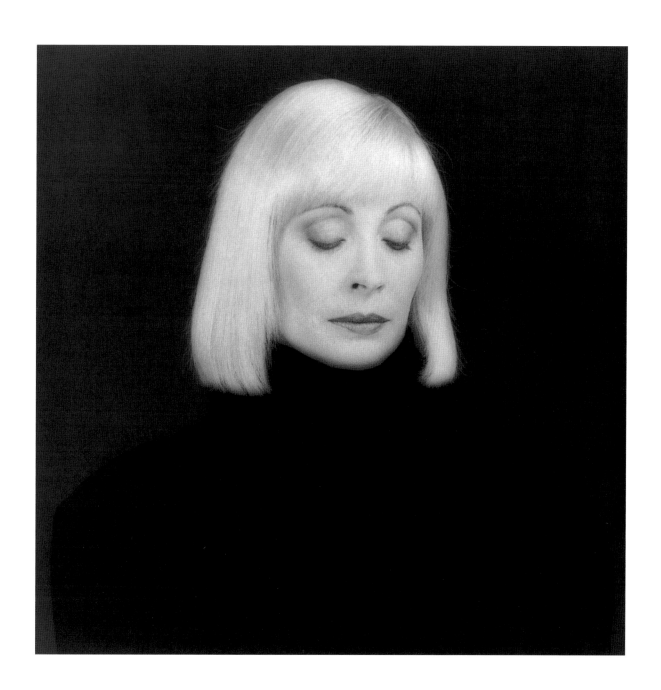

80. Robert Mapplethorpe

Doris Saatchi, 1983

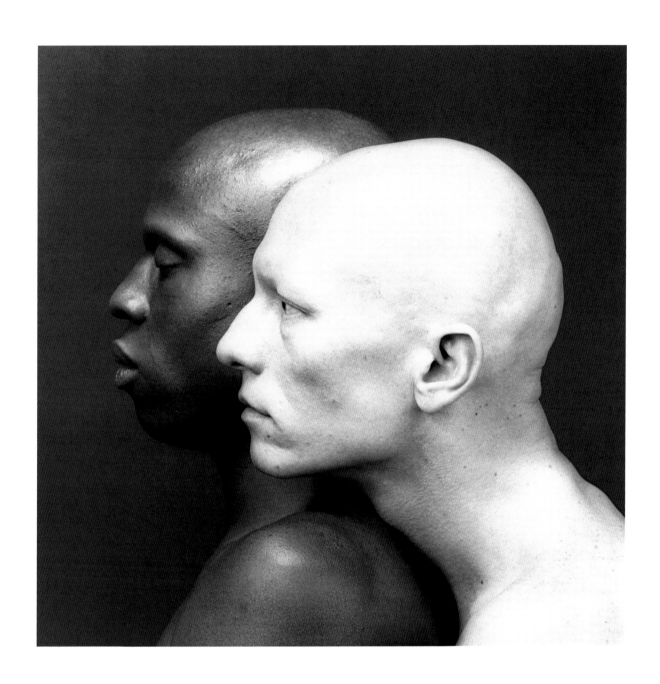

81. ROBERT MAPPLETHORPE

Ken Moody and Robert Sherman, 1984

Principio Omnipotens immensi conditor orbis
Esse polum iussit terræq; immobile pondus.
Hinc lucem tenebris remouet, noctemq; diemq;
Nuncupat; et longis spacys mox segregat vndas,
Æquora secernit terris; vos Lunaq; solq;
Præfectos dedit; hinc animalia cuncta creauit.
Post hæc natus homo est cælesti afflatus ab; aura,
Diuinæ consors mentis, dominusq; priorium.

F. Estius. Aº 1589

82. Jan Harmensz. Muller after Hendrick Goltzius

The Spirit of God on the Face of the Waters, from *Creation of the World*, 16th century

83. Jan Harmensz. Muller after Hendrick Goltzius

The Spirit Separating Light from Darkness, from *Creation of the World*, 16th century

84. Jan Harmensz. Muller after Hendrick Goltzius

The Creation of the Firmament and the Separation of the Waters Above and Below, from *Creation of the World*, 16th century

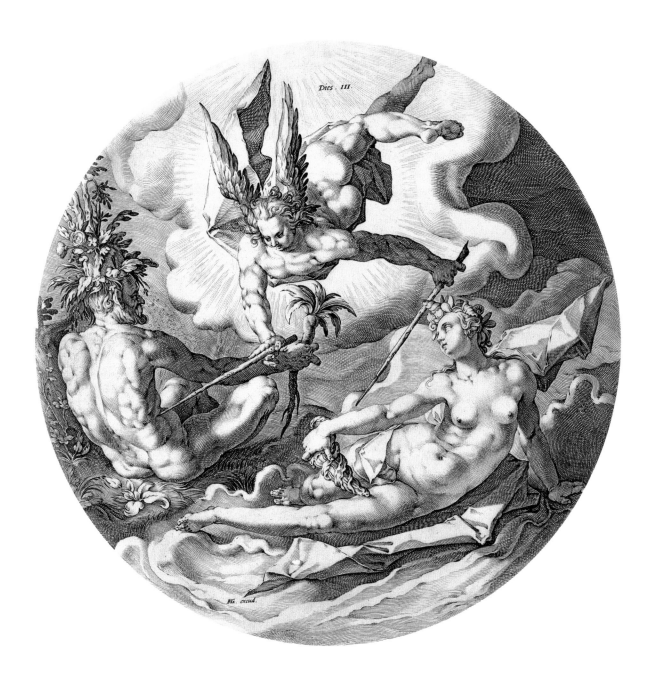

85. Jan Harmensz. Muller after Hendrick Goltzius

The Creation of Dry Land and the Seas, from *Creation of the World*, 16th century

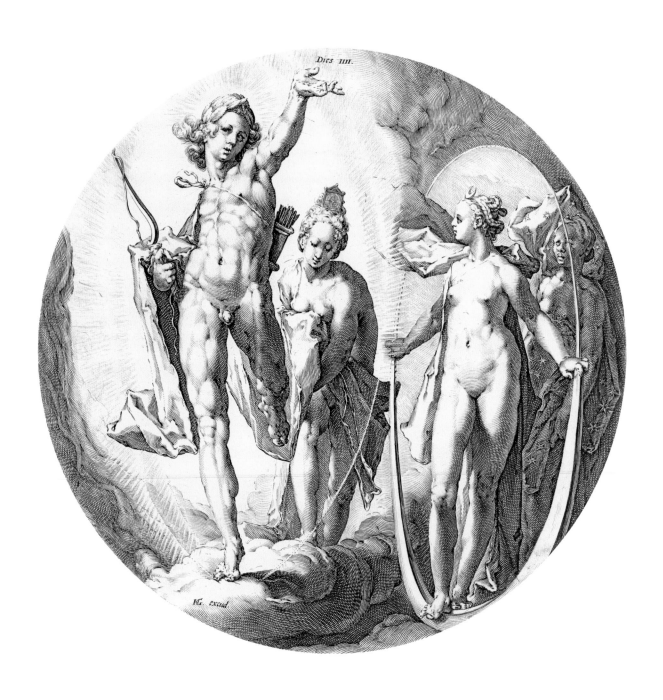

86. Jan Harmensz. Muller after Hendrick Goltzius

The Creation of the Sun and the Moon, from *Creation of the World*, 16th century

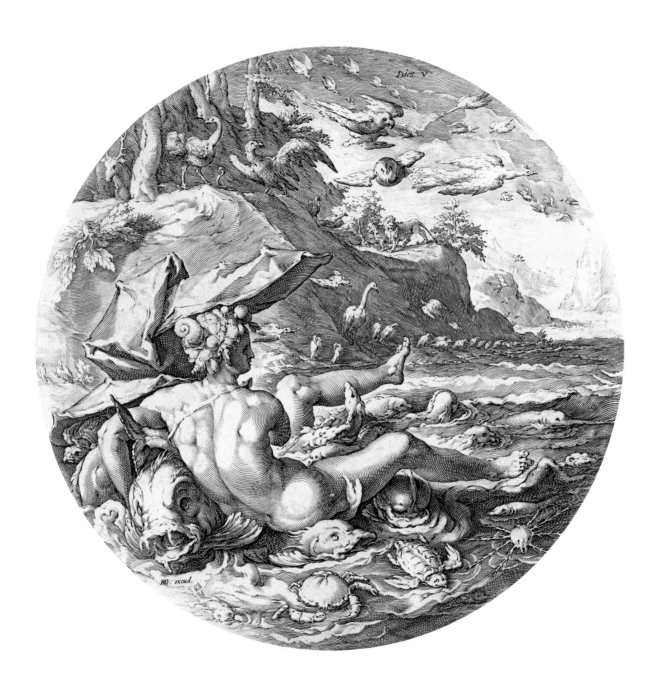

87. Jan Harmensz. Muller after Hendrick Goltzius

The Creation of Fishes, Birds, and Beasts, from *Creation of the World*, 16th century

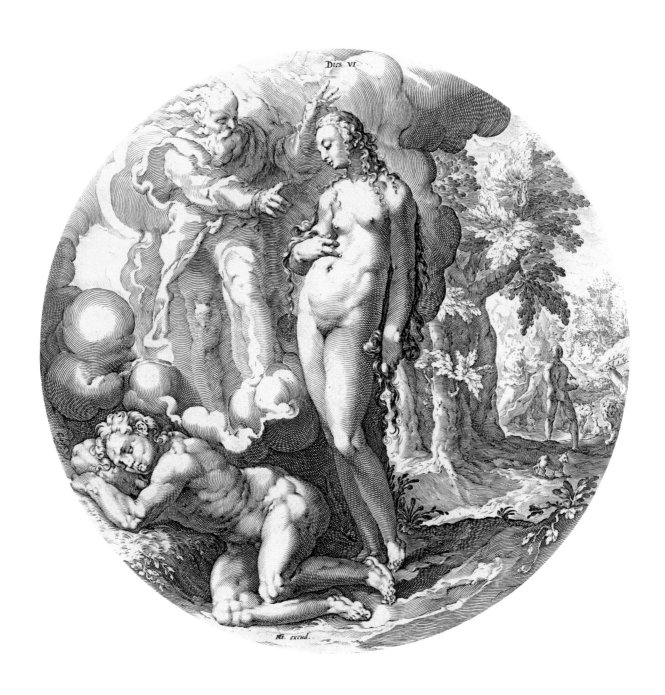

88. Jan Harmensz. Muller after Hendrick Goltzius

The Creation of Man and Woman, from *Creation of the World*, 16th century

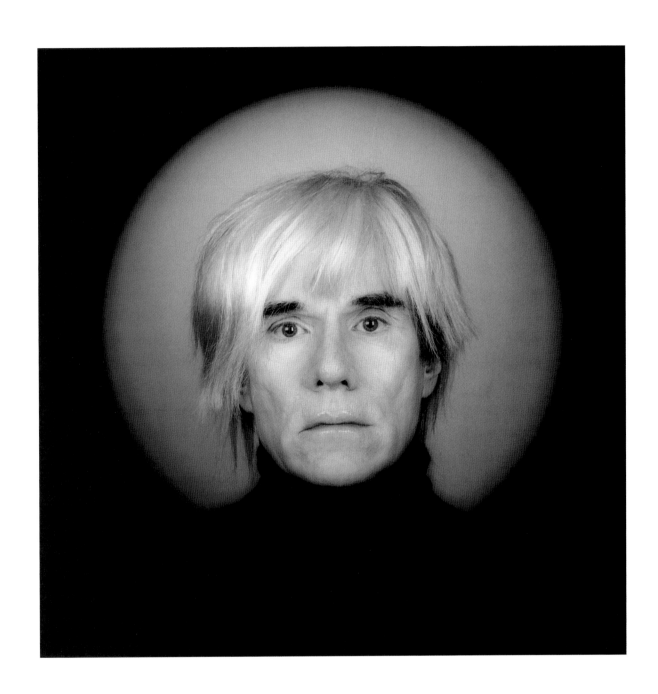

89. ROBERT MAPPLETHORPE

Andy Warhol, 1986

90. Robert Mapplethorpe

Cindy Sherman, 1983

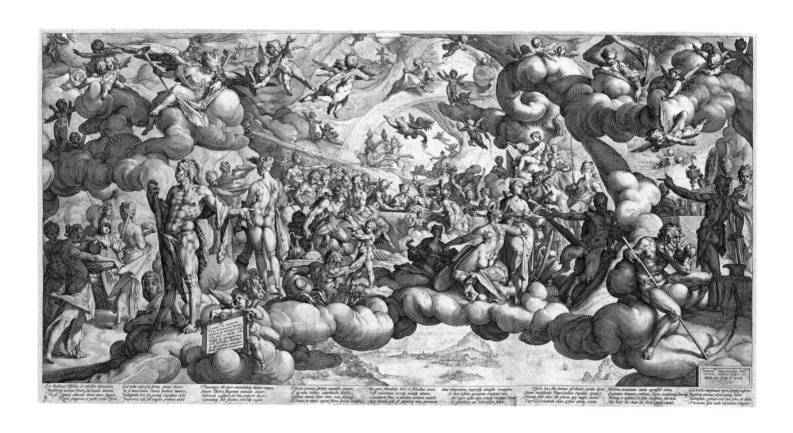

91. Hendrick Goltzius

The Wedding of Cupid and Psyche, 1587

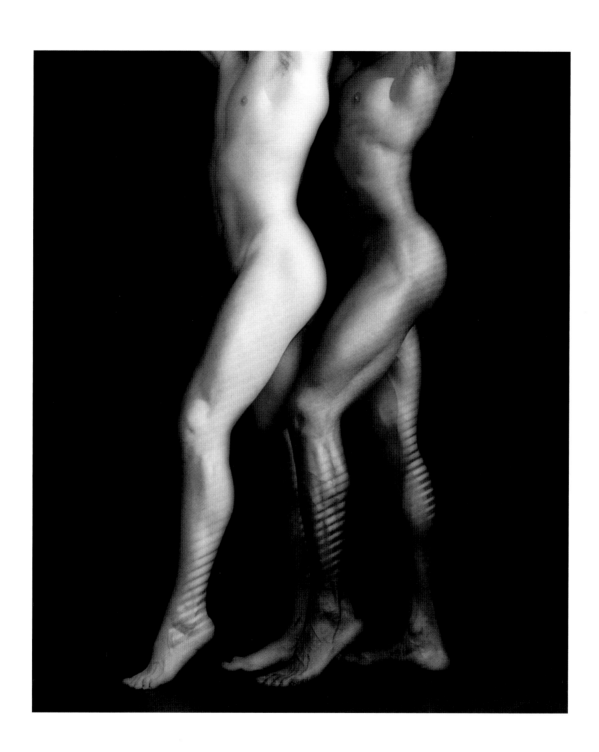

92. ROBERT MAPPLETHORPE

Ken and Tyler, 1985

"I don't understand the way my pictures are. . . . Taking a picture and sexuality are parallels. They're both unknowns. And that's what excites me most in life—the unknown."

Mapplethorpe, quoted in Mark Thompson, "Mapplethorpe," *The Advocate* (Atlanta), July 24, 1980.

"I studied painting and sculpture. I never really studied photography when I was at school. Photography just kind of crept into me."

Mapplethorpe, quoted in Lawrence Chua, "Robert Mapplethorpe," *Flash Art International* (Milan), no. 144 (Jan.–Feb. 1989), p. 102.

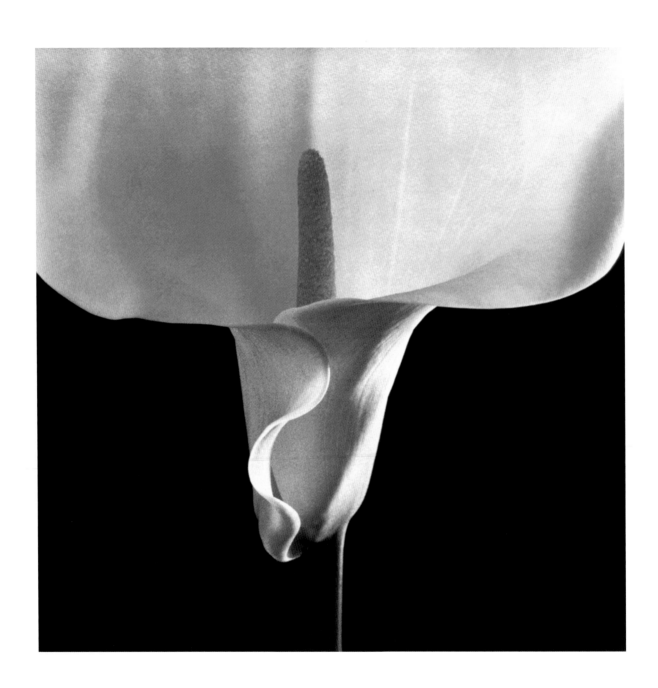

93. ROBERT MAPPLETHORPE

Calla Lily, 1988

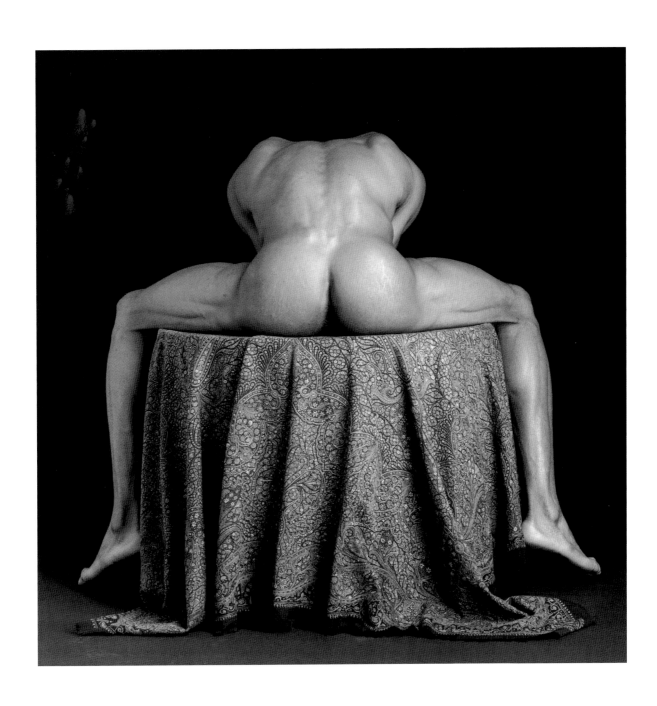

94. Robert Mapplethorpe

Carlton, 1987

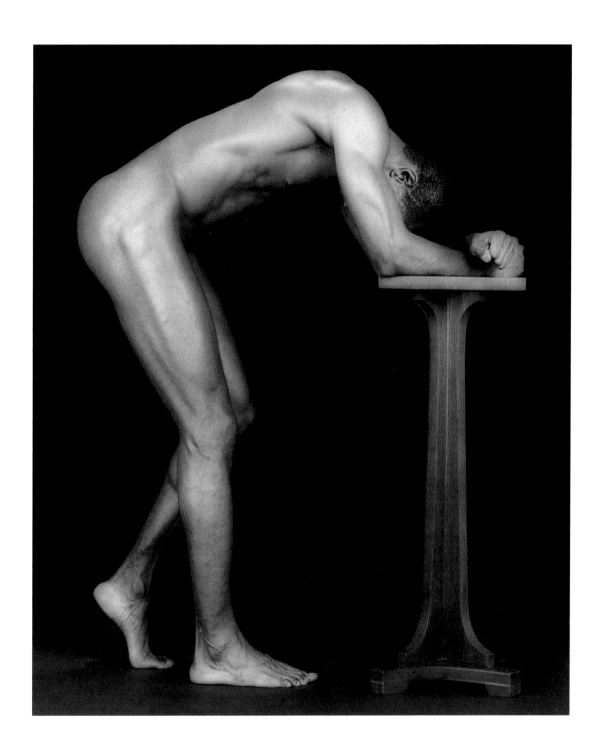

95. ROBERT MAPPLETHORPE

Thomas, 1986

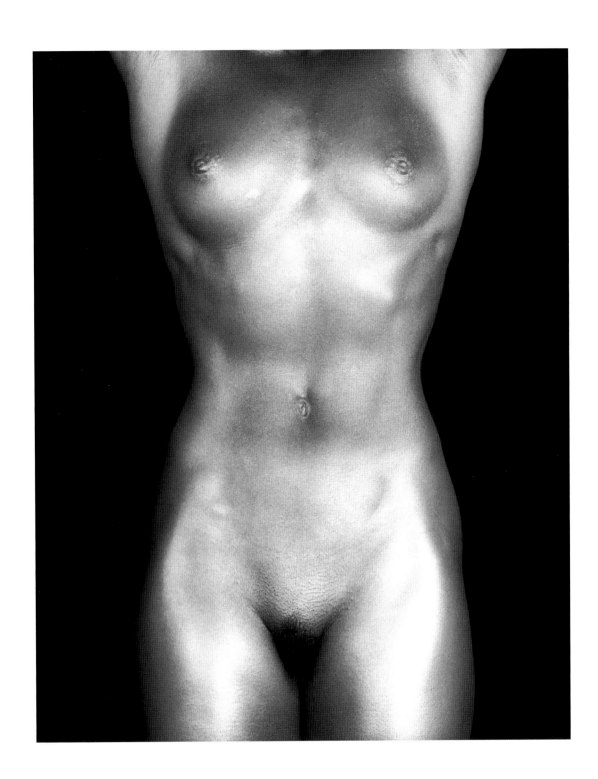

96. ROBERT MAPPLETHORPE

Lydia Cheng, 1985

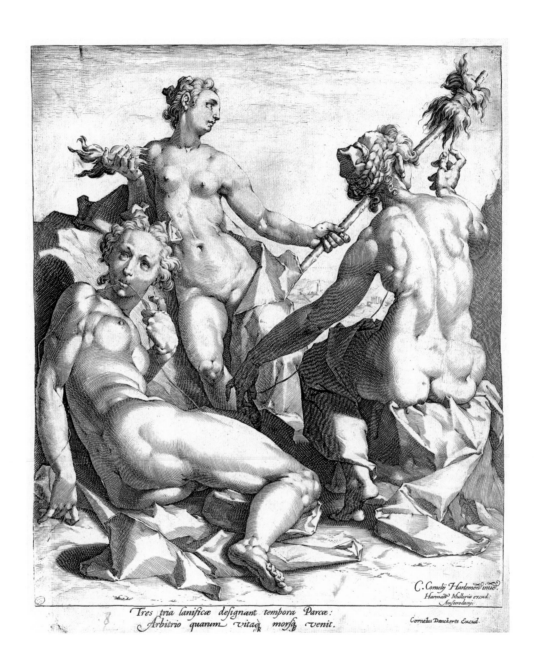

Tres tria lanificæ designant tempora Parcæ:
Arbitrio quarum vitaq̈ morsq̈ venit.

C. Cornelij Harlemensi inue.
Harman⁹ Mullerus excud:
Amsterodamij.

Cornelius Danckerts Excud.

97. JAN HARMENSZ. MULLER AFTER CORNELIS CORNELISZ. VAN HAARLEM

The Fates, 16th century

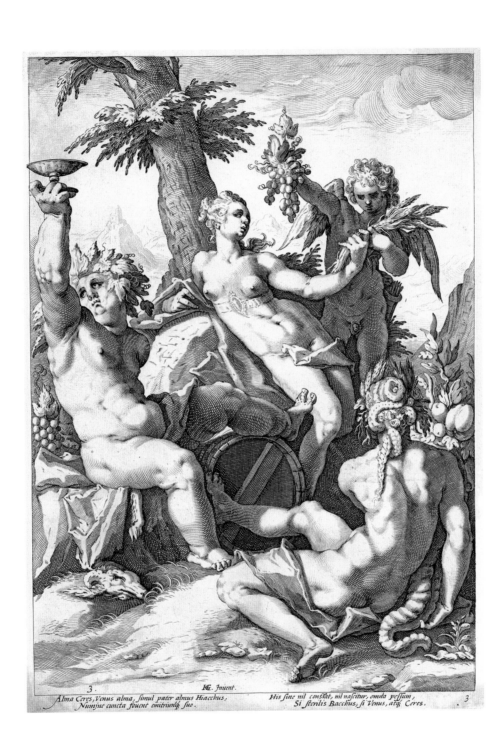

Alma Ceres, Venus alma, simul pater almus Bacchus, Nunque cuncta fovent emtriuoque suo. His sine nil constat, nil nascitur, omnia pessum, Si sterilis Bacchus, si Venus, atque Ceres.

98. Jacob Matham after Hendrick Goltzius

The Alliance of Venus, Bacchus, and Ceres, 16th century

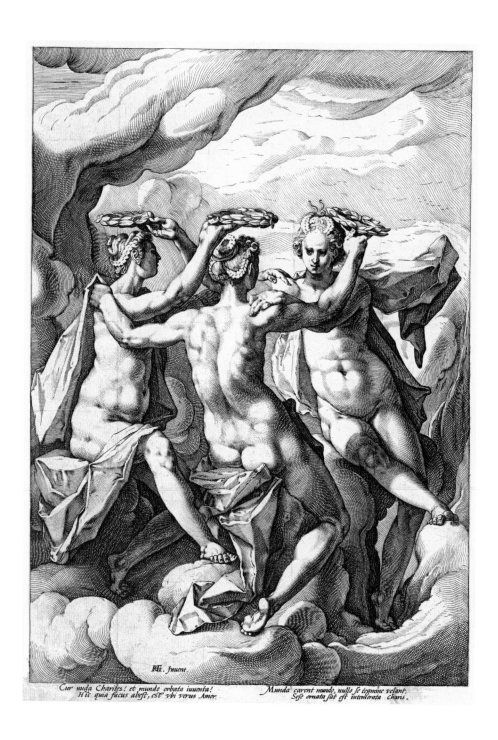

Cur nuda Charites! et mundo orbata iuuenta! Munda carent mundo, nullo se tegmine velant.
Hic quia fucus abest, est vbi verus Amor. Sese ornata sat est intemerata Charis.

99. Jacob Matham after Hendrick Goltzius

The Graces, 16th century

100. ROBERT MAPPLETHORPE

Ken, Lydia, and Tyler, 1985

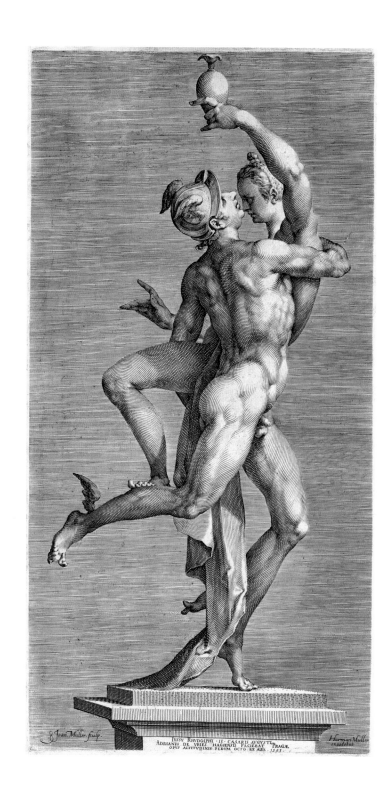

101. Jan Harmensz. Muller after the bronze statue by Adriaen de Vries

Mercury Abducting Psyche: Mercury Seen in Profile from the Right, from *The Abduction of Psyche*, 16th century

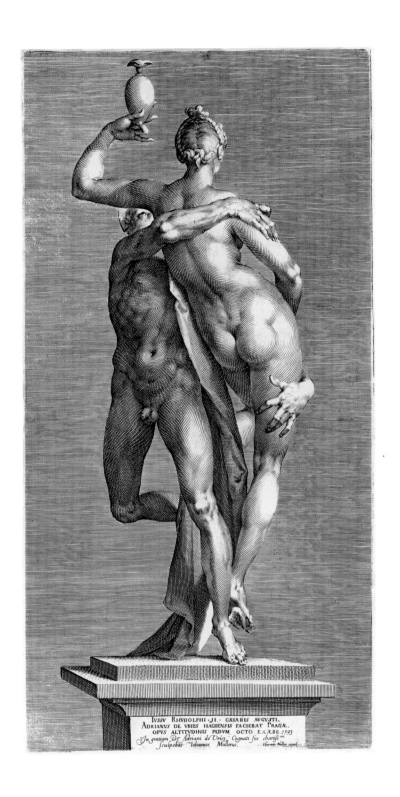

IVSSV RHVDOLPHI·II· CÆSARIS AVGVSTI,
ADRIANVS DE VRIES HAGIENSIS FACIEBAT PRAGÆ.
OPVS ALTITVDINIS PEDVM OCTO E.X ÆRE 1593
In gratiam D: Adriani de Vries, Cognati sui chariss
sculpebat Iohannes Mullerus. Harman Muller excud.

102. Jan Harmensz. Muller after the bronze statue by Adriaen de Vries

Mercury Abducting Psyche: Mercury Seen in Full Face, from *The Abduction of Psyche*, 16th century

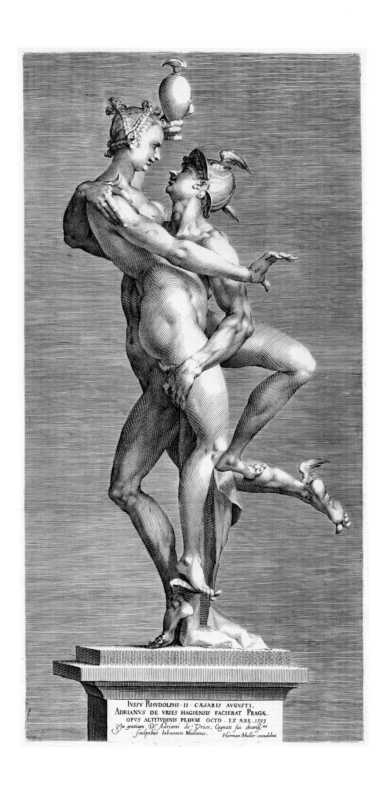

103. JAN HARMENSZ. MULLER AFTER THE BRONZE STATUE BY ADRIAEN DE VRIES

Mercury Abducting Psyche: Mercury Seen in Profile from the Left, from *The Abduction of Psyche*, 16th century

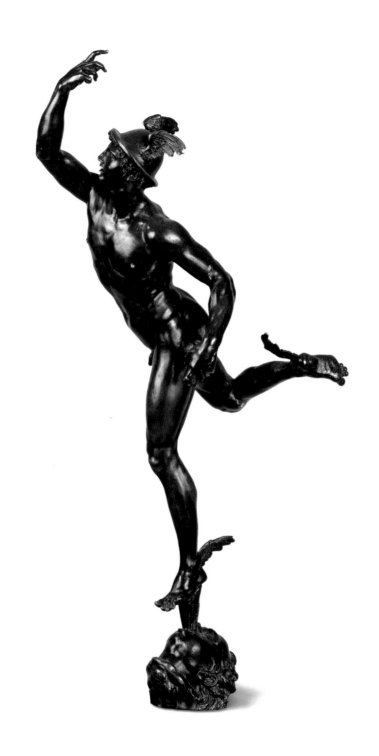

104. WORKSHOP OF GIOVANNI BOLOGNA

Mercury, late 16th century

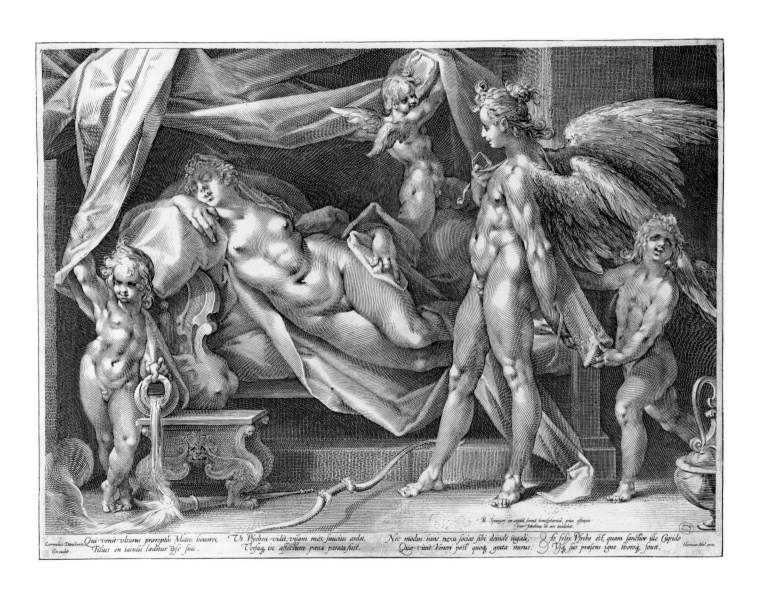

105. JAN HARMENSZ. MULLER AFTER A BAS-RELIEF BY BARTHOLOMÄUS SPRANGER

Eros Discovering Psyche in His Bed, 16th century

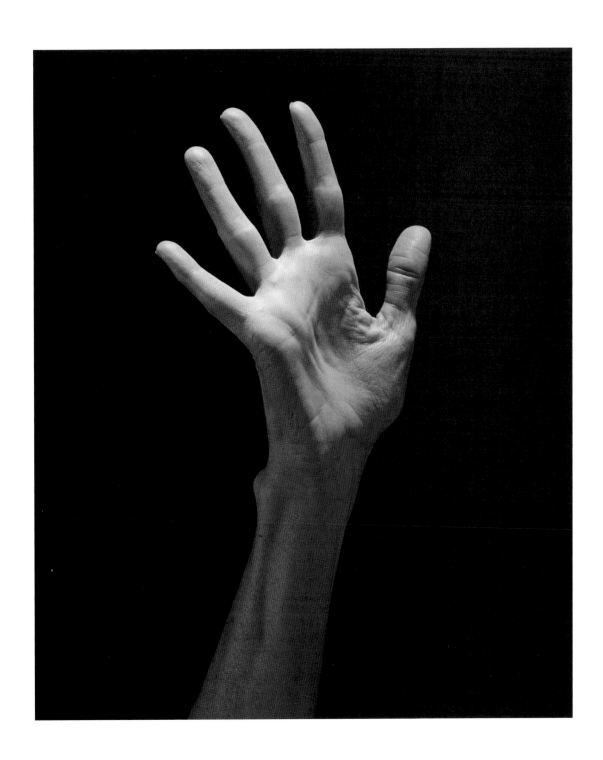

106. ROBERT MAPPLETHORPE

Lucinda's Hand, 1985

107. Anonymous

Mars, late 19th century?

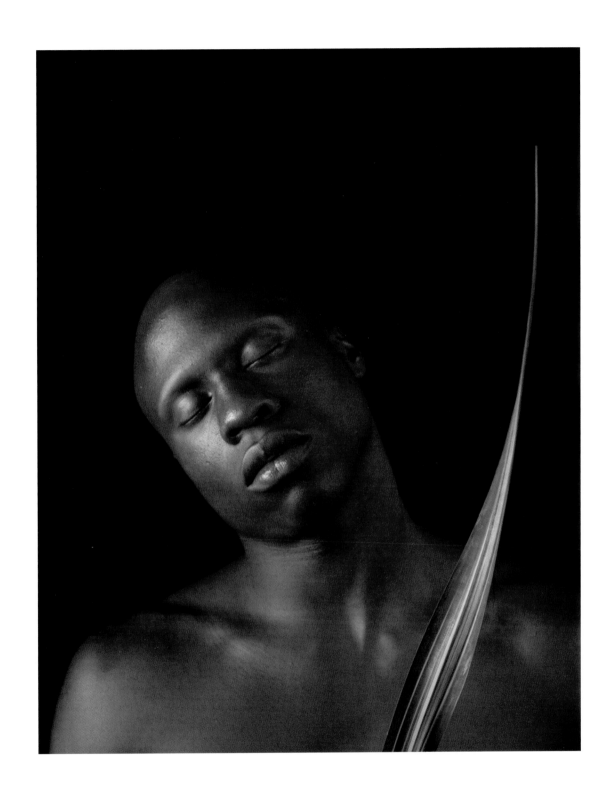

108. ROBERT MAPPLETHORPE

Ken Moody, 1984

109. Robert Mapplethorpe

Italian Devil, 1988

110. ROBERT MAPPLETHORPE

Mercury, 1986

III. Anonymous

Ermes, late 19th century?

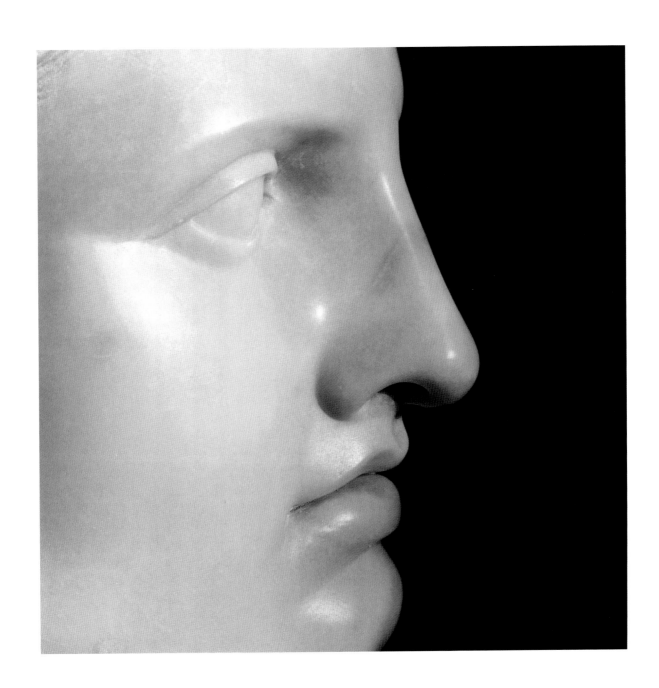

112. Robert Mapplethorpe

Apollo, 1988

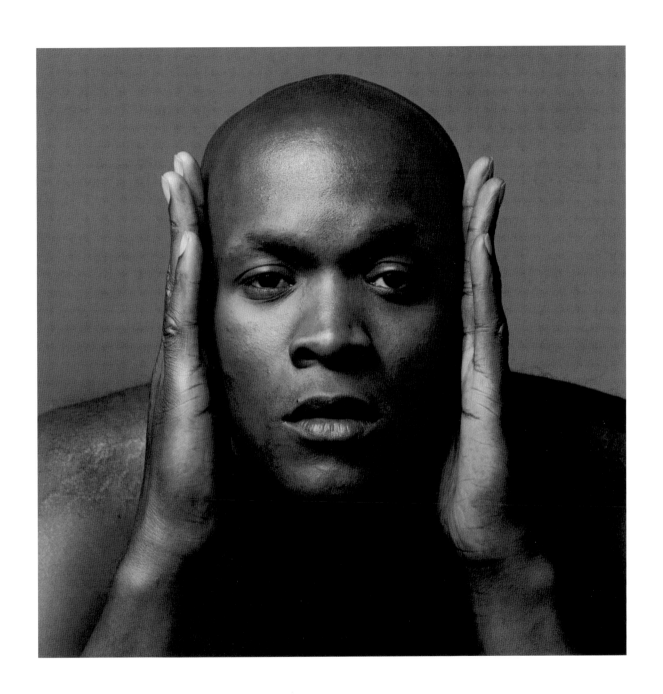

113. ROBERT MAPPLETHORPE

Donald Cann, 1982

114. Jacob Matham after Cornelis Cornelisz. van Haarlem

Apollo in the Clouds, 16th century

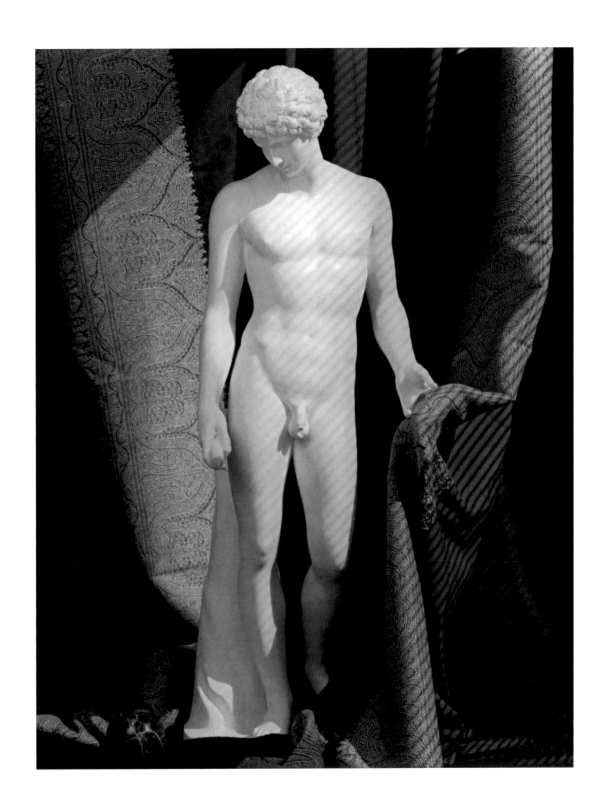

115. Robert Mapplethorpe

Antinous, 1987

" 'I submit to the subject. I go with it, relating my personality to the one I'm photographing.' . . . 'I don't photograph things I've not been involved with myself.' "

Mapplethorpe, quoted in Sarah Kent, "Mapplethorpe," *Time Out* (London), Nov. 3–9, 1983, p. 12.

"When art is purely art, it has a certain magic about it. It transcends whatever it is, it's something you can't quite put words to."

Mapplethorpe, quoted in Lawrence Chua, "Robert Mapplethorpe," *Flash Art International* (Milan), no. 144 (Jan.–Feb. 1989), p. 103.

116. Jan Saenredam after Abraham Bloemaert

Allegory of Vanity, 16th century

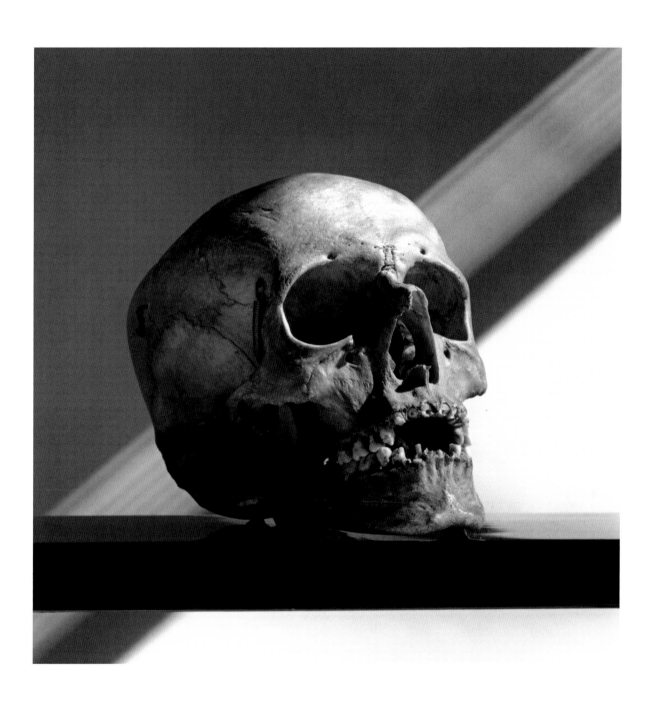

117. Robert Mapplethorpe

Skull, 1988

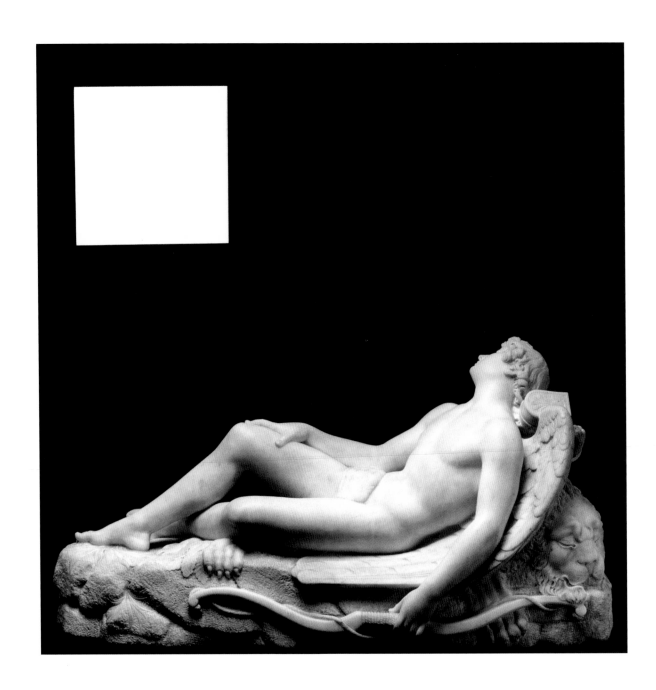

118. Robert Mapplethorpe

Sleeping Cupid, 1989

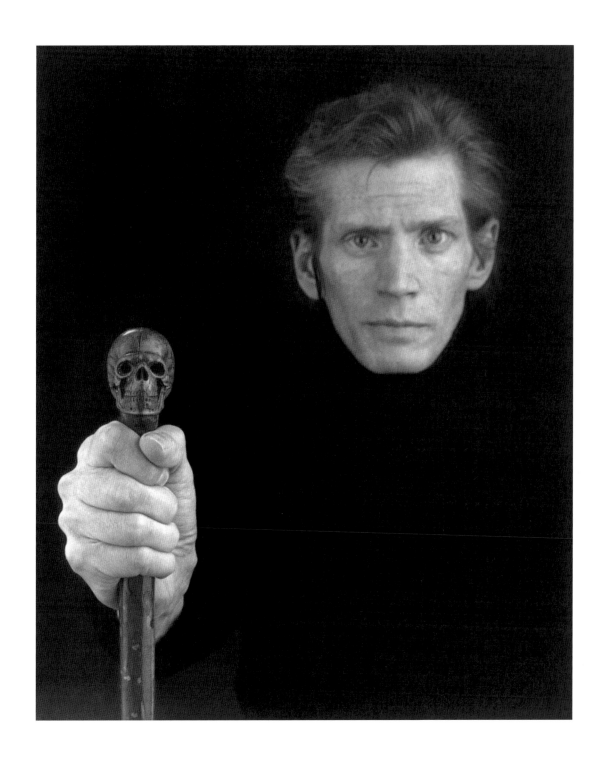

119. ROBERT MAPPLETHORPE

Self-Portrait, 1988

120. ROBERT MAPPLETHORPE

Self-Portrait, 1988

Glossary

Catalogue Checklist

Selected Bibliography

Abduction of the Sabine Women
An episode from Rome's foundation myths recounted by the historian Livy. After Rome's mythological founder Romulus declared an asylum to increase the city's population, an influx of male newcomers led to a shortage of women. At first the Romans asked the neighboring Sabine tribes for the women, but when their offer was turned down, they decided to invite the people of the Sabine region to a festival in honor of Neptune. Halfway through the ceremony, the Romans surprised their guests and abducted the young Sabine women.

Ada
A model.

Adonis
According to Ovid's *Metamorphoses*, Myrrha, a young girl, fell in love with her father Cinyras and surreptitiously became pregnant by him. When Cinyras discovered he had been sleeping with his daughter, Myrrha fled in terror. To avoid her father's wrath, she was turned into a myrrh tree by the gods. The tree later burst open, allowing her son Adonis to emerge. Once the child was born, Venus was so moved by his beauty that she sheltered him and entrusted him to Persephone. The queen of the Underworld was also taken by his beauty and refused to give him back. The dispute between the two goddesses was settled by Jupiter: until his death Adonis was to spend one third of every year with each goddess, while he could spend the last third wherever he wanted. He always chose to spend two thirds of the year with Venus. This made her lover, Mars, extremely jealous, and one day he sent a wild boar into the forest to kill Adonis. From each drop of the slain youth's blood, an anemone grew.

Ajitto
A model.

Allegory of Vanity
An illustration of a moral lesson in symbolic terms. The word "vanity" is derived from the Latin *vanitas* and suggests the shallowness of mortal life and the transience of earthly pleasures and achievements. The skull is a traditional memento mori.

Antinous
Born in the Greek province of Bithynia on the northwest coast of Asia Minor. An intelligent and striking boy, Antinous became the Roman Emperor Hadrian's "favorite" and lover and is represented in many sculptures of historical events. In the year 130 CE while touring Egypt, which was now ruled by Rome, Antinous drowned mysteriously in the river Nile. Prompted by the Egyptian belief that those who drowned were claimed by the gods as their own, the grief-stricken Hadrian immediately declared him a god and founded a memorial city, Antinopolis, exactly where he died. Within a few years of his death, many temples and statues were erected marking devotion to him throughout the known world.

Apollo, Battle with Python
Son of Jupiter and Leto, twin brother of Diana. Youthful, beautiful Olympian God of the sun, and patron of fine arts—especially poetry and music, medicine, philosophy, science, and archery. When Apollo established his temple of Delphi in Greece, he slew the Python, a dragon that lived nearby, using his arrows.

Apollo Belvedere
A Roman marble copy of a fifth-century BCE Greek original. It is called the Apollo Belvedere because it was placed in the Belvedere Courtyard, now part of the Pio Clementino Museum at the Vatican.

Athena
Greek goddess of wisdom and counsel, war, the arts, industry, and justice; in Roman mythology Athena was often called Minerva. Jupiter swallowed his pregnant wife Metis out of fear she would bear a son who would overthrow him. Jupiter's son Vulcan, the blacksmith of the gods, split his father's skull open. From his head emerged Athena, fully grown and wearing helmet and shield. Athena's shield is often depicted with a Gorgon's head, a gift from Perseus, at its center.

Bacchus
Son of Jupiter and Semele; god of vegetation, wine, and intoxication. The Bacchanalia, a festival of wild, delirious, drunken celebrations, were held in his honor.

Giovanni Bologna
Born 1524, Douai, The Netherlands, died 1608, Florence.

Bruce
A model.

Cain Killing Abel
According to the Book of Genesis, Cain and Abel were born after their parents Adam and Eve had been thrown out of the Garden of Eden. Cain became a farmer, while Abel chose to be a shepherd. When the day came to make an offering to God, Abel brought one of the finest lambs from his flocks, while Cain deliberately brought only an average-quality offering from his crops. God accepted Abel's offering with favor, but he rejected Cain's. Cain became jealous and angry toward Abel and murdered his brother.

Donald Cann
A model.

Carlton
A model.

Benvenuto Cellini
Born 1500, Florence, Italy, died 1571, Florence.

Ceres
Daughter of Saturn and mother of Persephone; goddess of agriculture, grain, and the harvest. Ceres is usually portrayed with a scepter, a basket with flowers or fruits, known as the cornucopia, and a garland made of the ears of corn.

Lydia Cheng
Professional bodybuilder.

Francesco Clemente
Italian painter.

The Creation of the Firmament and the Separation of the Waters Above and Below
Referring to Genesis I, 6–8: And God said, Let an expanse be in the midst of the waters, and let it be dividing between the waters and the waters. And God made the expanse, and He separated between the waters which were under the expanse and the waters which were above the expanse. And it was so. And God called the expanse, Heavens.

The Creation of Dry Land and the Seas
Referring to Genesis I, 9–10: And God said, Let the waters under the heavens be collected to one place, and let the dry land appear. And it was so. And God called the dry land, Earth. And He called the collection of the waters, Seas.

The Creation of the Sun and the Moon
Referring to Genesis I, 14–18: And God said, Let luminaries be in the expanse of the heavens, to divide between the day and the night. And let them be for signs and for seasons, and for days and years. And let them be for luminaries in the expanse of the heavens, to give light on the earth. And it was so. And God made the two great luminaries: the great luminary to rule the day, and the small luminary and the stars to rule the night. And God set them in the expanse of the heavens, to give light on the earth, and to rule over the day and over the night; and to divide between the light and the darkness.

The Creation of Fishes, Birds, and Beasts
Referring to Genesis I, 20–21: And God said, Let the waters swarm with swarmers having a soul of life; and let the birds fly over the earth, on the face of the expanse of the heavens. And God created the great sea animals, and all that creeps, having a living soul, which swarmed the waters, according to its kind; and every bird with wing according to its kind.

And Genesis I, 24–25: And God said, Let the earth bring forth the soul of life according to its kind: cattle, and creepers, and its beasts of the earth, according to its kind. And it was so. And God made the beasts of the earth according to its kind, and cattle according to its kind, and all creepers of the ground according to its kind.

The Creation of Man and Woman
Referring to Genesis I, 26–27: And God said, Let Us make man in Our image, according to Our likeness; and let them rule over the fish of the sea, and over the birds of the heavens, and over the cattle, and over all the earth, and over all the creepers creeping on the earth. And God created the man in His own image; in the image of God He created him. And He created them male and female.

Derrick Cross
A modern dancer.

Cupid
The Roman god of Love, son of Venus, counterpart of the Greek Eros. Sometimes portrayed as a small, winged boy, blindfolded, carrying bow and arrows; sometimes portrayed as a young man with his beloved Psyche. Images of a sleeping god of Love in art date to the Hellenistic Greek period and are often accompanied by attributes of Hercules, such as the lion's skin, to denote love's power.

Diana
Identified with the Greek Artemis, twin sister of Apollo, honored as a virgin goddess. She was the goddess of forests, the hunt, the moon, fertility and women in childbirth, and patron of wild animals. Her favorite weapons are the bow and arrow.

Dominick and Elliot
Acquaintances.

Dovanna
A professional model.

Eros
Greek god of Love, counterpart of Roman Cupid.

The Fates
Personifications of the inescapable destiny of man. According to Greek mythology, they had the power of deciding over the destiny of both gods and mortals. Traditionally the Fates were depicted as three women: one Fate spins the thread of life, the second measures its length, and the third cuts it off, bringing life to an end.

The Five Senses
Sight, sound, smell, touch, and taste.

Fortune
From the Latin *fortuna*, the goddess of chance; unpredictable and inconstant; personification of material wealth, usually depicted as a beautiful woman, desired by all, blind or blindfolded to illustrate the fact that she disperses richness randomly. Her main attribute is a cornucopia or horn of plenty; or a ship's rudder.

The Four Elements
According to the Greek philosopher and scientist Empedocles (fifth century BCE), all matter was comprised of four "roots" or elements of earth, air, fire, and water. In his Doctrine of the Four Elements, Empedocles described these elements not only as physical manifestations or material substances, but also as spiritual essences.

Hendrick Goltzius
Born 1558, Mulbracht, The Netherlands, died 1617, Haarlem, The Netherlands.

The Graces
Personifications of aspects of loveliness and attendants of Venus. They are usually three in number: Aglaia, whose name is Greek for splendor; Euphrosyne, myrth; and Thalia, good cheer.

Hercules
Most popular ancient hero, a symbol of strength and courage, the son of Jupiter and the mortal Alcmena. The most well-known of the many legends associated with him are his Twelve Labors. The hero is typically depicted in art as a muscular figure with the attributes of a lion's skin and club, as in the Farnese Hercules, a Roman copy of a fourth-century BC Greek statue discovered in the Baths of Caracalla in Rome in 1546. It is believed to depict Hercules resting after completing his Labors; in his right hand he holds the Apples of the Hesperides, which had been guarded by the daughters of Night.

Hermes
Greek god, counterpart of Roman Mercury.

Icarus
According to Ovid's *Metamorphoses*, Icarus was the son of the inventor Daedalus, who had been imprisoned by King Minos on Crete. To escape, Daedalus crafted feathered wings held together by wax for himself and his son. Ignoring his father's warning, Icarus tried to reach the heavens and flew too close to the sun. The wax on his wings melted, and he fell to his death in the sea.

Italian Devil
The devil as fallen angel deprived of the revelation of God as a consequence of its rebellion against God. The traditional attributes of the devil, such as hooves and horns, developed in the Middle Ages. Mapplethorpe, who grew up a Catholic, was fascinated throughout his life with the devil and Satan, and incorporated devil imagery into a number of works.

Ixion
The first human to shed kindred blood, Ixion was purified by Jupiter and received as a guest on Olympus. There, he betrayed Jupiter's hospitality by desiring to sleep with his host's wife, Juno. For this he was cast down to Tartarus, the Underworld, where he was bound to an eternally revolving, fiery wheel. The punishment of Ixion is described in Vergil's *Aeneid*.

Jamie
A model.

Jim
Acquaintance.

Alan Lyne
A dancer with the Peter Reed Ballet Company.

Lisa Lyon
Professional bodybuilder, winner of the first World Women's Bodybuilding Championship in 1979.

Robert Mapplethorpe
born November 4, 1946, Queens, New York, died March 9, 1989, Boston, Massachusetts.

Mars
God of war, in Roman religion second in importance only to Jupiter. Almost always depicted as an armed warrior, wearing a large war helmet and carrying a shield and spear.

Mercury, the Abduction of Psyche
In Roman mythology the god of commerce, travel, and thievery; counterpart of the Greek god Hermes, whose main duty it was, as messenger of the gods, to guide the souls of the dead down to the Underworld. His attributes are a herald's staff with two intertwined snakes and a pouch, symbol of his connection with commerce, winged sandals, and a winged hat. Psyche was the beautiful daughter of an ancient king. According to Apuleius, Venus was so jealous of Psyche's beauty she wanted to punish her, but her son Cupid fell in love with her. After much travail, Cupid convinced Venus to consent to their marriage and sent Mercury to bring Psyche up to Olympus for her wedding.

Jacob Matham
Born 1571, Haarlem, The Netherlands, died 1631, Haarlem.

Ken Moody
A model, athlete and fitness instructor.

Jan Harmensz. Muller
Born 1571 Amsterdam, The Netherlands, died 1628, Amsterdam.

Nox
Ancient personification of night, daughter of Chaos, mother of Aether and Day. She rode across the sky in a two-horse chariot drawing her dark mist across the sky, bringing darkness.

Persephone
Daughter of Jupiter and Ceres; in Roman mythology also known as Proserpina; was seized by Pluto, god of the Underworld, and taken down to his kingdom to be his wife. In revenge her mother, the grief-stricken Ceres, sent cold and famine all over the earth: crops withered, animals died, the human race was threatened. Jupiter intervened and convinced Pluto to free the girl as long as she had not eaten any food of the dead; whoever eats the food of the dead must stay in the Underworld forever. Proserpina had swallowed a pomegranate seed, but a compromise was reached. She would spend four months each year in the Underworld, causing the earth to mourn and creating the seasons.

Perseus
Sent by King Polydectes to fetch the head of the Gorgon Medusa, who had the power to turn every living being that gazed directly upon her into stone. In his quest to bring Medusa's head back to Polydectes, Perseus was helped by the gods. Minerva gave him a mirrored shield that would reflect Medusa's gaze, which allowed him to slay the monster without looking directly at it. Perseus succeeded in his task and revealed the Medusa's head to Polydectes, who was turned into stone.

Phaeton
Son of Helius, the Sun god. According to Ovid's *Metamorphoses*, the young Phaeton sought permission to steer his father's chariot for one day. But, as he took off, the inexperienced Phaeton lost control of the horses. The chariot, speeding toward heaven, threatened the stars, and plummeting too close to the face of the earth, scorched its surface, drying out the Libyan desert and giving the Ethiopians their dark skin. In answer to the Earth's prayers, Jupiter hurled a lightning-bolt at the chariot, destroying it and leaving Phaeton to fall to his death.

Barthélémy Prieur
born ca. 1540 Berzieux, France, died 1611 Paris, France.

Phillip Prioleau
A model.

Brian Ridley and Lyle Heeter
Acquaintances.

Doris Saatchi
British interior designer and author, former wife of noted British collector Charles Saatchi.

Jan Saenredam
Born 1565, Zaandam, The Netherlands, died 1607, Assendelft, The Netherlands.

Samson
According to the Book of Judges: Samson's long hair was a symbol of his devotion to God and a source of his strength. When Delilah cut his hair and removed his strength, he was captured and blinded by the Philistines. When his hair grew back, he regained his strength and tore down the temple of the Philistines with his bare hands.

Arnold Schwarzenegger
Bodybuilder, actor, and politician.

Tim Scott
Musician with the Rockcats.

The Seven Virtues
According to Christian theology, the seven cardinal virtues are a combination of the four natural virtues, first enumerated by Plato: prudence, temperance, courage, and justice; and the three theological virtues: faith, hope, and charity.

Cindy Sherman
American photographer, part of the generation of photographers who rose to prominence at the same time as Mapplethorpe.

Robert Sherman
A performance artist.

Patti Smith
American singer-songwriter and performance artist, close friend and confidante of Mapplethorpe.

The Spirit Separating Light from Darkness
Referring to Genesis I, 1–5: In the beginning God created the heavens and the earth; and the earth being without form and empty, and darkness on the face of the deep, and the Spirit of God moving gently on the face of the waters, then God said, Let light be! And there was light. And God saw the light that it was good, and God separated between the light and darkness. And God called the light, Day. And He called the darkness, Night.

Tantalus
According to some accounts, he tested the gods' omniscience by serving them the dismembered body of his own son, Pelops. For this he was condemned to suffer everlasting thirst and hunger in the Underworld, with food and water always just outside his reach.

Telephos
Son of Hercules and princess Auge, daughter of King Aleus of Tegea. According to one version of the myth, the king exposed his daughter's infant son after she became pregnant against his wishes. The story of Telephos is one of Pergamum's foundation myths, and since the Hellenistic period artists have depicted scenes of Hercules discovering and rescuing his abandoned son.

Thomas
Friend, dancer, and film actor.

Venus
The goddess of love and beauty. The most popular account has her born from the foam of the sea; she was also considered a goddess of the sea and a patroness of sailors. At the wedding of Peleus and Thetis, Paris presented Venus with the apple of dischord, setting in motion the events which led to the Trojan War.

Andy Warhol
American Pop Artist, 1928–1987.

Wrestler
Wrestling was one of the most popular sports in ancient Greek culture, adapted later by the Romans. Wrestling was a featured competition in the Olympic games and was included in the Olympic pentathlon and the pancratium, a no-holds-barred combination of wrestling and boxing. Wrestlers were frequently depicted in ancient art, and literary description of wrestling dates back to the wrestling match between Ajax and Ulysses in Homer's *Iliad*.

Full citations for abbreviations referring to catalogues raisonnés are as follows:

Bartsch: Adam Bartsch, *Le peintre-graveur*, 21 vols. (Vienna: J. V. Degen, 1803–21).

Hollstein: F. W. H. Hollstein, *Dutch and Flemish Etchings, Engravings and Woodcuts, ca. 1450–1700*, 64 vols. to date. (Amsterdam-Roosendaal-Rotterdam, 1949–).

Illus. Bartsch, vol. 3 (Comm.): Walter L. Strauss, ed., *The Illustrated Bartsch*, vol. 3 (Commentary) (New York: Abaris Books, 1982).

Strauss: Walter L. Strauss, *Hendrick Goltzius 1558–1617: The Complete Engravings and Woodcuts*, 2 vols. (New York: Abaris Books, 1977).

1. Jan Harmensz. Muller after Adriaen de Vries
Apollo Armed with His Bow for the Battle with Python, 16th century
Engraving
15 ½ x 11 ¹³⁄₁₆ inches (39.4 x 30 cm)
Kupferstichkabinett, Staatliche Museen zu Berlin, Preussischer Kulturbesitz

2. Robert Mapplethorpe
Arnold Schwarzenegger, 1976
Gelatin-silver print
Edition 5/10
13 ⅞ x 13 ¹⁵⁄₁₆ inches (35.2 x 35.4 cm)
Solomon R. Guggenheim Museum, New York, Gift, Robert Mapplethorpe Foundation
97.4389

3. After Michelangelo
Samson Conquers Two Philistines, 16th century
Bronze
Height: 14 ⅜ inches (36.5 cm)
Skulpturensammlung, Staatliche Museen zu Berlin, Preussischer Kulturbesitz

4. Robert Mapplethorpe
Derrick Cross, 1983
Gelatin-silver print
A.P. 1/2
19 ³⁄₁₆ x 15 ⅜ inches (48.7 x 39.1 cm)
Solomon R. Guggenheim Museum, New York, Gift, Robert Mapplethorpe Foundation
96.4369

5. Jacob Matham after Cornelis Cornelisz. van Haarlem
Diana in the Clouds, 16th century
Engraving
12 ¾ x 8 ¹¹⁄₁₆ inches (32.4 x 22 cm)
Bartsch 96; Hollstein XI, 227, no. 200 (only one state is known)
State Hermitage Museum, St. Petersburg
OG-30414

6. Robert Mapplethorpe
Lisa Lyon, 1981
Gelatin-silver print
Edition 8/10
19 ¹⁄₁₆ x 15 ³⁄₁₆ inches (48.4 x 38.6 cm)
Solomon R. Guggenheim Museum, New York, Gift, Robert Mapplethorpe Foundation
93.4292

7. Robert Mapplethorpe
Ken Moody, 1983
Platinum print
A.P. 1/1
26 x 22 inches (66 x 55.9 cm)
Solomon R. Guggenheim Museum, New York, Gift, Robert Mapplethorpe Foundation
95.4335

8. Robert Mapplethorpe
Female Torso, 1978
Gelatin-silver print
20 x 16 inches (50.8 x 40.6 cm)
Robert Mapplethorpe Foundation

9. Robert Mapplethorpe
Lydia Cheng, 1987
Gelatin-silver print
A.P. 2/2
23 ⅛ x 19 ¼ inches (58.7 x 48.9cm)
Solomon R. Guggenheim Museum, New York, Gift, Robert Mapplethorpe Foundation
96.4378

10. Robert Mapplethorpe
Wrestler, 1989
Gelatin-silver print
24 x 20 inches (61x 50.8 cm)
Robert Mapplethorpe Foundation

11. Hendrick Goltzius
The Farnese Hercules, from *Antique Statues in Rome*, ca. 1592, dated 1617
Engraving
15 ¹⁵⁄₁₆ x 11 ⁹⁄₁₆ inches (40.5 x 29.4 cm)
Bottom left: HGoltzius sculp. Cum privilig. / Sa. Cae. M. / Herman Adolfx / excud. Haerlemen
Bartsch 143; Strauss 312; Illus. Bartsch, vol. 3 (Comm.), 143 (second state of two)
State Hermitage Museum, St. Petersburg
OG-30918

12. Robert Mapplethorpe
Ken Moody, 1983
Gelatin-silver print
A.P. 2/2
15 ⅛ x 15 ¼ inches (38.4 x 38.7 cm)
Solomon R. Guggenheim Museum, New York, Gift, Robert Mapplethorpe Foundation
93.4298

13. Robert Mapplethorpe
Black Bust, 1988
Gelatin-silver print
24 x 20 inches (61 x 50.8 cm)
Robert Mapplethorpe Foundation

14. Jan Harmensz. Muller after Cornelis Cornelisz. van Haarlem
Fortune Showing Its Blindness by the Way It Dispenses Its Favors, 16th century
Engraving printed from two plates
21 ¼ x 37 ⁵⁄₁₆ inches (54 x 94.7 cm)
Bartsch 33; Hollstein XIV, 109, no. 71 (second state of four)
State Hermitage Museum, St. Petersburg
OG-30416

15. Robert Mapplethorpe
Ajitto, 1981
Gelatin-silver print
A.P. 1/3
17 ¹⁵⁄₁₆ x 14 inches (45.6 x 35.6 cm)
Solomon R. Guggenheim Museum, New York, Gift, Robert Mapplethorpe Foundation
95.4322

16. Robert Mapplethorpe
Ajitto, 1981
Gelatin-silver print
A.P. 15/15
20 x 16 inches (50.8 x 40.6 cm)
Solomon R. Guggenheim Museum, New York,
Gift, Robert Mapplethorpe Foundation
95.4323

17. Robert Mapplethorpe
Ajitto, 1981
Gelatin-silver print
A.P. 9/15
17 $^{15}/_{16}$ x 14 inches (45.6 x 35.6 cm)
Solomon R. Guggenheim Museum, New York,
Gift, Robert Mapplethorpe Foundation
95.4324

18. Robert Mapplethorpe
Ajitto, 1981
Gelatin-silver print
A.P. 2/3
17 $^{7}/_{8}$ x 14 inches (45.4 x 35.6 cm)
Solomon R. Guggenheim Museum, New York,
Gift, Robert Mapplethorpe Foundation
95.4326

19. Jan Saenredam after Hendrick Goltzius
Venus, 16th century
Engraving
9 $^{3}/_{16}$ x 6 $^{15}/_{16}$ inches (23.4 x 17.7 cm)
Below center: HG.
Bartsch 66; Hollstein XXIII, 51, no. 67; Strauss 337
(as the work of Goltzius; only one state is known)
State Hermitage Museum, St. Petersburg
OG-31121

20. Robert Mapplethorpe
Lisa Lyon, 1981
Gelatin-silver print
Edition 10/10
20 x 16 inches (50.8 x 40.6 cm)
Solomon R. Guggenheim Museum, New York,
Gift, Robert Mapplethorpe Foundation
98.4440

21. Robert Mapplethorpe
Derrick Cross, 1982
Gelatin-silver print
A.P. 1/2
7 $^{5}/_{8}$ x 19 $^{1}/_{4}$ inches (19.4 x 48.9 cm)
Solomon R. Guggenheim Museum, New York,
Gift, Robert Mapplethorpe Foundation
96.4368

22. Robert Mapplethorpe
Derrick Cross, 1983
Gelatin-silver print
16 x 20 inches (40.6 x 50.8 cm)
Robert Mapplethorpe Foundation

23. Robert Mapplethorpe
Lisa Lyon, 1982
Gelatin-silver print
20 x 16 inches (50.8 x 40.6 cm)
Robert Mapplethorpe Foundation

24. Robert Mapplethorpe
Derrick Cross, 1983
Gelatin-silver print
20 x 16 inches (50.8 x 40.6 cm)
Robert Mapplethorpe Foundation

25. Robert Mapplethorpe
Donald Cann, 1982
Gelatin-silver print
A.P. 2/2
20 x 16 inches (50.8 x 40.6 cm)
Solomon R. Guggenheim Museum, New York,
Gift, Robert Mapplethorpe Foundation
93.4295

26. Robert Mapplethorpe
Patti Smith, 1976
Gelatin-silver print
A.P. 1/2
20 x 16 inches (50.8 x 40.6 cm)
Solomon R. Guggenheim Museum, New York,
Gift, Robert Mapplethorpe Foundation
93.4278

27. Barthélémy Prieur
Young Woman Cutting Her Toenails, ca .1565
Bronze
Height: 3 $^{5}/_{16}$ inches (8.4 cm)
Skulpturensammlung, Staatliche Museen zu Berlin,
Preussischer Kulturbesitz

28. Robert Mapplethorpe
Alan Lyne, 1979
Gelatin-silver print
A.P. 1/2
20 x 16 inches (50.8 x 40.6 cm)
Solomon R. Guggenheim Museum, New York,
Gift, Robert Mapplethorpe Foundation
98.4433

29. Robert Mapplethorpe
Bruce, 1980
Gelatin-silver print
A.P. 2/3
20 x 16 inches (50.8 x 40.6 cm)
Solomon R. Guggenheim Museum, New York,
Gift, Robert Mapplethorpe Foundation
98.4437

30. Jan Harmensz. Muller after Cornelis Cornelisz.
van Haarlem
Cain Killing Abel, 16th century
Engraving
13 $^{3}/_{16}$ x 16 $^{5}/_{16}$ inches (33.5 x 41.4 cm)
Bartsch 29; Hollstein XIV, 105, no. 8 (only one
state is known)
State Hermitage Museum, St. Petersburg
OG-93724

31. Robert Mapplethorpe
Dominick and Elliot, 1979
Gelatin-silver print
A.P. 1/2
14 $^{15}/_{16}$ x 14 inches (37.9 x 35.6 cm)
Solomon R. Guggenheim Museum, New York,
Gift, Robert Mapplethorpe Foundation
97.4395

32. Robert Mapplethorpe
Jim, Sausalito, 1977
Gelatin-silver print
A.P. 1/1
20 x 16 inches (50.8 x 40.6 cm)
Solomon R. Guggenheim Museum, New York,
Gift, Robert Mapplethorpe Foundation
98.4427

33. Robert Mapplerthorpe
Brian Ridley and Lyle Heeter, 1979
Gelatin-silver print
Edition 1/10
20 x 16 inches (50.8 x 40.6 cm)
Solomon R. Guggenheim Museum, New York,
Gift, Robert Mapplethorpe Foundation
93.4287

34. Jan Saenredam after Hendrick Goltzius
Ceres, 16th century
Engraving
9 $^{3}/_{16}$ x 6 $^{15}/_{16}$ inches (23.4 x 17.7 cm)
Bartsch 67; Hollstein XXIII, 51, no. 68; Strauss 338
(as the work of Goltzius; only one state is known)
State Hermitage Museum, St. Petersburg
OG-31122

35. Jan Saenredam after Hendrick Goltzius
Bacchus, 16th century
Engraving
9 $^{3}/_{16}$ x 6 $^{15}/_{16}$ inches (23.4 x 17.7 cm)
Above center: HG ; below center: Cornelio Cornelij
Harlemaeo / Pictori egregio Xeniolj loco / D.D. /
HGoltzius
Bartsch 65; Hollstein XXIII, 51, no. 66; Strauss 336
(as the work of Goltzius; first state of two)
State Hermitage Museum, St. Petersburg
OG-31120

36. Robert Mapplethorpe
Jamie, 1974
Unique gelatin-silver print with painted frame
20 x 16 inches (50.8 x 40.6 cm)
Solomon R. Guggenheim Museum, New York,
Gift, Robert Mapplethorpe Foundation
98.4423

37. Robert Mapplethorpe
Robert Sherman, 1979
Gelatin-silver print
A.P. 1/2
13 $^{7}/_{8}$ x 13 $^{13}/_{16}$ inches (35.2 x 35.1 cm)
Solomon R. Guggenheim Museum, New York,
Gift, Robert Mapplethorpe Foundation
95.4314

38. Robert Mapplethorpe
Lydia Cheng, 1985
Gelatin-silver print
20 x 16 inches (50.8 x 40.6 cm)
Robert Mapplethorpe Foundation

39. Robert Mapplethorpe
Lisa Lyon, 1982
Gelatin-silver print
20 x 16 inches (50.8 x 40.6 cm)
Robert Mapplethorpe Foundation

40. Hendrick Goltzius after Cornelis Cornelisz. van Haarlem
Ixion, from *The Four Disgracers*, late 16th century, first state dated 1588
Engraving
Diameter: 13 ¹/₁₆ inches (33.1 cm)
Bartsch 261; Strauss 260; Illus. Bartsch, vol. 3 (Comm.), 261 (second state of three)
State Hermitage Museum, St. Petersburg
OG-30420

41. Hendrick Goltzius after Cornelis Cornelisz. van Haarlem
Phaeton, from *The Four Disgracers*, late 16th century, first state dated 1588
Engraving
Diameter: 12 ¹⁵/₁₆ inches (32.9 cm)
Bartsch 260; Strauss 259; Illus. Bartsch, vol. 3 (Comm.), 260 (second state of three)
State Hermitage Museum, St. Petersburg
OG-30417

42. Hendrick Goltzius after Cornelis Cornelisz. van Haarlem
Icarus, from *The Four Disgracers*, late 16th century
Engraving
Diameter: 13 ¹/₁₆ inches (33.1 cm)
Bartsch 259; Strauss 258; Illus. Bartsch, vol. 3 (Comm.), 259 (only one state is known)
State Hermitage Museum, St. Petersburg
OG-30418

43. Hendrick Goltzius after Cornelis Cornelisz. van Haarlem
Tantalus, from *The Four Disgracers*, late 16th century, first state dated 1588
Engraving
Diameter: 13 ¹/₁₆ inches (33.2 cm)
Bartsch 258; Strauss 257; Illus. Bartsch, vol. 3 (Comm.), 258 (second state of three)
State Hermitage Museum, St. Petersburg
OG-30419

44. Robert Mapplethorpe
Thomas, 1987
Gelatin-silver print
A.P. 1/2
18 ⅞ x 18 ⅞ inches (47.9 x 47.9 cm)
Solomon R. Guggenheim Museum, New York, Gift, Robert Mapplethorpe Foundation
93.4304

45. Robert Mapplethorpe
Thomas, 1987
Gelatin-silver print
20 x 24 inches (50.8 x 61 cm)
Robert Mapplethorpe Foundation

46. Robert Mapplethorpe
Thomas, 1987
Gelatin-silver print
24 x 20 inches (61 x 50.8 cm)
Robert Mapplethorpe Foundation

47. Robert Mapplethorpe
Thomas, 1987
Gelatin-silver print
24 x 20 inches (61 x 50.8 cm)
Robert Mapplethorpe Foundation

48. Jan Harmensz. Muller after waxworks by Adriaen de Vries
A Roman Abducting a Sabine Woman, from *The Rape of the Sabine Women*, 16th century
Engraving
17 ¹¹/₁₆ x 11 inches (45 x 27.9 cm)
Below left: Adrianus de vries Hagien. / inuentor ; below right: Joah. Muller. Sculpsit. Dancker Danckertz. Exc.
Bartsch 79; Hollstein XIV, 108, no. 67 (fourth state of seven)
State Hermitage Museum, St. Petersburg
OG-153449

49. Robert Mapplethorpe
Thomas and Dovanna, 1986
Gelatin-silver print
A.P. 1/2
23 ⅛ x 19 ¼ inches (58.7 x 48.9 cm)
Solomon R. Guggenheim Museum, New York, Gift, Robert Mapplethorpe Foundation
93.4303

50. Hendrick Goltzius
Hercules and Telephos, from *Antique Statues in Rome*, ca. 1592, dated 1617
Engraving
15 ¹³/₁₆ x 11 ½ inches (40.1 x 29.1 cm)
Bottom left: HGoltzius sculp. Cum privil. Sa. Cae. M. ; bottom right: Herman Adolfz / excud. Haerlemen
Bartsch 144; Strauss 313; Illus. Bartsch, vol. 3 (Comm.), 144 (second state of two)
State Hermitage Museum, St. Petersburg
OG-30919

51. Hendrick Goltzius
The Apollo Belvedere, from *Antique Statues in Rome*, ca. 1591, dated 1617
Engraving
15 ¹³/₁₆ x 11 ½ inches (40.2 x 29.2cm)
Bottom left: HGsculp. ; bottom right: Cum privil. Sa. Cae. M. / Herman Adolfz excud. Haerlemens
Bartsch 145; Strauss 314; Illus. Bartsch, vol. 3 (Comm.), 145 (second state of two)
State Hermitage Museum, St. Petersburg
OG-30920

52. Robert Mapplethorpe
Thomas and Dovanna, 1986
Gelatin-silver print
24 x 20 inches (61 x 50.8 cm)
Robert Mapplethorpe Foundation

53. Jan Harmensz. Muller after waxworks by Adriaen de Vries
A Roman Abducting a Sabine Woman, from *The Rape of the Sabine Women*, 16th century
Engraving
17 ¹¹/₁₆ x 11 inches (45 x 27.9 cm)
Bottom right: HMuller. Ex. ; below left: Adrianus de Vries Hagien. / inuentor ; below right: Joan.Muller. Sculpsit.
Bartsch 78; Hollstein XIV, 108, no. 66 (sixth state of seven)
State Hermitage Museum, St. Petersburg
OG-153448

54. Workshop of Benvenuto Cellini
Perseus, late 16th century
Bronze
Height: 21 ¼ inches (54 cm)
State Hermitage Museum, St. Petersburg

55. Robert Mapplethorpe
Lisa Lyon, 1982
Gelatin-silver print
A.P. 2/2
19 ⅛ x 15 ¼ inches (48.6 x 38.7 cm)
Solomon R. Guggenheim Museum, New York, Gift, Robert Mapplethorpe Foundation
95.4329

56. Hendrick Goltzius
Persephone (Flora), ca. 1594
Chiaroscuro woodcut printed from three blocks: black, sepia, and ochre
13 ¹¹/₁₆ x 10 ⁵/₁₆ inches (34.7 x 26.2 cm)
Center left: HG.
Bartsch 236; Strauss 424; Illus. Bartsch, vol. 3 (Comm.), 236 (only one state is known)
State Hermitage Museum, St. Petersburg
OG-1271419

57. Hendrick Goltzius
Persephone (Flora), ca. 1594
Chiaroscuro woodcut printed from three blocks: black, hazel, and brown
13 ¹¹/₁₆ x 10 ¼ inches (34.5 x 26 cm)
Center left: HG
Bartsch 236; Strauss 424; Illus. Bartsch, vol. 3 (Comm.), 236 (only one state is known)
State Hermitage Museum, St. Petersburg
OG-133487

58. Hendrick Goltzius
Venus Marina, ca. 1594
Chiaroscuro woodcut printed from two tone blocks
13 ¹¹/₁₆ x 10 ¼ inches (34.5 x 26 cm)
Bottom right: HG.fe.
Bartsch 235; Strauss 422; Illus. Bartsch, vol. 3 (Comm.), 235 (second state of two)
State Hermitage Museum, St. Petersburg
OG-271425

59. Robert Mapplethorpe
Orchid, 1986
Gelatin-silver print
A.P. 1/2
24 x 20 inches (61x 50.8 cm)
Solomon R. Guggenheim Museum, New York, Gift, Robert Mapplethorpe Foundation
98.4455

60. Robert Mapplethorpe
Calla Lily, 1986
Oversized gelatin-silver print
Edition 1/1
36 ½ x 36 ½ inches (92.7 x 92.7 cm)
Solomon R. Guggenheim Museum, New York, Gift, Robert Mapplethorpe Foundation
97.4416

61. Hendrick Goltzius
Nox, ca. 1594
Chiaroscuro woodcut printed from three blocks:
black, hazel, and brown
13 11/16 x 10 1/4 inches (34.5 x 26 cm)
Bottom center: HG.f.
Bartsch 237; Strauss 420; Illus. Bartsch, vol. 3
(Comm.), 237 (second state of two)
State Hermitage Museum, St. Petersburg
OG-271423

62. Hendrick Goltzius
The Magician (The Cave of Eternity), ca. 1594
Chiaroscuro woodcut printed from two blocks:
black and chlorine
13 3/4 x 10 1/4 inches (35 x 26.1 cm)
Below center: HG.f.
Bartsch 238; Strauss 418; Illus. Bartsch, vol. 3
(Comm.), 238 (second state of two)
State Hermitage Museum, St. Petersburg
OG-133488

63. Robert Mapplethorpe
Poppy, 1988
Gelatin-silver print
A.P. 1/2
19 3/16 x 19 1/4 inches (48.7 x 48.9 cm)
Solomon R. Guggenheim Museum, New York,
Gift, Robert Mapplethorpe Foundation
98.4457

64. Robert Mapplethorpe
Orchid, 1987
Gravure
A.P. 1/2
32 1/2 x 32 1/4 inches (82.6 x 81.9 cm)
Solomon R. Guggenheim Museum, New York,
Gift, Robert Mapplethorpe Foundation
96.4377

65. Jan Harmensz. Muller after Bartholomäus
Spranger
Venus and Mercury, 16th century
Engraving
14 5/8 x 10 5/8 inches (37.1 x 27 cm)
Bartsch 68; Hollstein XIV, 108, no. 63 (only one
state is known)
State Hermitage Museum, St. Petersburg
OG-93728

66. Jacob Matham after Hendrick Goltzius
The Alliance of Athena and Mercury, 16th century
Engraving
11 5/16 x 8 1/8 inches (28.8 x 20.7 cm)
Bottom center: HG.excud.
Bartsch 281; Hollstein XI, 228, no. 240 (first
state of three)
State Hermitage Museum, St. Petersburg
OG-31076

67. Jan Saenredam after Hendrick Goltzius
Venus, Bacchus, and Ceres, 16th century
Engraving
16 7/16 x 12 7/16 inches (41.8 x 31.6 cm)
Bartsch 69; Hollstein XXIII, 59, no. 76 (first
state of two)
State Hermitage Museum, St. Petersburg
OG-153309

68. Jacob Matham after Hendrick Goltzius
The Five Senses, 16th century
Engraving
11 5/16 x 8 1/8 inches (28.8 x 20.7 cm)
Bottom right: HG. Jnuent.
Bartsch 279; Hollstein XI, 228, no. 238 (third
state of three)
State Hermitage Museum, St. Petersburg
OG-31074

69. Jacob Matham after Hendrick Goltzius
The Seven Virtues, 16th century
Engraving
11 5/16 x 8 1/8 inches (28.8 x 20.7 cm)
Bottom center: HG.Jnuent.
Bartsch 282; Hollstein XI, 228, no. 241 (third
state of three)
State Hermitage Museum, St. Petersburg
OG-31077

70. Jan Saenredam after Hendrick Goltzius
*Drinkers Asking Bacchus for the Continuation
of His Gifts*, 16th century
Engraving
16 9/16 x 12 3/8 inches (42.1 x 31.5 cm)
Bartsch 72; Hollstein XXIII, 55, no. 71 (first
state of two)
State Hermitage Museum, St. Petersburg
OG-91126

71. Jacob Matham, after Hendrick Goltzius
The Four Elements, 1588
Engraving
11 5/16 x 8 1/8 inches (28.8 x 20.7 cm)
Bottom right: HGoltzius jnue. / KCVischer excud.
Ao1588
Bartsch 278; Hollstein XI, 228, no. 237 (second
state of three)
State Hermitage Museum, St. Petersburg
OG-31073

72. Robert Mapplethorpe
Tim Scott, 1980
Oversized gelatin-silver print
Edition 1/1
30 x 30 inches (76.2 x 76.2 cm)
Solomon R. Guggenheim Museum, New York,
Gift, Robert Mapplethorpe Foundation
97.4397

73. Robert Mapplethorpe
Ada, 1982
Gelatin-silver print
A.P. 1/2
19 1/4 x 15 1/4 inches (48.9 x 38.7 cm)
Solomon R. Guggenheim Museum, New York,
Gift, Robert Mapplethorpe Foundation
97.4406

74. Robert Mapplethorpe
Francesco Clemente, 1982
Gelatin-silver print
A.P. 1/2
15 1/4 x 15 1/4 inches (38.7 x 38.7 cm)
Solomon R. Guggenheim Museum, New York,
Gift, Robert Mapplethorpe Foundation
96.4363

75. Robert Mapplethorpe
Lisa Lyon, 1982
Gelatin-silver print
A.P. 2/2
20 x 16 inches (50.8 x 40.6 cm)
Solomon R. Guggenheim Museum, New York,
Gift, Robert Mapplethorpe Foundation
93.4294

76. Robert Mapplethorpe
Phillip Prioleau, 1982
Gelatin-silver print
A.P. 8/10
15 3/16 x 15 3/8 inches (38.6 x 39.1 cm)
Solomon R. Guggenheim Museum, New York,
Gift, Robert Mapplethorpe Foundation
96.4362

77. Robert Mapplethorpe
Embrace, 1982
Gelatin-silver print
Edition 7/10
20 x 16 inches (50.8 x 40.6 cm)
Solomon R. Guggenheim Museum, New York,
Gift, Robert Mapplethorpe Foundation
98.4442

78. Jacob Matham after Hendrick Goltzius
The Fates, 16th century
Engraving
11 5/16 x 8 1/8 inches (28.8 x 20.7 cm)
Bottom left: HG.Jnuent.
Bartsch 284; Hollstein XI, 228, no. 243 (third
state of three)
State Hermitage Museum, St. Petersburg
OG-31078

79. Robert Mapplethorpe
Lydia Cheng, 1987
Gelatin-silver print
24 x 20 inches (61x 50.8 cm)
Robert Mapplethorpe Foundation

80. Robert Mapplethorpe
Doris Saatchi, 1983
Platinum print
A.P. 1/1
19 1/4 x 19 1/2 inches (48.9 x 49.5 cm)
Solomon R. Guggenheim Museum, New York,
Gift, Robert Mapplethorpe Foundation
98.4446

81. Robert Mapplethorpe
Ken Moody and Robert Sherman, 1984
Platinum print
A.P. 1/1
19 3/8 x 19 11/16 inches (49.2 x 50 cm)
Solomon R. Guggenheim Museum, New York,
Gift, Robert Mapplethorpe Foundation
93.4299

82. Jan Harmensz. Muller after Hendrick Goltzius
The Spirit of God on the Face of the Waters,
from *Creation of the World*, 16th century
Engraving
Diameter: 10 ⅜ inches (26.3 cm)
Bottom left: HGoltzius Jnuent. Et excud. / Iohan
Muller sculptor
Bartsch 35; Hollstein XIV, 105, no. 1 (second state
of two)
State Hermitage Museum, St. Petersburg
OG-31086

83. Jan Harmensz. Muller after Hendrick Goltzius
The Spirit Separating Light from Darkness,
from *Creation of the World*, 16th century
Engraving
Diameter: 10 ⅜ inches (26.3 cm)
Bottom center: HG.Excud.
Bartsch 36; Hollstein XIV, 105, no. 2 (second
state of two)
State Hermitage Museum, St. Petersburg
OG-31087

84. Jan Harmensz. Muller after Hendrick Goltzius
*The Creation of the Firmament and the Separation
of the Waters Above and Below*, from *Creation of
the World*, 16th century
Engraving
Diameter: 10 ⅜ inches (26.3 cm)
Bottom center: HG.Excud.
Bartsch 37; Hollstein XIV, 105, no. 3 (second
state of two)
State Hermitage Museum, St. Petersburg
OG-31088

85. Jan Harmensz. Muller after Hendrick Goltzius
The Creation of Dry Land and the Seas, from
Creation of the World, 16th century
Engraving
Diameter: 10 ⅜ inches (26.3 cm)
Bottom left: HG.Excud.
Bartsch 38; Hollstein XIV, 105, no. 4 (second
state of two)
State Hermitage Museum, St. Petersburg
OG-31089

86. Jan Harmensz. Muller after Hendrick Goltzius
The Creation of the Sun and the Moon, from
Creation of the World, 16th century
Engraving
Diameter: 10 ⅜ inches (26.3 cm)
Bottom left: HG.Excud.
Bartsch 38; Hollstein XIV, 105, no. 5 (second
state of two)
State Hermitage Museum, St. Petersburg
OG-31090

87. Jan Harmensz. Muller after Hendrick Goltzius,
The Creation of Fishes, Birds, and Beasts, from
Creation of the World, 16th century
Engraving
Diameter: 10 ⅜ inches (26.3 cm)
Bottom left: HG.Excud.
Bartsch 40; Hollstein XIV, 105, no. 6 (second
state of two)
State Hermitage Museum, St. Petersburg
OG-31091

88. Jan Harmensz. Muller after Hendrick Goltzius
The Creation of Man and Woman, from *Creation
of the World*, 16th century
Engraving
Diameter: 10 ⅜ inches (26.3 cm)
Bottom left: HG. Excud.
Bartsch 41; Hollstein XIV, 105, no. 7 (second state
of two)
State Hermitage Museum, St. Petersburg
OG-31092

89. Robert Mapplethorpe
Andy Warhol, 1986
Gelatin-silver print
A.P. 2/2
19 ¼ x 19 ¼ inches (48.9 x 48.9 cm)
Solomon R. Guggenheim Museum, New York,
Gift, Robert Mapplethorpe Foundation
95.4339

90. Robert Mapplethorpe
Cindy Sherman, 1983
Gelatin-silver print
A.P. 1/2
19 ¼ x 15 ¼ inches (48.9 x 38.7 cm)
Solomon R. Guggenheim Museum, New York,
Gift, Robert Mapplethorpe Foundation
95.4333

91. Hendrick Goltzius
The Wedding of Cupid and Psyche, 1587
Engraving printed from two plates
17 x 33 ⁷⁄₁₆ inches (43.2 x 85 cm)
Bartsch 277; Strauss 255; Illus. Bartsch, vol. 3
(Comm.), 277 (first state of four)
State Hermitage Museum, St. Petersburg
OG-393126

92. Robert Mapplethorpe
Ken and Tyler, 1985
Platinum print
Edition 2/3
23 ¼ x 19 ⁹⁄₁₆ inches (59.1 x 49.7 cm)
Solomon R. Guggenheim Museum, New York,
Gift, Robert Mapplethorpe Foundation
96.4373

93. Robert Mapplethorpe
Calla Lily, 1988
Platinum print
A.P. 1/1
18 ⅞ x 19 ⅛ inches (47.9 x 48.6 cm)
Solomon R. Guggenheim Museum, New York,
Gift, Robert Mapplethorpe Foundation
96.4380

94. Robert Mapplethorpe
Carlton, 1987
Gelatin-silver print
24 x 20 inches (61 x 50.8 cm)
Robert Mapplethorpe Foundation

95. Robert Mapplethorpe
Thomas, 1986
Gelatin-silver print
A.P. 2/2
22 ¹¹⁄₁₆ x 18 ¹³⁄₁₆ inches (57.6 x 47.9 cm)
Solomon R. Guggenheim Museum, New York,
Gift, Robert Mapplethorpe Foundation
97.4414

96. Robert Mapplethorpe
Lydia Cheng, 1985
Gelatin-silver print
20 x 16 inches (50.8 x 40.6 cm)
Robert Mapplethorpe Foundation

**97. Jan Harmensz. Muller after Cornelis Cornelisz.
van Haarlem**
The Fates, 16th century
Engraving
11 ¼ x 9 ¹³⁄₁₆ inches (28.6 x 25 cm)
Bottom right: C.Cornelij Harmen inue. / Harman
Mullerus excud: Amsterodamj ; below right: Cornelus
danckerts Excud.
Bartsch 31; Hollstein XIV, 109, no. 69 (third state
of three)
State Hermitage Museum, St. Petersburg
OG-30415

98. Jacob Matham after Hendrick Goltzius
The Alliance of Venus, Bacchus, and Ceres,
16th century
Engraving
11 ⁵⁄₁₆ x 8 ⅛ inches (28.8 x 20.7 cm)
Bottom center: HG/Jnuent.
Bartsch 280; Hollstein XI, 228, no. 239 (third state
of three)
State Hermitage Museum, St. Petersburg
OG-31075

99. Jacob Matham after Hendrick Goltzius
The Graces, 16th century
Engraving
11 ⁵⁄₁₆ x 8 ⅛ inches (28.8 x 20.7 cm)
Bottom left: HG/Jnuent.
Bartsch 285; Hollstein XI, 228, no. 244 (first state
of three)
State Hermitage Museum, St. Petersburg
OG-31079

100. Robert Mapplethorpe
Ken, Lydia, and Tyler, 1985
Gelatin-silver print
16 x 20 inches (40.6 x 50.8 cm)
Robert Mapplethorpe Foundation

**101. Jan Harmensz. Muller after the bronze statue by
Adriaen de Vries**
*Mercury Abducting Psyche: Mercury Seen in Profile
from the Right*, from *The Abduction of Psyche*,
16th century
Engraving
21 ⅞ x 10 ¹⁄₁₆ inches (55.6 x 25.6 cm)
Bartsch 84; Hollstein XIV, 108, no. 58 (second state
of two)
State Hermitage Museum, St. Petersburg
OG-393129

102. Jan Harmensz. Muller after the bronze statue by
Adriaen de Vries
Mercury Abducting Psyche: Mercury Seen in Full Face,
from *The Abduction of Psyche*, 16th century
Engraving
21 ⅞ x 10 ¹/₁₆ inches (55.6 x 25.6 cm)
Bartsch 83; Hollstein XIV, 108, no. 57 (second state
of two)
State Hermitage Museum, St. Petersburg
OG-393130

103. Jan Harmensz. Muller after the bronze statue by
Adriaen de Vries
*Mercury Abducting Psyche; Mercury Seen in Profile
from the Left*, from *The Abduction of Psyche*,
16th century
Engraving
21 ⅞ x 10 ¹¹/₁₆ inches (55.6 x 25.6 cm)
Kupferstichkabinett, Staatliche Museen zu Berlin,
Preussischer Kulturbesitz

104. Workshop of Giovanni Bologna
Mercury, late 16th century
Bronze
Height: 20 ¹¹/₁₆ inches (52.5 cm)
State Hermitage Museum, St. Petersburg

105. Jan Harmensz. Muller after a bas-relief by
Bartholomäus Spranger
Eros Discovering Psyche in His Bed, 16th century
Engraving
14 ¼ x 22 ⅞ inches (36.2 x 57 cm)
Bartsch 70; Hollstein XIV, 107, no. 51 (second state
of two)
State Hermitage Museum, St. Petersburg
OG-148971

106. Robert Mapplethorpe
Lucinda's Hand, 1985
Gelatin-silver print
Edition 6/10
20 x 16 inches (50.8 x 40.6 cm)
Solomon R. Guggenheim Museum, New York,
Gift, Robert Mapplethorpe Foundation
93.4301

107. Anonymous
Mars, late 19th century?
Bronze
Height: 40 inches (101.6 cm)
Robert Mapplethorpe Foundation

108. Robert Mapplethorpe
Ken Moody, 1984
Unique color print with black mat and frame
23 ⅞ x 19 ⅜ inches (60.6 x 49.2 cm)
Solomon R. Guggenheim Museum, New York,
Gift, Robert Mapplethorpe Foundation
98.4447

109. Robert Mapplethorpe
Italian Devil, 1988
Platinum print
A.P. 1/1
19 ⅛ x 19 inches (48.6 x 48.3 cm)
Solomon R. Guggenheim Museum, New York,
Gift, Robert Mapplethorpe Foundation
98.4459

110. Robert Mapplethorpe
Mercury, 1986
Gelatin-silver print
A.P. 2/2
23 ¼ x 19 ⅛ inches (59.1 x 48.6 cm)
Solomon R. Guggenheim Museum, New York,
Gift, Robert Mapplethorpe Foundation
97.4417

111. Anonymous
Ermes, late 19th century?
Marble
Height: 21 inches (53.3 cm)
Robert Mapplethorpe Foundation

112. Robert Mapplethorpe
Apollo, 1988
Gelatin-silver print
A.P. 1/2
19 ¼ x 19 ⁵/₁₆ inches (48.9 x 49.1 cm)
Solomon R. Guggenheim Museum, New York,
Gift, Robert Mapplethorpe Foundation
95.4342

113. Robert Mapplethorpe
Donald Cann, 1982
Gelatin-silver print
16 x 20 inches (40.6 x 50.8 cm)
Robert Mapplethorpe Foundation

114. Jacob Matham after Cornelis Cornelisz. van
Haarlem
Apollo in the Clouds, 16th century
Engraving
13 ⅜ x 8 ⅞ inches (34 x 22.5 cm)
Bartsch 95; Hollstein XI, 227, no. 182 (first state
of two, before the address of Gerard van Keulen)
State Hermitage Museum, St. Petersburg
OG-30413

115. Robert Mapplethorpe
Antinous, 1987
Gelatin-silver print
Edition 5/10
24 x 20 inches (61x 50.8 cm)
Robert Mapplethorpe Foundation

116. Jan Saenredam after Abraham Bloemaert
Allegory of Vanity, 16th century
Engraving
14 ⅞ x 11 ¹¹/₁₆ inches (37.8 x 29.7 cm)
Kupferstichkabinett, Staatliche Museen zu Berlin,
Preussischer Kulturbesitz

117. Robert Mapplethorpe
Skull, 1988
Gelatin-silver print
A.P. 1/2
19 ³/₁₆ x 19 ⁵/₁₆ inches (48.7 x 49.1 cm)
Solomon R. Guggenheim Museum, New York,
Gift, Robert Mapplethorpe Foundation
96.4381

118. Robert Mapplethorpe
Sleeping Cupid, 1989
Gelatin-silver print
Edition 10/10
19 x 19 ¹/₁₆ inches (48.3 x 48.4 cm)
Solomon R. Guggenheim Museum, New York,
Gift, Robert Mapplethorpe Foundation
97.4421

119. Robert Mapplethorpe
Self-Portrait, 1988
Platinum print
A.P. 1/1
23 ⅛ x 19 ¹/₁₆ inches (58.7 x 48.4 cm)
Solomon R. Guggenheim Museum, New York,
Gift, Robert Mapplethorpe Foundation
93.4305

120. Robert Mapplethorpe
Self-Portrait, 1988
Gelatin-silver print
24 x 20 inches (61x 50.8 cm)
Robert Mapplethorpe Foundation

SELECTED BIBLIOGRAPHY

Mannerism

Exhibition Catalogues

Ackley, Clifford S. *Printmaking in the Age of Rembrandt*. Boston: Museum of Fine Arts, 1981.

Baarsen, R., W. Kloek, G. Luitjen, M. Schapelhouman, and A. van Suchtelen. *Dawn of the Golden Age. Northern Netherlandish Art, 1580–1620*. Amsterdam: Rijksmuseum, 1993.

Bialler, Nancy. *Chiaroscuro Woodcuts, Hendrick Goltzius (1588–1617) and His Time*. Amsterdam: Rijksmuseum, Rijksprentenkabinet; Cleveland: Cleveland Museum of Art, 1992.

Davis, Bruce. *Mannerist Prints. International Style in the Sixteenth Century*, Los Angeles, Calif.: Los Angeles County Museum of Art, 1988.

Hand, John Oliver, et al. *The Age of Brueghel: Netherlandish Drawings of the Sixteenth Century*. Washington, D.C.: National Gallery of Art, 1986.

Haskell, Francis, and Nicholas Penny. *Taste and the Antique. The Lure of Classical Sculpture 1500–1900*. New Haven, Conn.: Yale University Press, 1981.

Hasselt, Carlos van. *Clairs-obscurs. Gravures sur bois imprimées en couleurs de 1500 à 1800 provenant de collections hollandaises*. Paris: Institut Néerlandais, 1965.

Korazija, Eva. *Eros und Gewalt: Hendrick Goltzius und der niederländische Manierismus*. Zurich: Graphische Sammlung der Eidgenössischen Technischen Hochschule Zurich, 1982.

Leeflang, Huigen, and Ger Luijten. *Hendrick Goltzius (1558–1617) Drawings, Prints and Paintings*. Amsterdam: Rijksmuseum; New York: Metropolitan Museum of Art; Toledo, Ohio: Toledo Museum of Art, 2003.

Mielke, Hans. *Manierismus in Holland um 1600. Kupferstiche, Holzschnitte und Zeichnungen aus dem Berliner Kupferstichkabinett*. Berlin: Staatliche Museen Preussischer Kulturbesitz, 1979.

Rodari, Florian. *Dieux et héros*. Geneva: Musée d'art et d'histoire, 1978.

Books and Articles

Bartsch, Adam. *Le Peintre-graveur*. 21 vols. Vienna: J. V. Degen, 1803–21.

Bryan, Michael. *Bryan's Dictionary of Painters and Engravers*. 4th ed. 5 vols. London: G. Bell and Sons, 1921.

Hirschmann, Otto. *Meister der Graphik, Band VII: Hendrick Goltzius*. Leipzig: Klinkhardt und Biermann, 1919.

———. *Verzeichnis des graphischen Werks von Hendrick Goltzius*. Leipzig: Klinkhardt und Biermann, 1921.

Hollstein, F. W. H. *Dutch and Flemish Etchings, Engravings, and Woodcuts, ca. 1450–1700*. 64 vols. to date. Amsterdam-Roosendaal-Rotterdam, 1949–.

Reznicek, E. K. J. "Jan Harmensz. Muller als Tekenaar." *Nederlands Kunsthistorisch Jaarboek 7* (1956), pp. 65–120.

———. "Jan Harmensz. Muller as Draughtsman: Addenda." *Master Drawings* 18 (1980), pp.115–33.

———. *Die Zeichnungen von Hendrick Goltzius*. 2 vols. Utrecht: Haentjens Dekker und Gumbert, 1961.

Riggs, Timothy A. *Hieronymus Cock, Printmaker and Publisher*. New York: Garland Publishing, 1977.

Schéle, Sune. *Cornelis Bos: A Study of the Origins of the Netherlandish Grotesque*. Stockholm: Almquist & Wiskell, 1965.

Strauss, Walter L. *Chiaroscuro: The Clair-Obscur Woodcuts by the German and Netherlandish Masters of the XVIth and XVIIth Centuries*. Greenwich, Conn.: New York Graphic Society, 1973.

———. *Hendrick Goltzius 1558–1617: The Complete Engravings and Woodcuts*. 2 vols. New York: Abaris Books, 1977.

Tervarent, Guy de. *Attributs et symboles dans l'art profane 1450–1600*. Geneva: Librairie E. Droz, 1958.

Thiel, Pieter J. J. van. "Cornelis Cornelisz. van Haarlem as a Draughtsman." *Master Drawings* 3 (1965), pp. 123–54.

Veldman, Ilja M. *Maarten van Heemskerck and Dutch Humanism in the Sixteenth Century*. Maarssen: Gary Schwartz, 1977.

Wurzbach, Alfred von. *Niederländisches Künstler-Lexikon*. 3 vols. Vienna: Verlag von Halm und Goldmann, 1906–11.

Robert Mapplethorpe

Books by the artist

The Agency. New York: Hardison Fine Arts Gallery, 1983.

Lady: Lisa Lyon. Text by Bruce Chatwin, foreword by Sam Wagstaff. New York: Viking Press, 1983.

Certain People: A Book of Portraits. Text by Susan Sontag. Los Angeles: Twelvetree Press, 1985.

Black Book. New York: St. Martin's Press, 1986.

Robert Mapplethorpe. Introduction by Ikuroh Takano, interview by David Hershkovits. Tokyo: Parco Co., 1987.

Some Women. Introduction by Joan Didion. Boston: Bulfinch Press; Little, Brown and Company, 1989.

Flowers. Introduction by Patti Smith. Boston: Bullfinch Press; Little, Brown and Company, 1990.

Exhibition Catalogues

Amaya, Mario. *Robert Mapplethorpe Photographs.* Norfolk, Va.: Chrysler Museum, 1978.

Augur, Julie. *American Portraits of the Sixties and Seventies.* Aspen, Colo.: Aspen Center for the Visual Arts, 1979.

Barendse, Henry. *The Fashionable Image: Unconventional Fashion Photography.* Charlotte, N.C.: Mint Museum, 1986.

Barents, Els. *Robert Mapplethorpe.* Amsterdam: Stedelijk Museum, 1988.

Barents, Els, with Karel Schampers, *Instant Fotografie.* Amsterdam: Stedelijk Museum, 1981.

Barter, Judith, and Anne Mochon. *Rules of the Game: Culture Defining Gender.* Amherst, Mass.: Mead Art Museum, Amherst College, 1986.

Black Males. Introduction by Edmund White. Amsterdam: Galerie Jurka, 1979.

Blessing, Jennifer. *Rrose is a Rrose is a Rrose: Gender Performance in Photography.* New York: Guggenheim Museum, 1997.

Bookhardt, Eric D. *Radical Photography: The Bizarre Image.* Atlanta: Nexus Gallery, 1984.

Borden, Janet. *Presentation: Recent Portrait Photography.* Cincinnati, Ohio: Taft Museum, 1983.

Cathcart, Linda, and Craig Owens. *The Heroic Figure.* Houston: Contemporary Arts Museum, 1984.

Celant, Germano. *Robert Mapplethorpe Fotografie*, Venice: Centro di Documentazione di Palazzo Fortuny; Milan: Idea Books Edizioni, 1983.

———. *Robert Mapplethorpe.* Bologna: Palazzo d'Accursio, 1986.

———. *Mapplethorpe versus Rodin.* Milan: Electa, 1992.

———. *Robert Mapplethorpe.* London: Hayward Gallery, 1996.

Cheim, John, ed. *Robert Mapplethorpe. Early Works 1970–1974.* New York: Robert Miller Gallery, 1991.

Collington, Robert, et al. *Figures: Forms and Expressions.* Buffalo: Albright-Knox Art Gallery, 1981.

Compton, Michael. *New Art.* London: Tate Gallery, 1983.

Conrad, Peter. *Mapplethorpe Portraits.* London: National Portrait Gallery Publications, 1988.

Cruger, George. *Portrait: Faces of the '80s.* Richmond: Virginia Museum of Fine Arts, 1987.

Curtis, Verna Posever. *Of People and Places: The Floyd and Josephine Segal Collection of Photography.* Milwaukee: Milwaukee Art Museum, 1987.

Dugan, Ellen. *First Person Singular: Self-Portrait Photography 1840–1987.* Atlanta: High Museum at Georgia-Pacific Center, 1988.

Fernandes, Joyce. *Sex-Specific: Photographic Investigations of Contemporary Sexuality.* Chicago: School of the Art Institute of Chicago, 1984.

Foss, Paul. *Robert Mapplethorpe: Photographs 1976–1985.* South Yarra: Australian Center for Contemporary Art, 1986.

Frank, Peter. *Self-Portraits.* Seattle: Linda Farris Gallery, 1983.

Friis-Hansen, Dana. *Nude. Naked. Stripped.* Cambridge: Massachusetts Institute of Technology, Hayden Gallery, List Visual Arts Center, 1985.

Fuchs, Rudi. *Documenta 7.* Kassel: Documenta, 1982.

Fuhr, Rein von der. *Robert Mapplethorpe.* Amsterdam: Galerie Jurka, 1979.

Gamwell, Lynn, and Victoria Kogan. *Inside Out—Self Beyond Likeness.* Newport Beach, Calif.: Newport Harbor Museum, 1981.

Hartshorn, Willis. *Art & Advertising, Commercial Photography by Artists.* New York: International Center of Photography, 1986.

Hedberg, Lars Peder. *US Art Now.* Stockholm: Nordiska Kompaniet, 1981.

Holmes, Jon. *Twelve on 20 x 24.* Cambridge, Mass.: New England Foundation for the Arts, 1984.

Kardon, Janet, David Joselit, Kay Larson, and Patti Smith. *Robert Mapplethorpe: The Perfect Moment.* Philadelphia: Institute of Contemporary Art, University of Pennsylvania, 1988.

Lebon, Baudoin. *Robert Mapplethorpe Portraits: Patti Smith Dessins.* Paris: Galerie Baudoin Lebon, 1998.

Lebon, Baudoin, and Jean Pierre Faur. *Les autoportraits de Mapplethorpe.* Paris: Galerie Baudoin Lebon, 1996.

Lifson, Ben. *Faces Photographed.* New York: Grey Art Gallery and Study Center, New York University, 1982.

Livingstone, Jane. *The Collection of Sam Wagstaff.* Washington, D. C.: Corcoran Gallery of Art, 1977.

Longwell, Dennis. *Surrealist Photographic Portraits 1920–1980.* New York: Marlborough Gallery, 1981.

Macklowe, Linda. *Flower as Image in 20th-Century Photography.* Bronx, New York: Wave Hill, 1984.

Marincola, Paula. *Investigations 10, Face to Face: Recent Portrait Photography.* Philadelphia: Institute of Contemporary Art, University of Pennsylvania, 1984.

Marshall, Richard, Richard Howard, and Ingrid Sischy. *Robert Mapplethorpe.* New York: Whitney Museum of American Art, in association with New York Graphic Society Books and Little, Brown and Company, 1988.

Mayer, Charles S. *Intimate/INTIMATE.* Terre Haute: Turman Gallery, Indiana State University, 1986.

Michetti, Chantal, and Charles Riley. *Robert Mapplethorpe.* Pully-Lausanne: FAE Musée d'art contemporain, 1991.

Morgan, Stuart, and Alan Hollinghurst. *Robert Mapplethorpe 1970–1983.* London: Institute of Contemporary Arts, 1983.

Naef, Weston J. *Counterparts: Form and Emotion in Photographs.* New York: Metropolitan Museum of Art, in association with E. P. Dutton, 1982.

1981 Biennial. New York: Whitney Museum of American Art, 1981.

Olander, William. *Picture Taking: Weegee, Walker Evans, Sherrie Levine, Robert Mapplethorpe.* Evanston, Ill.: Northwestern University, Mary and Leigh Block Gallery, 1985.

Parker, Fred. *Attitudes.* Santa Barbara, Calif.: Santa Barbara Museum of Art, 1979.

Photographs from the Collection of Robert Mapplethorpe. New York: Sotheby Park Bernet Inc., 1982.

Ribalta, J. *Robert Mapplethorpe.* Madrid: Galeria Weber, Alexander y Cobo, 1991.

Robert Mapplethorpe Flowers. Introduction by Sam Wagstaff. Tokyo: Watari Gallery, 1983.

Robert Mapplethorpe 1986. Interview by Anne Horton. Berlin: Raab Galerie; Cologne: Kicken-Pauseback, 1987.

Saul, Julie M. *Photography in America 1910–1983*. Tampa, Fla.: Tampa Museum, 1983.

Schneckenburger, Manfred. *Documenta 6*. Kassel: Documenta, 1977.

Sheftel, Bruce. *Presences: The Figure and Manmade Environments*. Reading, Pa.: Freedman Gallery, Albright College, 1980.

Sidlauskas, Susan. *Intimate Architecture: Contemporary Clothing Design*. Cambridge: Hayden Gallery, List Visual Arts Center, Massachusetts Institute of Technology, 1982.

Squiers, Carol. *Quattro fotografi differenti*. Milan: Padiglione d'Arte Contemporanea and Idea Editions, 1980.

Szarkowski, John. *Mirrors and Windows: American Photography Since 1960*. New York: Museum of Modern Art, 1978.

Walsh, Philip Hotchkiss, et al. *Phototypes*. New York: Whitney Museum of American Art, Downtown Branch, 1983.

Weiermair, Peter, ed. *Robert Mapplethorpe*. Frankfurt: Frankfurter Kunstverein, 1981.

Books

Barnes, L., ed. *The Male Nude in Photography*. Waisfield, Vermont: Vermont Crossroads Press, 1980.

Barthes, Roland. *Camera Lucida: Reflections on Photography*. Translated by Richard Howard. New York: Hill and Wang, 1981.

Celant, Germano. *Artmakers: Art, Architecture, Photography, Dance and Music in the U.S.A.* Milan: Feltrinelli, 1984.

Clyne, Jim, ed. *Exquisite Creatures*. New York: William Morrow and Company, 1985.

Contemporary American Erotic Photography, vol. 1. Los Angeles: Melrose, 1984.

Danto, Arthur C. *Mapplethorpe*. New York: Random House, 1992.

———. *Playing with the Edge: The Photographic Achievement of Robert Mapplethorpe*. Berkeley: University of California Press, 1996.

Frank, P., ed. *Dact: An Anthology of Art Criticism*. New York: Willis, Locker and Owens, 1984.

Levas, Dimitri, ed. *Pictures. Robert Mapplethorpe*. New York: Arena Editions, 1999.

Minkkinen, A. R. *New American Nudes*. New York: Morgan and Morgan, 1982.

Morrisroe, Patricia. *Mapplethorpe: A Biography*. New York: Random House, 1995.

Naef, W., and B. Rathbone, eds. *The Gallery of World Photography/New Directions*. Tokyo: Shueisha Publishing, 1984.

Rimbaud, Arthur. *A Season in Hell*. Translated by Paul Schmidt, with photogravures by Robert Mapplethorpe. New York: Limited Editions Club, 1986.

Smith, Patti. *Robert Mapplethorpe*. Bellport, N.Y.: Bellport Press, 1987.

Sullivan, C., ed. *Nude: Photographs 1850–1980*. New York: Harper and Row, 1980.

———. *Legacy of Light*. New York: Alfred A. Knopf, 1987.

Wise, K., ed. *Portrait: Theory*. New York: Lustrum Press, 1982.

Photo Credits

All works from the State Hermitage Museum: photos by Yurii Molotkovetz © 2004 State Hermitage Museum, St. Petersburg.

Cat. nos. 1, 103, 116: photos by Jörg Anders © Kupferstichkabinett, Staatliche Museen zu Berlin, Preussischer Kulturbesitz; cat. nos. 3, 27: photos by Jörg Anders © Skulpturensammlung, Staatliche Museen zu Berlin, Preussischer Kulturbesitz; p. 15: photo © Teylers Museum, Haarlem, The Netherlands; p. 20: photo © Rijksmuseum Amsterdam; p. 28, top: photo © George Eastman House, International Museum of Photography and Film, Rochester, New York; p. 28, bottom: photo © Science Museum/Science & Society Picture Library ; p. 29, top: photo by Avshalom Avital © The Israel Museum Jerusalem; p. 31, bottom: Courtesy of Matthew Marks Gallery, New York; p. 38: photo by Lynn Rosenthal, 1993 © Philadelphia Museum of Art; p. 40: photo by Joaquín Cortés/José Luis Municio © Archivo Fotográfico Museo Nacional Centro de Arte Reina Sofía, Madrid; p. 42: photo © Giraudon/Art Resource; p. 44: photo © Scala/Art Resource; p. 46: photo by Adam Rzepka © Musée Rodin, Paris; p. 48: Cameraphoto/Art Resource.